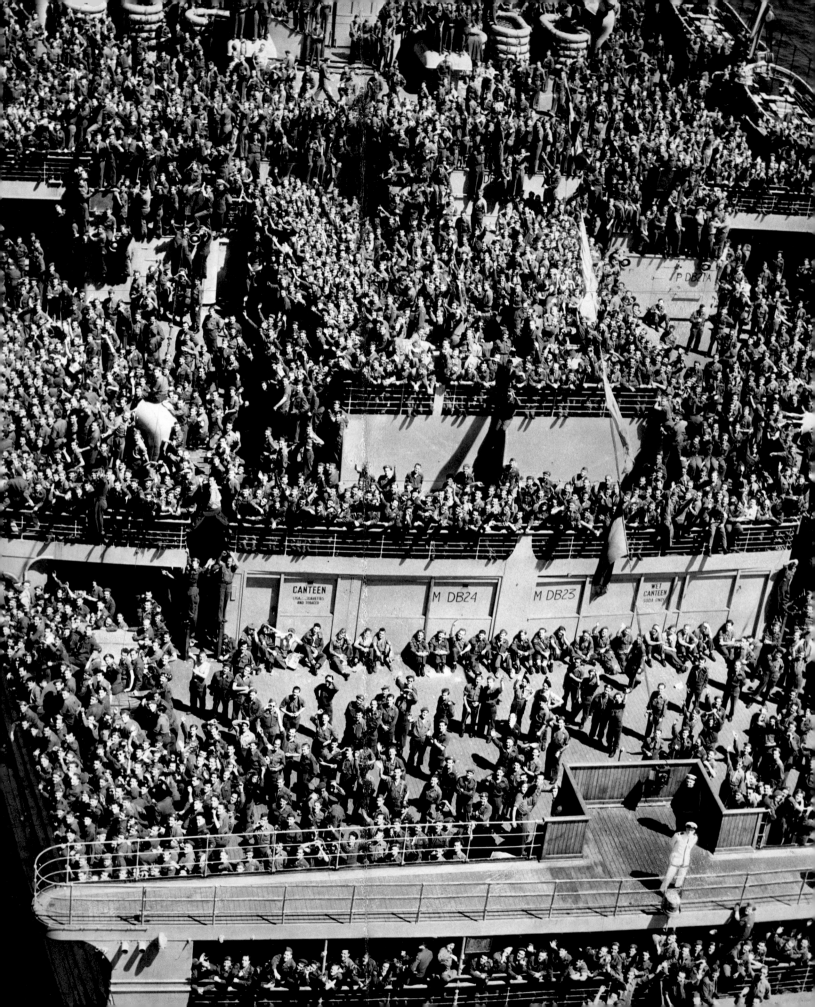

Pictures of the Times
A Century of Photography from The New York Times

Edited by Peter Galassi and Susan Kismaric

Essays by William Safire and Peter Galassi

The Museum of Modern Art, New York

Distributed by Harry N. Abrams, Inc., New York

Published on the occasion of the exhibition *Pictures of the Times: A Century of Photography from The New York Times*, organized by Peter Galassi, Chief Curator, and Susan Kismaric, Curator, Department of Photography, The Museum of Modern Art, New York, June 27–October 8, 1996.

The exhibition is supported in part by The New York Times Company Foundation.

Produced by the Department of Publications
The Museum of Modern Art, New York
Osa Brown, Director of Publications
Edited by Harriet Schoenholz Bee
Designed by Gregory Van Alstyne
Production by Marc Sapir
Composition by U.S. Lithograph, typographers, New York
Duotone separations by Robert J. Hennessey
Printed by Meridian Printing, East Greenwich, Rhode Island
Bound by The Riverside Group, Rochester, New York

Library of Congress Catalogue Card Number: 96-076115

ISBN 0-87070-115-0 (clothbound, The Museum of Modern Art, Thames & Hudson)
ISBN 0-87070-116-9 (paperbound, The Museum of Modern Art)
ISBN 0-8109-6167-9 (clothbound, Harry N. Abrams)

Published by The Museum of Modern Art
11 West 53 Street, New York, New York 10019
Printed in the United States of America

Clothbound edition distributed in the United States and Canada by Harry N. Abrams, Inc., New York, A Times Mirror Company
Clothbound edition distributed outside the United States and Canada by Thames & Hudson, London

Cover: detail, "Selection of Jury Delays Snyder Trial." April 1927. *Times Wide World Photos* (see page 63)

Frontispiece: detail, "It Was a Record Day for Allied Soldiers as 34,355 Arrived Here." July 11, 1945. *U.S. Coast Guard via Associated Press* (see page 96)

Contents

Foreword

On August 18, 1896, Adolph S. Ochs purchased *The New-York Times*, a paper with a daily circulation of 9,000 and a regional audience. One hundred years later the paper has a circulation of over 1,150,000 and is widely regarded as the preeminent American newspaper as well as one of the most prominent newspapers in the world. The Museum of Modern Art is pleased to join in the centennial celebrations of Mr. Ochs's acquisition of the *Times* by presenting a major exhibition of photographs from the archive of the great paper that he built.

In the spirit of this important event, *The New York Times* has announced a gift to The Museum of Modern Art of three hundred remarkable photographs from its archive of over five million pictures. This gift initiates The New York Times Collection at the Museum and forms the basis of the one hundred and fifty photographs that constitute the exhibition, *Pictures of the Times: A Century of Photography from The New York Times*. The exhibition is supported in part by The New York Times Company Foundation.

This generous gift is most welcome, for it enhances the Museum's commitment to addressing photography's worldly as well as artistic functions. As Ochs's *Times* grew, it became a leader in defining the role of photography in the news, publishing images of national and international significance that have transformed our understanding and memory of critical events. Who can forget the crash of the B-25 into the Empire State Building as recorded by Ernie Sisto or the aftermath of the World Trade Center bombing as recorded by Marilynn K. Yee? The paper's extensive picture archive is an ideal resource through which to explore the ways in which news photography has shaped our image of the modern world.

In organizing *Pictures of the Times*, the Museum joins three other New York institutions in celebrating the paper's centennial: The American Museum of Natural History, the New York Public Library, and the Pierpont Morgan Library. Each institution has sought to consider, independently, a different aspect of the history of the *Times*, under the overall title "Adolph S. Ochs: The Man Who Changed The Times, A Centennial Celebration of *The New York Times*."

I wish to thank Susan W. Dryfoos, Director of New York Times History Productions and Chairwoman of the Centennial Committee, and Arthur Gelb, President of The New York Times Company Foundation and Vice Chairman of the Centennial Committee, for the energy and cooperative spirit they have brought to this collaboration between our two institutions. I am grateful as well to William Safire of *The New York Times* for contributing his thoughtful perspective on photography in the news.

The exhibition and the publication that accompanies it would not have been possible without the work of Peter Galassi, Susan Kismaric, and the entire staff of the Department of Photography. Their enthusiastic commitment to this project has resulted in an exhibition and publication of enduring importance.

Glenn D. Lowry
Director

Preface and Acknowledgments

The Museum of Modern Art has long recognized newspaper photography as a fundamental aspect of the modern visual vocabulary and has twice before devoted major exhibitions to it. *The Exact Instant* (1949), organized by Edward Steichen, celebrated photography's legendary capacity to create images that would come to stand for the essence of events. *From the Picture Press* (1973), organized by John Szarkowski and accompanied by a catalogue, approached daily news photography critically, concluding that its essential subject is not the momentous and exceptional but the typical and ritualistic. The present book accompanies an exhibition that explores the diversity of news photography through the archive of a newspaper that has played a leading role in defining photography's functions in the news.

The New York Times conservatively estimates that its Picture Library houses between five and six million photographs made over the past century. Most of the pictures arrived as candidates for immediate use in the newspaper and later were classified, very roughly, by subject. It is not a systematic collection but a massive accumulation, and therein lies its richness.

Devoting ten seconds to each picture and working regular forty-hour weeks, one person would need to spend some seven years to review the entire archive. The present selection is the fruit of a collective review undertaken by six people: two at the *Times*—Mark Bussell, Special Projects Editor and former Picture Editor at both the newspaper and the Sunday magazine; and Nancy Weinstock, a staff picture editor—and four in the Department of Photography at The Museum of Modern Art—Virginia Dodier, Study Center Supervisor; Darsie Alexander,

Curatorial Assistant; and the two editors of this book and the exhibition it accompanies.

The six of us together compiled extensive lists of promising subject categories, then divided the categories and individually reviewed the photographs filed under each. Each of us also occasionally consulted other files at random. Nancy Weinstock, who oversaw the complex logistics of our research, estimates that together we consulted some 3,000 subject categories and looked at approximately one and a half million pictures, or about a quarter of the archive. The initial reviews yielded a total of more than 6,000 photographs, from which the two editors made the final selection.

All but a handful of the 154 photographs reproduced in the plate section have appeared once or more in *The New York Times*, although a number first appeared long after they were made. The criteria of selection, however, were very different from those that prevail at the newspaper. At the *Times*, it is essential to illustrate the leading stories of the day, even if the available photographs are disappointing. Here the priorities have been reversed: no particular subject was deemed to be essential, and a remarkable picture was welcome even if it carried little historical weight. For the subject of this book is not twentieth-century history as seen through photographs but the medium of news photography as seen through the archive of a great newspaper.

Although the pictures here span the century, and although we did our best to seek out a wide range of subjects, in the end we chose the photographs that spoke most clearly and forcefully in their own terms. Thus, for example, we included three photographs of Adolf Hitler (all made in 1933 or 1934) but none

of Mao Zedong, and two of Richard Nixon (neither made while he was President) but none of John F. Kennedy. And we accepted a radical imbalance that seems to place the United States at the center of the world and New York City at the center of the United States.

The Picture Library of *The New York Times* is so vast that a selection could be crafted to serve almost any thesis. The thesis here is that the vitality of photography in the newspaper is a function of its heterogeneity—of the diverse strategies spawned by the need to produce pictures for the paper. It follows that the meanings of the photographs—either as elements of the news or as adjuncts to history—are contingent upon the particular circumstances that brought each into being.

•

We are deeply grateful to Susan W. Dryfoos, Arthur Gelb, and others at *The New York Times* for the opportunity to explore the newspaper's extraordinary archive of photographs and to select from it as we saw fit. We are grateful as well to have had Mark Bussell and Nancy Weinstock as our guides and collaborators, and we thank them for their experienced eyes and hard work and for the generosity with which they shared their extensive knowledge of the history and present role of photography at the *Times*. Their dedicated efforts made an invaluable contribution to the exhibition and the book. Margarett Loke, a writer at the *Times*, conducted extensive research on the newspaper's history, which has been indispensable both to Peter Galassi's introductory essay and to the chronology that appears at the end of the book. Thanks also are due Nancy Lee, Picture Editor; Charles Robinson, Director of Information Services, and his staff in the Picture Library; Roger Strong, staff picture editor and former assistant to the Information and Technology Editor; and Carl Sharif, staff artist.

In the course of research for the picture captions and the chronology and on the identity of agency photographers, we and others had occasion to call upon the knowledge and expertise of dozens of people. We are particularly thankful to Eddie Hausner, a former staff photographer who joined the *Times* in 1946; Michael O'Keefe, a former picture editor at the *Times* Sunday magazine; Bill Kuykendall of the School of Journalism at the University of Missouri; Billie Shaddix, consultant to The White House Photographic Office; Arty Pomerantz, former President of the New York Press Photographers' Association; Jane Waisman of The Bettmann Archive; Michael Shulman of Archive Photos; Susan Williams of Agence France-Presse; and Chuck Zoeller of the Associated Press. The parts of the chronology that concern recent innovations in digital technologies could not have been written without the generous cooperation of David Frank, assistant to the Picture Editor, and Richard Meislin, Senior Editor for Information and Technology, at the *Times*; Vincent Alabiso, Chief Picture Editor, the Associated Press; Gary Cosimini, formerly of the *Times* and now at Adobe Systems; and Richard Benson. Henry Wilhelm of Wilhelm Imaging Research went out of his way to be helpful.

We appreciate the kind cooperation of photographers and picture agencies who granted permission to reproduce their photographs in the book and who in a number of cases lent original negatives so that new prints could be made. The new prints were made by Preston Rescigno, whom we thank for his excellent work.

At The Museum of Modern Art the exhibition and the book involved the efforts of many people, including the entire staff of the Department of Photography. Virginia Dodier deserves particular thanks for her thoughtful and energetic supervision of every aspect of the project. Sarah Hermanson, Curatorial Assistant; Thomas W. Collins, Jr., the Beaumont and Nancy Newhall Curatorial Fellow; Lydia Marks, Assistant to the Chief Curator; and Darsie Alexander all contributed in essential ways. Jana Joyce in the Department of the Registrar oversaw the care of hundreds of prints that were brought to the Museum from the *Times*. Paper

conservators Karl Buchberg and Erika Mosier skillfully restored dozens of prints that bore the marks of repeated use. Without the often astonishing transformations that they performed, the book and the exhibition simply would not have been possible.

We are grateful to Harriet Schoenholz Bee for her experienced editorial guidance and to Christopher Lyon for further work on the text. Greg Van Alstyne, assisted by Makiko Ushiba, created the imaginative and efficient design. The production of the book was overseen with care by Marc Sapir, and its duotone plates were printed from halftone separations made by Robert J. Hennessey. It is thanks not only to his exceptional mastery of his craft but also to his profound dedication to photography that the plates of this book so faithfully render the pictures.

Peter Galassi, *Chief Curator*
Susan Kismaric, *Curator*
Department of Photography

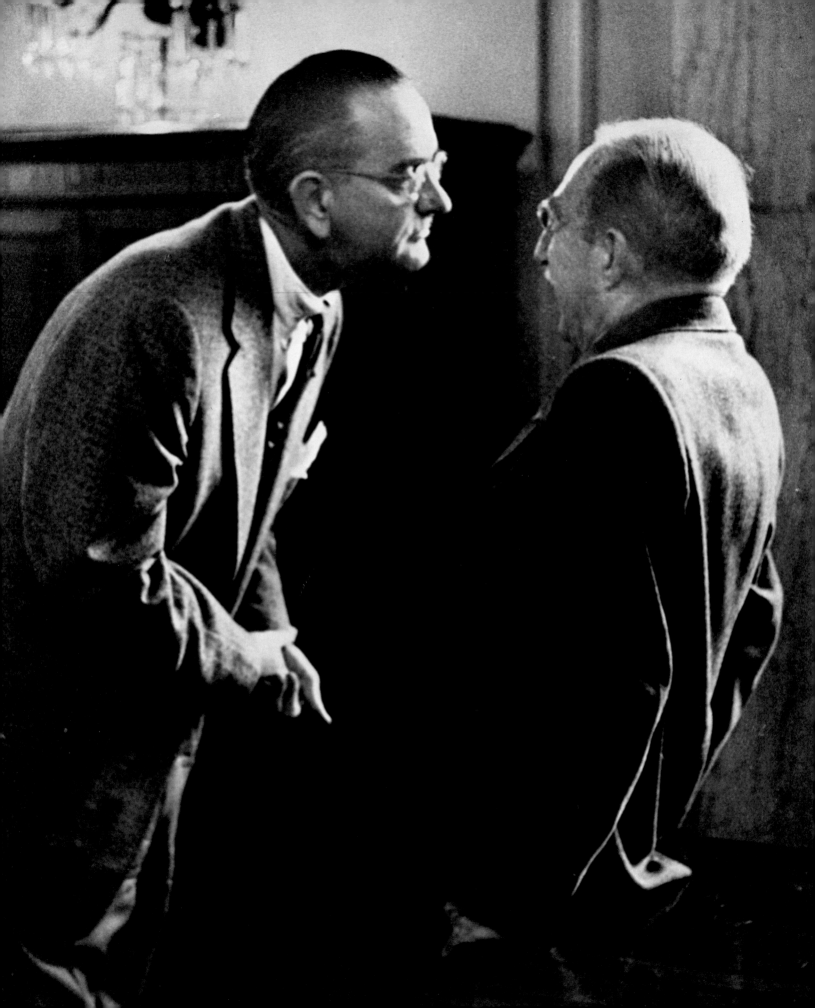

Standing History Still:
A Prolegomenon

William Safire

"One look is worth a thousand words." Frederick R. Barnard, national advertising manager of Street Railways Advertising used that headline over an ad he ran in *Printers' Ink* magazine on December 8, 1921. "So said a famous Japanese philosopher," he wrote, and went on to sell the idea of using illustrations in advertising. Six years later, in another ad in the same publication, he sharpened his observation to "One picture is worth ten thousand words." This time, the copy-bashing adman ran a picture of the words in Chinese characters, captioning it "an ancient Chinese proverb."

That attribution made it to quotation books as "a Confucian saying." For years, Chinese scholars knocked themselves out looking in the Analects of Confucius and hundreds of manuscripts for that apt piece of wisdom; finally, the quotations anthologist Burton Stevenson discovered that the source was Barnard himself, who evidently felt that an adman's original thought would not sufficiently impress the reader and attributed the aphorism to the ancients to give it weight.

That is how the most famous saying about photography—"a picture is worth a thousand words"—got its somewhat phony start. In the same way, we often fiddle with sayings and even the records of events until we get them the way we like them. Sometimes it's harmless, like attributing a saying to the ancients; sometimes it's legitimate, as when a photo editor "crops" a negative—trimming the superfluous top or side or bottom of a photograph to enhance the composition and focus the looker's attention on the essential elements of the shot. In the picture of Jack Ruby murdering Lee Harvey Oswald in a Dallas hallway (page 131), the whole picture as taken is shown, with an extraneous detective looking the wrong way; it gains impact as it is cropped to the killer, the victim, and the astounded guard in the hat.

Such editing removes no significant truth from the moment being captured. Less legitimate—subtracting from authenticity—is deceptive reenactment; or staging a "pseudoevent," in the historian Daniel Boorstin's term, for the sole purpose of being captured on film; or airbrushing out a face as communist historians did when creating nonpersons; or—and here photojournalism will have great trouble with credibility in the future—altering images by computer without revealing the technique in the caption.

Those actions subvert the essence of a news photograph: instantaneous truth, the stopping of time for close observation. Of course, lying in photography has been with us a long time. There is Franklin D. Roosevelt in 1938, in profile (page 79) aboard a warship, hair whipped by the wind, the picture of vigor and strength—with the shriveled, paralyzed legs concealed from view. In the fuzzy radio photo of the "Big Three" conference at Yalta in 1945 (page 94), part of the photograph is lying, while the totality of the shot reveals a truth about relationships: FDR's legs are arranged and draped to appear normal, and no braces show—but the truth in the picture is in the relationships among the three men. The American president is portrayed bareheaded, in a dashing cape, seated in the middle doing the talking, with the becapped and peacoated Churchill, hands in motion and cigar in mouth, listening amusedly, and the uniformed Stalin leaning in to catch a communication he surely cannot understand. In a matter of months, the middle one would die and the remaining two become implacable foes.

The Johnson Treatment. 1957. Senate majority leader Lyndon Baines Johnson, six feet three inches tall, corners Senator Theodore Francis Green of Rhode Island. *George Tames/The New York Times.*

Illustrating relationships is one function of photojournalism; another is catching the moment that wordlessly tells a story. George Tames, the legendary *New York Times* photographer in Washington, D.C., told me how he wanted to show the meaning of "the Johnson treatment," a phrase that described the combination of fierce harangue and honeyed promises that Lyndon B. Johnson used to persuade politicians to vote his way. Tames matched the senate majority leader with a short senator and waited; LBJ began working over Senator Theodore Green, literally bending him back with the power of his argument (page 10). Tames did not tell the two men to hold still. He held them still himself by catching the moments in a series culminating in the one shown here. The story is in the picture and the action he stopped continues to this day in this book.

"Stop the world; I want to get off." (Sorry, cannot track down that coiner.) Everything we see with the naked eye that is alive is moving through time's inexorable continuum, and most human beings yearn for the chance to bring it all to a sudden halt, at least for a few moments, to take a closer look, to let their eyes wander around the scene and catch the parts not in immediate focus.

That's what the best news photography does. Photojournalism confronts an unfolding drama and freezes the frame, refusing to let the fleeting instant flee. It stops the world at that moment of history and lets us get on.

A collection of photographs like this—selected from the archive assembled in the century that the Ochs family has owned *The New York Times*—illustrates how connected those moments can be. Look at the "hunger marchers" being driven from Hyde Park in London in 1932 (page 71) and think of pictures of the Chicago police storming antiwar protesters at the Democratic Party convention of 1968; look at Frenchmen kicking at German prisoners in 1944 (page 95) and think of similar shots of Muslims jeering at Serb prisoners not long after the atrocity of Srebrenica. Look at Mayor John Lindsay touring the garment district in New York City (page 148) and Governor Nelson Rockefeller about to stuff a plebeian hot dog in his mouth and think of every picture of every patrician politician uncomfortably acting as if he understands the life and concerns of the great unwashed. (George McGovern, at a "photo opportunity" in a delicatessen, ethnically blundered by ordering "a kosher hot dog and a glass of milk.")

But even connected themes have separate effects. Calvin Coolidge, who kept cool before cool was cool, posed before throwing out the first ball at the opening of baseball season (page 58); compare that to every other president who posed for the traditional, annual shot. On another level, the heart-stopping picture of Jews lined up against a wall in 1943 to be "searched" and shot after the uprising at the Warsaw ghetto (page 92) is one of many such tragic pictures from the Holocaust, but this particular one—hands up against the wall—evokes a comparison with Jews praying at Jerusalem's Wailing Wall (renamed the Western Wall by Israelis who reject the lamenting image). The Chinese father, baby cradled in his arms, being assisted by police as they escape from a 1954 fire in Kowloon (page 120), is like so many other rescued-from-the-flames photos, except that the diagonal composition and leaning legs transmute the timeliness of news into the timelessness of art.

What is it like to take a famous picture? I'm no photographer, as the following anecdote will vividly demonstrate, but as Archimedes told the boys from Syracuse, "Give me a lever long enough, and a fulcrum strong enough, and a place to stand, and single-handed I can move the world." The mechanism-firing doohickey or button on a camera is the lever; the fulcrum is a news event and its personalities; the place to stand is the right spot at the historic moment. Here is how I came to press the lever that moved the world—a little.

Moscow in 1959; the American exhibition in Sokolniki Park, showing off our products to astonished Russians, with Vice President Richard Nixon the host and Soviet leader Nikita

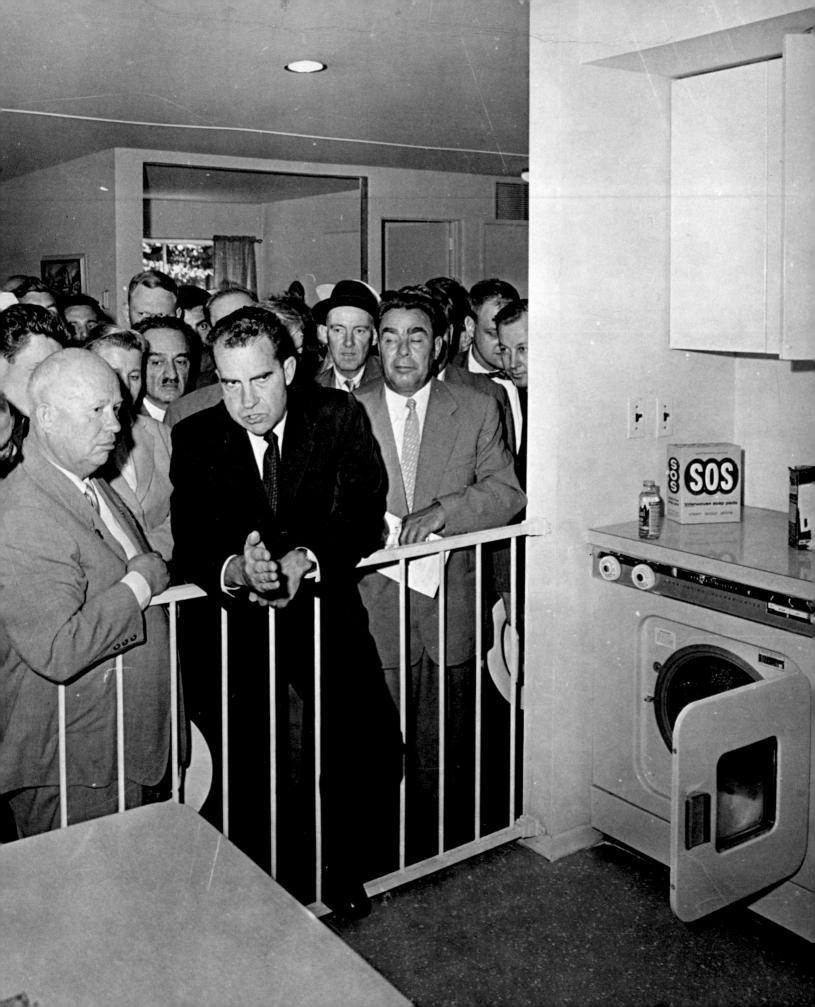

Khrushchev determined not to be impressed. I was the press agent for the "typical American house," then selling for $11,000 in suburban developments in the U.S., which *Pravda* had derided as propaganda—a Taj Mahal that no worker could afford.

Nixon had just been verbally roughed up by the Russian in debate in an exhibit of an American television studio; the vice president had to make a comeback that day or his reputation for standing up to the Russians would be ruined. "This way to the typical American house!" I hollered, and as the two men entered the walkway dividing the ranch house, I spilled a crowd in from the other side, trapping them in my kitchen. Nixon moved to the rhetorical attack. I slipped Harrison Salisbury of *The New York Times* into the kitchen to take pool notes, explaining to the Russian guards he was the refrigerator demonstrator, and tried to do the same with Hans von Knolde, the AP photographer, but my story that he was to demonstrate the garbage disposal unit foundered when it turned out that this kitchen had no garbage disposal unit.

There we were, at a moment in history that cried out for a picture, with no photographer permitted in the kitchen. Von Knolde took a big chance; he lobbed his camera into my arms in the kitchen and motioned frantically at me to take the shot.

I looked through the camera at the scene. Nixon and Khrushchev were in the middle—that was okay—but the washing machine was not. I backed up to get the machine on the right and my boss's wife, Jinx Falkenburg McCrary, on the left. So much for "composition": the lady would be cropped later, but not the machine, which was part of the story. I waited only until the vice president made a hand gesture to shoot the picture, then quickly lobbed the big camera to the AP man. He lobbed it right back: "You had your hand over the aperture, idiot!" he cried. As the Russian leader glared at me for playing this distracting camera-basketball game during his debate, I got set again, motioning Nixon to move over toward the washing machine. He would have

moved, but a pushy Russian politician had elbowed his way next to him, making it impossible to tighten up the shot. (The tighter the shot, I was always told, the bigger the faces could be.) As soon as Nixon started talking and gestured with his hand—ensuring his domination of the picture—I held the AP's heavy camera steady and popped off the photo (page 124). (Caught the pushy politician with his eyes shut; served the publicity hog right.)

Von Knolde was able to move the picture to New York on Wirephoto before the Russians decided to review pictures of the event that showed their man on the defensive. Meanwhile, I persuaded the guard at the kitchen door to let a professional photographer in, who took a picture of Nixon poking his finger in Khrushchev's chest. I smuggled his film out of Moscow in my socks.

What profound lessons about photojournalism can we draw from this episode?

First, a certain amount of manipulation is to be expected in photographs involving the famous. FDR with the wind in his hair; Hitler with his top hat in his lap (page 72); and fighter Joe Louis and his wife out for a stroll (page 83) are all examples of people in conscious poses. This is the symbiosis of the photographer and the subject; each uses the other.

Next, there is the subtle connection of viewer and scene in the eyes of a minor subject who happens to be looking directly at the camera. In my case, it was Jinx, whose face says she knew exactly what I was doing. In the famous picture of the swearing-in of Lyndon Johnson as president on Air Force One (page 130), the eyes looking at the camera from the left edge of the picture are those of Jack Valenti, an advertising executive and aide to Johnson whose experienced media eye locked on the camera recording the scene rather than the scene itself. In the aforementioned shot of the Kowloon man saving his child, eyes in the upper left corner look back at us, saying they know a picture is being taken, connecting us to the action in a curious way.

The preservation of the moment is

part of the picture. I can write about the "Kitchen Debate" and almost put you there in prose, but the photo does it better. There are the two men joined in history, like Jurassic insects petrified in amber; the gesticulating flat hand is an inescapable part of the record.

In that preservation, there is the value of providing a record for retrospective analysis. When you stand time still you make it possible for future eyes to see something whose significance the photographer and the caption writer may have missed or couldn't have grasped at the time. The unknown pushy pol edging his way in, caught by my AP camera with his eyes shut? Years later, I looked again and realized it was Leonid Brezhnev, soon to help elbow Khrushchev out of power, who— a decade later—bestrode the Cold War world with Nixon at the summits of suspicious detente.

Will there be a place for the still news photograph in the multimedia internetted world, where video screens come alive with text illustrated by graphs in motion, and with instantaneous TV photo feeds competing with the most extensive film libraries?

Yes. The photo may not be made by a still camera; it may be a frame of a film or a snapshot of a moving image. But whatever the means of capture or transmission, the need will be to stop action, to make history stand still, to let the viewer fully absorb the beauty or horror or humor of the moment.

To make that point it has taken a *New York Times* writer two thousand words, which, at the going rate, are worth two reasonably good pictures.

Section 1

"All the News That's Fit to Print."

The New York Times.

THE WEATHER
Generally fair today and tomorrow; moderate to fresh southerly winds.
Temperature yesterday—Max.: 60; Min.: 53.
For weather report see Page 21.

Section 1

VOL. LXXVI....No. 25,320. •••• NEW YORK, SUNDAY, MAY 22, 1927. Including Rotogravure Picture Section in three parts—Magazine and Book Sections in Rotogravure FIVE CENTS In Manhattan / Elsewhere / Bronx and Brooklyn TEN CENTS

LINDBERGH DOES IT! TO PARIS IN 33½ HOURS; FLIES 1,000 MILES THROUGH SNOW AND SLEET; CHEERING FRENCH CARRY HIM OFF FIELD

COULD HAVE GONE 500 MILES FARTHER

Gasoline for at Least That Much More— Flew at Times From 10 Feet to 10,000 Feet Above Water.

ATE ONLY ONE AND A HALF OF HIS FIVE SANDWICHES

Fell Asleep at Times but Quickly Awoke—Glimpses of His Adventure in Brief Interview at the Embassy.

LINDBERGH'S OWN STORY TOMORROW.

Captain Charles A. Lindbergh was too exhausted after his arrival in Paris late last night to do more than indicate, as told below, his experiences during his flight. After he awakes today, he will narrate the full story of his remarkable exploit for readers of Monday's New York Times.

By CARLYLE MACDONALD.
Copyright, 1927, by The New York Times Company.
Special Cable to The New York Times.

PARIS, Sunday, May 22.—Captain Lindbergh was discovered at the American Embassy at 2:30 o'clock this morning. Attired in a pair of Ambassador Herrick's pajamas, he sat on the edge of a bed and talked of his flight. At the last moment Ambassador Herrick had canceled the plans of the reception committee and, by unanimous consent, took the flier to the embassy in the Place d'Iena.

A staff of American doctors who had arrived at Le Bourget Field early to minister to an "exhausted" aviator found instead a bright-eyed, smiling youth who refused to be examined.

"Oh, don't bother; I am all right," he said.

"I'd like to have a bath and a glass of milk. I could feel better," Lindbergh replied when the Ambassador asked him what he would like to have.

A bath was drawn immediately and in less than five minutes the youth had disrobed in one of the embassy guest rooms, taken his bath and was out again drinking a bottle of milk and eating a roll.

"No Use Worrying," He Tells Envoy.

"There is no use worrying about me, Mr. Ambassador," Lindbergh insisted when Mr. Herrick and members of the embassy staff wanted him to be examined by doctors and then go to bed immediately.

It was apparent that the young man was too full of his experiences to want sleep and he sat on the bed and chatted with the Ambassador.

By this time a corps of frantic newspaper men who had been madly chasing the airman, following one false scent after another, had finally tracked him to the embassy. In a body they descended upon the Ambassador, who received them in the salon and informed them that he had just left Lindbergh with strict instructions to go to sleep.

As Mr. Herrick was talking with the reporters his son-in-law came downstairs and said that Lindbergh had rung and announced that he did not care to go to sleep just yet and that he would be glad to see the newspaper men for a few minutes. A cheer went up from the group who dashed by Mr. Herrick and rushed upstairs.

Expected Trouble Over Newfoundland.

In the blue and gold room, with a soft light glowing, sat the conqueror of the Atlantic. He immediately stood up and held out his hands to greet his callers. THE NEW YORK TIMES correspondent being first to greet him.

"Sit down, please," urged every one with one voice, but Lindbergh only smiled again his famous boyish smile and said: "It's almost as easy to stand up as it is to sit down."

Questions were fired at him from all sides about his trip across the ocean, but Lindbergh seemed to dismiss them all with brief, nonchalant answers.

"I expected trouble over Newfoundland because I had been warned that the situation there was unfavorable. But I got over that hazard with no trouble whatsoever."

Sleet and Snow for 1,000 Miles.

"However, it wasn't easy going. I had sleet and snow for over 1,000 miles. Sometimes it was too high to fly over and sometimes too low to fly under, so I just had to go through it as best I could.

"I flew as low as 10 feet in some places and as high as 10,000 in others. I passed no ships in the daytime, but at night I saw the lights of several ships, the night being bright and clear."

Everyone then wanted to know if the flier had been sleepy on the voyage.

"I didn't really get what you might call downright sleepy," he said, "but I think I sort of nodded several times. In fact, I could have flown half that distance again. I had enough fuel

Continued on Page Two.

LEVINE ABANDONS BELLANCA FLIGHT

Venture Given Up as Designer Splits With Him—Plane Narrowly Escapes Burning.

BYRD'S CRAFT IS NAMED

Lindbergh Cheered at Ceremony—Commander, Now Last in Field, Waits on Weather.

Through no fault of his own, Clarence D. Chamberlin, who with Bert Acosta established a world's non-stop flying record a few weeks ago, will not fly the record-breaking monoplane in an attempt to establish a second New York-Paris non-stop flight.

G. M. Bellanca, designer of the plane, and Charles S. Levine of the Columbia Aircraft Company, owner of the ship, came to the parting of the ways last night and the designer finally severed his connection with the promoter. Then Levine issued a statement that the proposed flight, which has been talked of for weeks, was off.

The statement said:

"Due to the crowning blow of Mr. Bellanca's resignation, the plane will be placed in the hangar. Mr. Bellanca's resignation causes us to abandon plans for the New York-Paris flight for the present."

At the very moment that the statement was issued the plane was near the runway at Roosevelt Fie'd with gas tanks filled and oil and equipment aboard ready for the start for Paris.

Plane Threatened by Fire.

A few minutes later, as it was being wheeled out, preparatory to being housed for the night, it narrowly escaped being destroyed by fire. When the word came to the field that the flight was definitely off mechanics were ordered to empty one gasoline tank to lighten the machine. The gasoline spilled on the ground and while the ship was being towed away a careless spectator threw the stub of a lighted cigarette down.

In an instant there was a terrific flare and a dense burst of smoke as the gasoline blazed up.

"The Bellanca's gone," was the cry that rose from thousands of spectators who had gathered at the field.

Word was flashed to the army air station at Mitchel Field that there had been an accident and ambulances and fire-fighting apparatus were sent across the road. An ambulance from the Nassau County Hospital at Mineola was sent to Roosevelt Field, as well as fire apparatus from Mineola.

The plane, however, was beyond the danger line and was not injured. It had been announced that the Columbia would take off at 8 o'clock and Chamberlin was in his flying clothes ready to climb into the cockpit with the unnamed pilot who was to have accompanied him on the trip.

With the elimination of the Bellanca monoplane, only Lieut.

Over-Acidity quickly relieved by BELL-ANS for Indigestion, 25c & 75c, all druggists.—Advt.

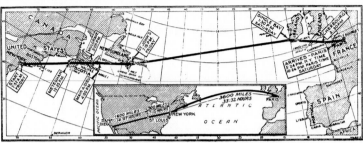

CAPTAIN CHARLES A. LINDBERGH,
Who Flew Alone Across the Atlantic, New York to Paris, in Thirty-three and One-half Hours.

Times Wide World Photo

New York Stages Big Celebration After Hours of Anxious Waiting

Harbor Craft, Factories, Fire Sirens and Radio Carry Message of the Flier's Victory Throughout the City—Theatres Halt While Audiences Cheer.

New York bubbled all day yesterday with excitement and expectancy, first yearning for word of Captain Lindbergh, then half-doubting, gaining confidence as the afternoon progressed and finally acclaiming the victory of the young aviator with street 'monstrations where the crowds were thickest, in which the ancient phrase, "I told you so," was often repeated. It was evident during the day that New York had confidence in the lad from the West.

On the streets and elsewhere Lindbergh was the one topic of conversation the whole day long. In the subway, on the elevated, in trains and cars, motion-picture houses, theatres, wherever a few had gathered, or even where one man could find another to talk to, one heard "Lindbergh — Lindbergh — Lindbergh."

And such expressions as this: "He'll make it, all right." "Some baby!" "Well, if he's hit Ireland, he's safe anyway." "He's away ahead of his time." "What's the difference in time between here and there, anyway?"

Confused On Difference in Time.

To 'is latter question there were some amazing answers. One woman who had the aviator's running time mixed with the difference in time between New York and Paris and here there was thirty-six hours difference in time between the cities.

She said it with an air which signified: "I don't mean maybe." A surprising number of persons insisted that the difference in time was three hours.

Early in the day, even before there was any good reason why there should be definite news, the interest of the people was demonstrated in two ways. At every news stand there were little groups scanning the headlines and buying newspapers. In every newspaper office the switchboards were literally swamped with inquiries. It was not sufficient that the operator said there was no word, or, later, that Lindbergh's plane had been seen over Ireland. The inquirers wanted specific information:

"Well, when will you get the first news?" they asked. And later: "If he's over Ireland how long will it be before he gets to Paris?" "Is he all right?"

The questions that were asked, considering that no news could possibly come direct from Captain Lindbergh before he landed, were as surprising as the guesses at the difference in time.

The Times Gets 10,000 Phone Calls.

The telephone inquiries came from all sorts of people and all directions. Not a few rang up THE TIMES office and apologetically explained that they were on golf links or elsewhere at a distance, and hence could not

PATERNO AUCTION ON PALISADES
Estate opportunity. See Page 4 of Real Estate section.—Advt.

LINDBERGH TRIUMPH THRILLS COOLIDGE

President Cables Praise to "Heroic Flier" and Concern for Nungesser and Coli.

CAPITAL THROBS WITH JOY

Kellogg, New, MacNider, Patrick and Many More Join in Paying Tribute to Daring Youth.

Special to The New York Times.

WASHINGTON, May 21.—The triumph of Captain Charles A. Lindbergh in flying from New York to Paris without a stop created a tremendous sensation in the national capital and found immediate response in a host of official messages and statements congratulating the daring aviator upon his achievement.

President Coolidge expressed his admiration in a message transmitted through Ambassador Herrick in Paris for delivery to the young flier in person.

With a single possible exception, this city has never been more thrilled since the armistice, when Woodrow Wilson mingled with many thousands in celebrating the end of the war. The exception was when Walter Johnson arose from apparent defeat and won the deciding world series baseball game in 1924.

"The American people," the President said, "rejoice with me at the brilliant termination of your heroic flight. The first non-stop flight of a lone aviator across the Atlantic crowns the record of American aviation, and in bringing the greetings of the American people to France you likewise carry the assurance of our admiration of those intrepid Frenchmen, Nungesser and Coli, whose bold spirits first ventured on your exploit, and likewise a message of our continued anxiety concerning their fate."

Secretary Kellogg, in a message similarly transmitted, said:

"I heartily congratulate you on the success of your great adventure in accomplishing a non-stop flight from New York to Paris. It is a great step in the advancement of aviation. Every one in the United States is proud of this achievement."

Knew Lindbergh as a Boy.

In a statement issued here Mr. Kellogg referred to his personal friendship for Lindbergh, whom he has known for years through the young man's late father, a Representative in Congress from the Secretary's home State of Minnesota.

"News has just reached me," Mr. Kellogg said, "of the success of Lindbergh in completing his flight from New York to Paris. It is an achievement of which every American can justly be proud. I have known Lindbergh since he was a boy and rejoice at this culmination of his ambitions, which could only have been gained by scientific knowledge, superb courage and physique and sterling character. Our rejoicing in Lindbergh's success, however, is tempered by our continued ignorance of the fate of Nungesser and Coli, whose courage and valor have been equaled, but cannot be surpassed."

Hanford MacNider, Acting Secre-

Continued on Page Four.

CROWD ROARS THUNDEROUS WELCOME

Breaks Through Lines of Soldiers and Police and Surging to Plane Lifts Weary Flier from His Cockpit

AVIATORS SAVE HIM FROM FRENZIED MOB OF 100,000

Paris Boulevards Ring With Celebration After Day and Night Watch—American Flag Is Called For and Wildly Acclaimed.

By EDWIN L. JAMES.
Copyright, 1927, by The New York Times Company.
Special Cable to The New York Times.

PARIS, May 21.—Lindbergh did it. Twenty minutes after 10 o'clock tonight suddenly and softly there slipped out of the darkness a gray-white airplane as 25,000 pairs of eyes strained toward it. At 10:24 the Spirit of St. Louis landed and lines of soldiers, ranks of policemen and stout steel fences went down before a mad rush as irresistible as the tides of the ocean.

"Well, I made it," smiled Lindbergh, as the little white monoplane came to a halt in the middle of the field and the first vanguard reached the plane. Lindbergh made a move to jump out. Twenty hands reached for him and lifted him out as if he were a baby. Several thousands in a minute were around the plane. Thousands more broke the barriers of iron rails round the field, cheering wildly.

Lifted From His Cockpit.

As he was lifted to the ground Lindbergh was pale with his hair unkempt, he looked completely worn out. He had strength enough, however, to smile, and waved his hand to the crowd. Soldiers with fixed bayonets were unable to keep back the crowd.

United States Ambassador Herrick was among the first to welcome and congratulate the hero.

A NEW YORK TIMES man was one of the first to reach the machine after its graceful descent to the field. Those first to arrive at the plane had a picture that will live in their minds for the rest of their lives. His cap off, his famous locks falling in disarray around his eyes, "Lucky Lindy" sat peering out over the rim of the little cockpit of his machine.

Dramatic Scene at the Field.

It was high drama. Picture the scene. Almost if not quite 100,000 people were massed on the east side of Le Bourget air field. Some of them had been there six and seven hours.

Off to the left the giant phare lighthouse of Mount Valerien flashed its guiding light 300 miles into the air. Closer on the left Le Bourget Lighthouse twinkled, and off to the right another giant revolving phare sent its beams high into the heavens.

Big arc lights on all sides with enormous electric glares were flooding the landing field. From time to time rockets rose and burst in varied lights over the field.

Seven thirty, the hour announced for the arrival, had come and gone. Then 8 o'clock came, and no Lindbergh; at 9 o'clock the sun had set but then came reports that Lindbergh had been seen over Cork. Then he had been seen over Valentia in Ireland and then over Plymouth.

Suddenly a message spread like lightning, the aviator had been seen over Cherbourg. However, remembering the messages telling of Captain Nungesser's flight, the crowd was skeptical.

"One chance in a thousand!" "Oh, he cannot do it without navigating instruments!" "It's a pity, because he was a brave boy." Pessimism had spread over the great throng by 10 o'clock.

The stars came out and a chill wind blew.

Watchers Are Twice Disappointed.

Suddenly the field lights flooded their glares onto the landing ground and there came the roar of an airplane's motor. The crowd was still, then began a cheer, but two minutes later the landing glares went dark for the searchlight had identified the plane and it was not Captain Lindbergh's.

Stamping their feet in the cold, the crowd waited patiently. It seemed quite apparent that nearly every one was willing to wait all night, hoping against hope.

Suddenly—it was 10:16 exactly—another motor roared over the heads of the crowd. In the sky one caught a glimpse of a white gray plane, and for an instant heard the sound of one. Then it dimmed, and the idea spread that it was yet another disappointment.

Again landing lights glared and almost by the time they had flooded the field the gray-white plane had lighted on the far side nearly half a mile from the crowd. It seemed to stop almost as it hit the ground, so gently did it land.

And then occurred a scene which almost passed description. Two companies of soldiers with fixed bayonets and the Le Bourget field police, reinforced by Paris agents, had held the crowd in good order. But as the lights showed the plane

Pictures of the Times

Peter Galassi

PARIS, May 21—Lindbergh did it. Twenty minutes after 10 o'clock tonight suddenly and softly there slipped out of the darkness a gray-white airplane as 25,000 pairs of eyes strained toward it. At 10:24 the Spirit of St. Louis landed and lines of soldiers, ranks of policemen and stout steel fences went down before a mad rush as irresistible as the tides of the ocean.

The New York Times,
Sunday, May 22, 1927

HOUSTON, Monday, July 21—Men have landed and walked on the moon.

Two Americans, astronauts of Apollo 11, steered their fragile four-legged lunar module safely and smoothly to the historic landing yesterday at 4:17:40 P.M. Eastern daylight time....

About six and a half hours later, Mr. Armstrong opened the landing craft's hatch, stepped slowly down the ladder and declared as he planted the first human footprint on the lunar crust:

"That's one small step for man, one giant leap for mankind."

The New York Times,
Monday, July 21, 1969

These two events evoke the headlong pace of technological change in the twentieth century. Front-page reports of them in *The New York Times*, both illustrated with photographs, roughly bracket the heyday of modern news photography, itself a wonder of technology.

Accompanying the Lindbergh story was a formal portrait of the handsome young aviator, made days earlier at the *Times* studio in New York. Embellishing the news of the Apollo 11 landing were pictures of Neil A. Armstrong and Edwin E. Aldrin, Jr., on the moon's surface.

The text reporting Lindbergh's Paris landing on Saturday evening reached New York via transatlantic cable in time to appear in Sunday's newspaper. Recent innovations had made it possible to transmit photographs by cable and radio, but the results were crude and did not appear in the *Times* until Tuesday, May 24. In 1927 the great majority of photographs sent from Europe to New York still traveled by boat, and extensive pictorial coverage of Lindbergh's landing did not appear in the *Times* until Wednesday, June 1. By 1969 the *Times* was able to receive images transmitted almost instantaneously from the moon, but so too was anyone who owned a television.

Only three decades before Lindbergh's flight, when Adolph S. Ochs purchased the *Times* in August 1896, there were no photographs at all in the newspaper. The medium of photography was more than half a century old, but the process of translating a photograph into ink on paper without copying it by hand was still in its infancy. Around the turn of the century, as photomechanical reproduction became practical for newspaper production, photographs gradually began to replace the hand-drawn illustrations that had been common since the 1840s and 1850s in such publications as the *Illustrated London News* and *Frank Leslie's Illustrated Newspaper.* By 1920 a newspaper without photographs had become unthinkable, which is why editors at *The New York Times,* knowing that photographs of Lindbergh's landing might not reach New York for days, made certain to take his portrait before he embarked. That is also why the *Times,* unable to send a photographer to the moon, printed still images from the video transmissions of the National Aeronautics and Space Administration, even if most of the newspaper's readers had already seen them.

The rise of photomechanical reproduction brought photographs to a vastly expanded audience. Access to that audience in turn created a new need for a realm of photographs that had barely existed before. Once photographs could appear in the newspaper, it eventually followed that they must, but it took time to establish networks for gathering photographs from around the world—and to learn how to make pictures that could wear the aspect of the news.

Thus the story of newspaper photography is not only a chronicle of ever more efficient ways of making, transmitting, and reproducing photographs. It is also the story of the invention of a new photographic vocabulary.

●

The basis of photomechanical reproduction is the halftone—a means of imitating photography's continuous scale of middle grays in the strictly black-or-white medium of ink on paper. This is accomplished by breaking up the image into hundreds of small dots, which the eye recomposes into areas of darker and lighter grays: half tones. The principle is nearly as old as photography itself, but its practical application in newspaper production was achieved on a significant scale only around the turn of the century.

Thus photographs began to appear in newspapers just as the modern newspaper industry was taking shape. Beginning in the second half of the nineteenth century and extending well into the twentieth, successive innovations steadily improved the efficiency of typesetting, the speed of printing, and techniques for fitting the type to the cylinders of high-speed rotary presses. The resulting explosion in press capacity for New York City newspapers—from some thirty-five thousand copies a day in 1851, the year *The New York Times* was founded, to one million in 1900—spawned aggressive business and editorial practices aimed at boosting circulation. One of these was the introduction of color in the comics and other nonphotographic illustrations (hence the epithet "yel-

"All the News That's Fit to Print"

The New York Times

LATE CITY EDITION
Weather: Rain, warm today; clear tonight. Sunny, pleasant tomorrow. Temp. range: today 80-66; Sunday 71-66. Temp.-Hum. Index yesterday 69. Complete U.S. report on P. 30.

VOL. CXVIII. No. 40,721 © 1969 The New York Times Company. NEW YORK, MONDAY, JULY 21, 1969 X 10 CENTS

MEN WALK ON MOON

ASTRONAUTS LAND ON PLAIN; COLLECT ROCKS, PLANT FLAG

Voice From Moon: 'Eagle Has Landed'

EAGLE (the lunar module): Houston, Tranquility Base here. The Eagle has landed.

HOUSTON: Roger, Tranquility, we copy you on the ground. You've got a bunch of guys about to turn blue. We're breathing again. Thanks a lot.

TRANQUILITY BASE: Thank you.

HOUSTON: You're looking good here.

TRANQUILITY BASE: A very smooth touchdown.

HOUSTON: Eagle, you are stay for T1. [The first step in the lunar operation.] Over.

TRANQUILITY BASE: Roger. Stay for T1.

HOUSTON: Roger and we see you venting the ox.

TRANQUILITY BASE: Roger.

COLUMBIA (the command and service module): How do you read me?

HOUSTON: Columbia, he has landed Tranquility Base. Eagle is at Tranquility. I read you five by. Over.

COLUMBIA: Yes, I heard the whole thing.

HOUSTON: Well, it's a good show.

COLUMBIA: Fantastic.

TRANQUILITY BASE: I'll second that.

APOLLO CONTROL: The next major stay-no stay will be for the T2 event. That is at 21 minutes 26 seconds after initiation of power descent.

COLUMBIA: Up telemetry command reset to reacquire on high gain.

HOUSTON: Copy. Out.

APOLLO CONTROL: We have an unofficial time for that touchdown of 102 hours, 45 minutes, 42 seconds and we will update that.

HOUSTON: Eagle, you loaded R2 wrong. We want 10254.

TRANQUILITY BASE: Roger. Do you want the horizontal 55 15.2?

HOUSTON: That's affirmative.

APOLLO CONTROL: We're now less than four minutes from our next stay-no stay. It will be for one complete revolution of the command module.

One of the first things that Armstrong and Aldrin will do after getting their next stay-no stay will be to remove their helmets and gloves.

HOUSTON: Eagle, you are stay for T2. Over.

Continued on Page 4, Col. 1

Neil A. Armstrong moves away from the leg of the landing craft after taking the first step on the surface of the moon

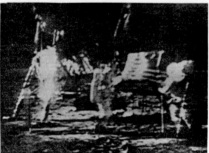

Col. Edwin E. Aldrin Jr. climbing down the ladder. The television camera was attached to a side of the lunar module.

VOYAGE TO THE MOON

By ARCHIBALD MacLEISH

Presence among us,
 wanderer in our skies,

dazzle of silver in our leaves and on our
 waters silver,

O
silver evasion in our farthest thought—
"the visiting moon"..."the glimpses of the moon"...

and we have found you!

From the first of time,
before the first of time, before the
 first men tasted time, we thought of you.
You were a wonder to us, unattainable,
a longing past the reach of longing,
a light beyond our light, our lives—perhaps
a meaning to us...

 Now
our hands have touched you in your depth of night.

Three days and three nights we journeyed,
steered by farthest stars, climbed outward,
crossed the invisible tide-rip where the floating dust
falls one way or the other in the void between,
followed that other down, encountered
cold, faced death—unfathomable emptiness...

Then, the fourth day evening, we descended,
made fast, set foot at dawn upon your beaches,
sifted between our fingers your cold sand.

We stand here in the dusk, the cold, the silence...

and here, as at the first of time, we lift our heads.
Over us, more beautiful than the moon, a
moon, a wonder to us, unattainable,
a longing past the reach of longing,
a light beyond our light, our lives—perhaps
a meaning to us...

 O, a meaning!

over us on these silent beaches the bright
earth,
 presence among us

A Powdery Surface Is Closely Explored

By JOHN NOBLE WILFORD
Special to The New York Times

HOUSTON, Monday, July 21—Men have landed and walked on the moon.

Two Americans, astronauts of Apollo 11, steered their fragile four-legged lunar module safely and smoothly to the historic landing yesterday at 4:17:40 P.M., Eastern daylight time.

Neil A. Armstrong, the 38-year-old civilian commander, radioed to earth and the mission control room here:

"Houston, Tranquility Base here. The Eagle has landed."

The first men to reach the moon—Mr. Armstrong and his co-pilot, Col. Edwin E. Aldrin Jr. of the Air Force—brought their ship to rest on a level, rock-strewn plain near the southwestern shore of the arid Sea of Tranquility.

About six and a half hours later, Mr. Armstrong opened the landing craft's hatch, stepped slowly down the ladder and declared as he planted the first human footprint on the lunar crust:

"That's one small step for man, one giant leap for mankind."

His first step on the moon came at 10:56:20 P.M., as a television camera outside the craft transmitted his every moved to an awed and excited audience of hundreds of millions of people on earth.

Tentative Steps Test Soil

Mr. Armstrong's initial steps were tentative tests of the lunar soil's firmness and his ability to move about easily in his bulky white spacesuit and backpacks and under the influence of lunar gravity, which is one-sixth that of the earth.

"The surface is fine and powdery," the astronaut reported. "I can pick it up loosely with my toe. It does adhere in fine layers like powdered charcoal to the sole and sides of my boots. I only go in a small fraction of an inch, maybe an eighth of an inch. But I can see the footprints of my boots in the treads in the fine sandy particles.

After 19 minutes of Mr. Armstrong's testing, Colonel Aldrin joined him outside the craft.

The two men got busy setting up another television camera out from the lunar module, planting an American flag into the ground, scooping up soil and rock samples, deploying scientific experiments and hopping and loping about in a demonstration of their lunar agility.

They found walking and working on the moon less taxing than had been forecast. Mr. Armstrong once reported he was "very comfortable."

And people back on earth found the black-and-white television pictures of the bug-shaped lunar module and the men tramping about it so sharp and clear as to seem unreal, more like a toy and toy-like figures than human beings on the most daring and far-reaching expedition thus far undertaken.

Nixon Telephones Congratulations

During one break in the astronauts' work, President Nixon congratulated them from the White House in what, he said, "certainly has to be the most historic telephone call ever made."

"Because of what you have done," the President told the astronauts, "the heavens have become a part of man's world. And as you talk to us from the Sea of Tranquility it requires us to redouble our efforts to bring peace and tranquility to earth.

"For one priceless moment in the whole history of man all the people on this earth are truly one—one in their pride in what you have done and one in our prayers that you will return safely to earth."

Mr. Armstrong replied:

"Thank you, Mr. President. It's a great honor and privilege for us to be here representing not only the United States but men of peace of all nations, men with interests and a curiosity and men with a vision for the future."

Mr. Armstrong and Colonel Aldrin returned to their landing craft and closed the hatch at 1:12 A.M., 2 hours 21 minutes after opening the hatch on the moon. While the third member of the crew, Lieut. Col. Michael Collins of the Air Force, kept his orbital vigil overhead in the command ship, the two moon explorers settled down to sleep.

Outside their vehicle the astronauts had found a bleak

Continued on Pages 2, Col. 1

Today's 4-Part Issue of The Times

This morning's issue of The New York Times is divided into four parts. The first part is devoted to news of Apollo 11 and includes Editorials and letters to the Editor (Page 14). Poems on the landing on the moon appear on Page 17.

General news begins on the first page of the second part. The News Summary and Index is on the first page of the third part, which includes sports news, obituaries (Page 31) and transportation news and weather reports (Pages 30 and 52).

Financial and business news begins on the first page of the fourth part.

Following is the News Index for today's issue:

	Page		Page
Bits in Washington	10	Food	42
Books	32	Movies	38-41
Bridge	32	Obituaries	31
Buyers	45	Society	37
Chess	32	Sports	43-47
Crossword	33	Theaters	38-41
Editorials	14	Transportation	30, 52
Fashions	37	TV and Radio	47
Financial	53-56*	Weather	52

News Summary and Index, Page 22

Mr. Armstrong, right, and Colonel Aldrin raise the U.S. flag. A metal rod at right angles to the mast keeps flag unfurled.

Associated Press

low journalism"); another was the increasing use of pictures, including photographs.

The picture commonly cited as the first photographic halftone in a New York City newspaper is a view of a shantytown that appeared in the *New York Daily Graphic* in 1880. But this was not a news photograph; it was part of a two-page pictorial spread illustrating "Fourteen Variations of

the Graphic Process." Photographs would not begin to appear regularly for two decades more and then initially were regarded as a diversion.

Proud of its sobriety, *The New York Times* was slow to make use of photographs outside of its illustrated Sunday magazine, which Ochs founded shortly after acquiring the paper. Praising Ochs's style of journalism, the *Newspapermaker* wrote in 1901 that *The New York Times* "does not print pictures, neither does it indulge in freak typography. It has avoided sensationalism and fakes of every description." The first photograph illustrating a news item was not printed in the newspaper proper until February 28, 1904, although one had appeared four years earlier in an advertisement.

In January 1905, however, Ochs introduced a Sunday broadsheet illustrated with photographs. On September 9, 1914, exploiting a flood of photographs from the Great War in Europe, the *Times* issued its first rotogravure *Mid-Week Pictorial War Extra*. In February 1915, the focus on the war was expanded to include a wide range of themes, and the *Mid-Week Pictorial* became a regular publication, sold separately at newsstands, until it was abandoned in October 1936—the year that *Life* magazine first appeared.

With the introduction of the *Mid-Week Pictorial* the *Times* discarded its initial wariness with respect to photographs and proceeded to take a leading role in defining the ambitious scope of modern news photography. In 1919 the paper launched its Times Wide World Photos syndicate, an elaborate organization for gathering and distributing news photographs. (Among the pictures here are Wide World photographs from Berlin [page 73], London [page 71], Pittsburgh [page 51], San Francisco [page 69], and Washington, D.C. [page 58].) In the early 1920s the *Times* began to build a staff of full-time photographers to cover local events, and by the mid-1930s advances in the transmission of photographs by radio and wire ended the paper's dependence upon delivery by train and boat. For a generation or more, until the television news achieved a global reach, photography in the daily newspaper enjoyed a heady prominence as the medium through which a vast public first encountered the image of the news.

In 1941 the *Times* sold Wide World Photos to the Associated Press. The AP had been created in 1848, when six New York newspapers (the *Herald*, the *Courier and Enquirer*, the *Journal of Commerce*, the *Tribune*, the *Sun*, and the *Express*) pooled resources to pay for access to a single telegraph wire, soon sharing not only expenses but also revenues derived from selling stories to other papers. The cooperative was a harbinger of the modern business of gathering and disseminating the news—a structure so vast that even the most powerful newspapers make use of syndicated services in addition to their own bureaus and reporters. A century after the founding of the AP, photography had become so fully integrated into the global newspaper business that it was no longer necessary for the *Times* to maintain a photographic network of its own, and its staff photographers increasingly narrowed their attention to New York City. The advent of digital technologies in the 1980s only accelerated this trend. Today, picture editors at the *Times* select candidates for many of the sixty photographs in a typical daily edition from digital screens that display a continuous electronic flow of photographs originating from countless sources around the world.

The style of those photographs does not resemble the calculated poise of the pictures that began to appear in *The New York Times* almost a century ago. Gone too is the steady gaze of the Speed Graphic camera, which dominated press photography from the 1930s through the 1950s, and whose large negatives and blinding flash rendered the subject in seemingly exhaustive detail. In its place is today's wide-angle shot, caught on the run with a 35mm camera: omnivorous, crowded, centrifugal.

•

The mythology of newspaper photography is embedded in the mythology of

what journalists call "spot news"—a notable event reported as rapidly as possible. For photographers perhaps the most appealing form of spot news is the sports contest, especially the baseball game, where most decisive confrontations involve no more than five elements, all easily framed in a single shot: the base, two opposing players, the ball, and the umpire (pages 110–113). As sports philosophers are forever explaining, however, baseball is enthralling precisely because it enacts a morality play whose clarity is lacking from the rest of experience. Moreover, the game is scheduled in advance.

As for the rest of experience, the genuine spot-news event is by definition unanticipated: a train wreck (page 66), a murder (page 125), an act of God (page 84), which precipitates a rush of writers and photographers to the scene. On rare and hence celebrated occasions—the explosion of the *Hindenburg* in 1937 or the shooting of Lee Harvey Oswald in 1963 (page 131)—the sensational story unfolds before the eyes of reporters and photographers who had gathered to record a far less momentous event. Otherwise and typically, the journalist's regard is retrospective.

In the typical case the reporter has a great advantage over the photographer, since words enable the writer at second hand to recreate the drama of firsthand experience. The photographer is able only to describe the aftermath: twisted wreckage, a corpse, the grief or aimless curiosity of onlookers. The challenge is to make a picture that represents the compelling immediacy of an event the photographer did not himself witness.

New York Times photographer Ernie Sisto met that challenge resourcefully after an errant B-25 bomber, lost in the fog, crashed into the seventy-ninth floor of the Empire State Building at 9:45 A.M. on July 28, 1945. Arriving on the scene, Sisto promised colleagues from other papers that he would make an exposure for each of them if they would hold him by the belt as he leaned perilously from the eighty-first floor. Thus his dizzying downward shot, evoking the grisly moment of impact, was made not once but several times (page 99).

Airplanes do not crash into buildings every day, however, and when they do the site is rarely so conveniently located. It is still more troublesome from the viewpoint of the photographer that few news stories offer such striking visual evidence. In 1947, for example, a leader of the terrorist Stern Gang visited New York from Palestine to advance his campaign to establish the state of Israel. Anxious to preserve his anonymity, he occupied a room at the Hotel St. Moritz and, shielded by an intermediary, spoke to reporters gathered in the next room. Faced with this unpromising circumstance, *Times* photographer Eddie Hausner made a picture that deftly captures his inability to get the picture he most wanted (page 100). The photograph is apt because in this case Hausner's frustration was a key aspect of the story; most often it is merely a frustration.

Nevertheless, just as the *Times* must appear each morning no matter how pallid the events of the day before, its stories must be illustrated by photographs even if there was nothing much to photograph. The inventive strategies created to fill this relentless vacuum have made news photography an elastic and heterogeneous category whose frequent divergence from the strict definition of spot news is essential to its vitality.

One perennial option is to lower the threshold of newsworthiness to include the ordinary: a pair of schoolchildren choosing a Christmas card for their teacher (page 31) or a barber taking a break from work (page 170). Many weather photographs—a heavy rain is enough to cause an editor to dispatch a photographer into the downpour—belong to this class of pictures, in which every citizen is flattered as a potential subject. Most such photographs preserve the candor of the spot-news formula in the sense that their subjects would have existed as pictured even if the newspaper were not there to report them. The same cannot be said for the many photographs that arise

from the mutual dependence of the newspaper and the newsmaker.

If the paper needs photographs, there is no shortage of people eager to appear in them. People were famous long before photography was invented, of course, but the circulation of their photographs to the huge readership of the modern newspaper is part of what transformed old-fashioned fame into modern celebrity. And certainly it was the newspaper idiom that spawned such images as Joe Louis and his wife out for a stroll (page 83) and socialite Brenda Frazier dining with her daughter at the Stork Club (page 102)—pictures whose function is to embody the idea of celebrity in the specificity of experience. As John Szarkowski pointed out two decades ago, photography is ideally suited to perform this function and thus ceaselessly to renew the drama of universal conditions: heroism and villainy, victory and defeat, confrontation and tragedy.

The photograph of Brenda Frazier was made and distributed by the Stork Club to solicit publicity. This accounts for the prominence of the restaurant's name in the foreground, but otherwise the picture looks just like one the *Times* itself might have made. Like the modern press release, the publicity picture achieves its aim by speaking in the voice of anonymous objectivity. No different in design or purpose, if more significant in consequence, were photographs made for press distribution by the United States Army (page 97) or NASA (page 139). In such cases a photo credit in the margin, or even a disclaimer in the caption, does little to qualify the presumed transparency of the image. Once the picture appears in the paper, it is part of the news no matter who made it or how it got there.

The functional irrelevance of the motives that lay behind the making of a photograph and of the path by which it reached the newspaper are richly exploited in millions of pictures best described as collaborations between the photographer and the photographed. Politicians held babies, appeared at baseball games, and otherwise mingled with the population before the advent of photomechanical reproduction. But once photographs of these encounters could reach many thousands of potential voters who had not been present at the scene, such rituals took on a new importance.

Eventually politicians and their handlers became so skillful at controlling the staged event that the only pictures it would yield were the ones they had choreographed in advance. In the meantime, however, the mutual dependence of politician and newspaper spawned a vivid theater of political performance. Many of the best pictures possess a spirit of comic irony that deflates the very pretensions the pictures seem to advance, producing an engaging if odd brand of candor. The more outlandish the performance, the more disarming the picture, since the reader of the newspaper is in on the joke along with the politician, the photographer, and the editor. Improbable scenes such as New York Mayor Abe Beame as impresario of Johnny Weissmuller's jungle yell (page 152) dissolve the polarity between skepticism and gullibility.

Or so at least it seems to the present viewer at the present time. It is perilous to ascribe stable meanings to pictures whose essential function is to fascinate, not to explain, and especially perilous where irony is involved. Irony depends upon point of view and context, and when either shifts irony may evaporate—or appear where it was least intended.

A case in point is a picture made in 1948 by *Times* staff photographer George Tames, in which Congressman Richard M. Nixon (R-California) presents himself as an intrepid Sherlock Holmes, inspecting a strip of microfilm: the famous "pumpkin papers" that would help convict Alger Hiss of spying for the Soviet Union (page 104). Today the terms "photo opportunity" and "spin doctor" have become common coin, and manipulation of the news is a frequent subject of the news. Thus perhaps we are more likely than readers (or newspaper editors) were in 1948 to see the picture as both sinister and comic: sinister, because, while the picture in fact proves nothing, it exudes

an aura of proof; comic, because the magnifying glass seems an obvious theatrical prop. (Surely Nixon studied the documents not from the film but from the enlargements stacked on the desk before him.) But perhaps this reading owes less to a rise in skepticism about the truth value of news photography than to the influence of historical hindsight, including our knowledge of Nixon's later misdeeds.

In any case, the picture is now precisely what it was when it first appeared: a frank representation of Nixon's self-image. Like all of the other pictures in this book, Tames's skillful photograph is not a document of history but part of it.

•

A picture editor at *The New York Times* might well be fired if, asked to produce a photograph of President Clinton in his former role as governor of Arkansas, he or she responded that there were more interesting pictures of President Bush in his former role as United States Ambassador to the United Nations (page 147). Yet it is precisely this liberty that has guided the selection of the photographs presented here. It would be odd if American presidents were omitted altogether, but no effort was made to include any particular one. This is not a compendium of momentous events and celebrated figures; it is a collection of outstanding photographs.

Another liberty has been taken with respect to the dates of publication of the photographs. In general the pictures assembled here appeared in *The New York Times* soon after they were made, but in several cases the lapse was much longer. Erich Salomon's 1931 photograph of Mussolini (page 65), for example, was not printed in the *Times* until 1953, when it illustrated a book review. The most notable case is the photograph on page 92, made in 1943 under the direction of Nazi general Jürgen Stroop to document the destruction of the Warsaw ghetto. This chilling picture—chilling not only because of what it records but because it was made at all—obviously was not intended to be reproduced at the time in any newspaper; it did not reach the *Times* until 1963.

Perhaps then the Stroop picture should appear here among photographs of the 1960s rather than photographs of the 1940s. On the other hand, it is not at all unusual for a photograph to be reproduced decades after it was made. This retrospective use is a further aspect of the heterogeneity of photography's functions in the newspaper. Date-stamped at each successive use and embellished with captions taped or pasted wherever they would fit, the back of a much-used photograph is a palimpsest of history, sometimes nearly as fascinating as the front. In the case of Bob Jackson's photograph of the shooting of Oswald or Eddie Adams's picture of South Vietnam's chief of police shooting a North Vietnamese prisoner (page 138), the back of the print traces the process through which the image on the front burrowed its way into our collective consciousness. We can no longer see these pictures as they were seen when they first appeared, because each has come to stand for something much greater than the incident it records.

In fact, it is impossible to see any of the pictures here as they were first seen. It is a truism that the passage of time makes almost all photographs more interesting: what was taken for granted at the moment of exposure—a style of clothing or automobile design, for example—becomes an object of fascination once it is no longer common. But time also subtracts interest from most news photographs, by withdrawing the urgency of the stories they were made to illustrate. Once the story no longer matters, neither does the photograph—unless the photograph itself is engaging enough to interest us in the story.

Photographs that have outlasted the stories they once accompanied may seem out of place among photographs that have come to symbolize great historical events. Yet the power of each arises from the function they all were made to serve: not to tell the story of the news but to set forth a presence beyond words.

The back of the photograph on page 130.

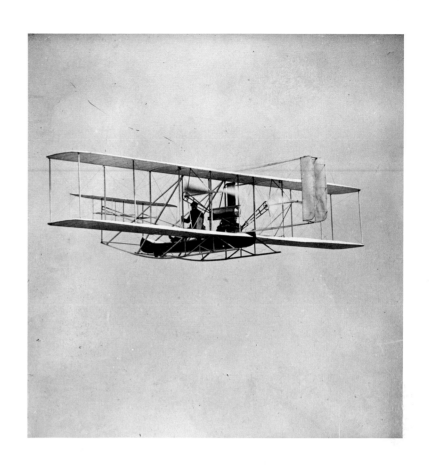

"Wright's Flight around Statue of Liberty." 1909

George Grantham Bain

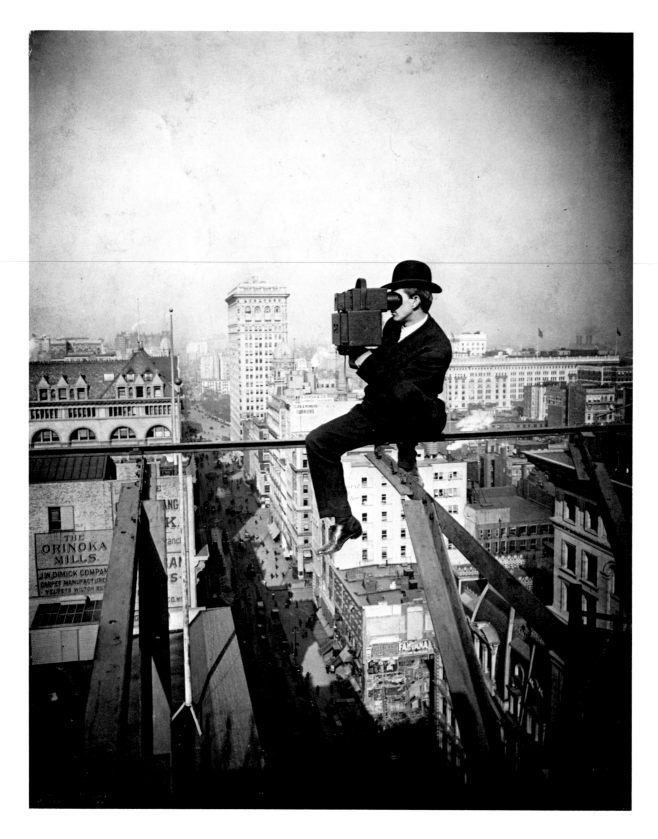

Above Fifth Avenue, Looking North.
1905

Underwood & Underwood

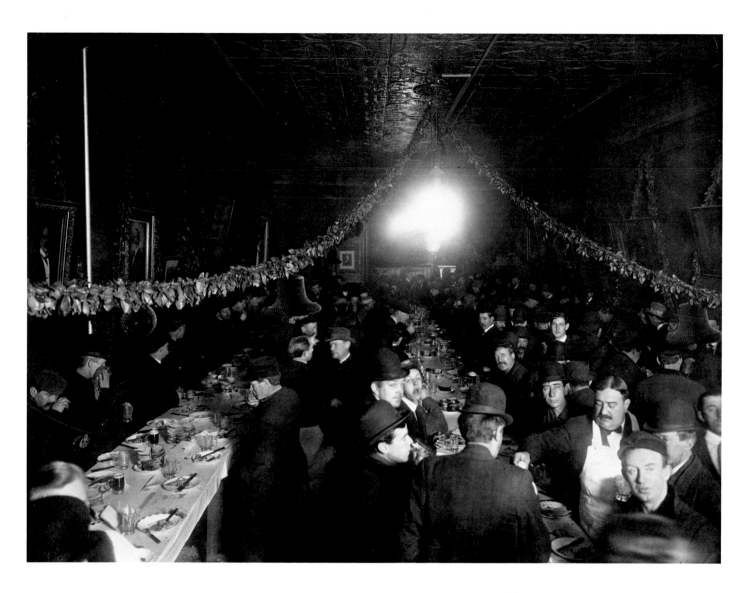

"Christmas Party Given by Jim Sullivan's Political Club, New York." c. 1900

January 8, 1961: "Free for some—the 'affair' (as such things were called), offering beer and food to the loyal, was once a political fixture."

Brown Brothers

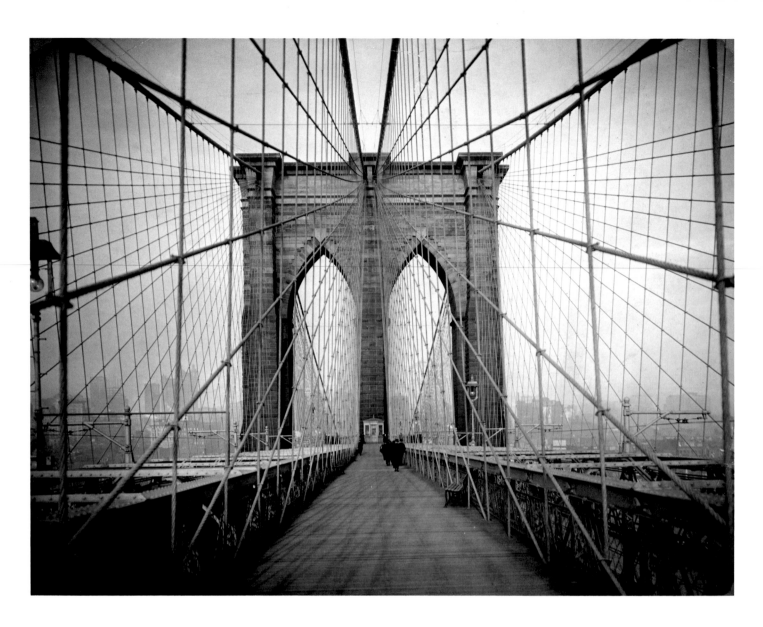

Brooklyn Bridge. c. 1914

Photographer unknown

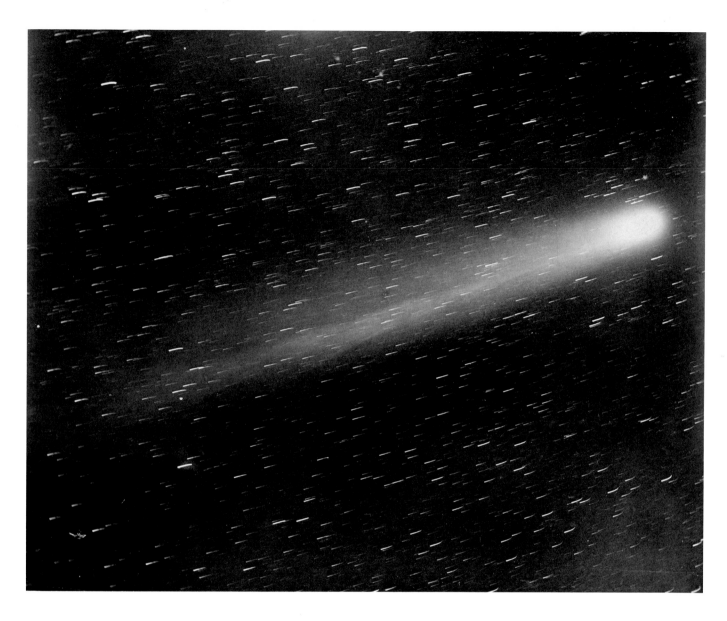

Halley's Comet. 1910

Yerkes Observatory

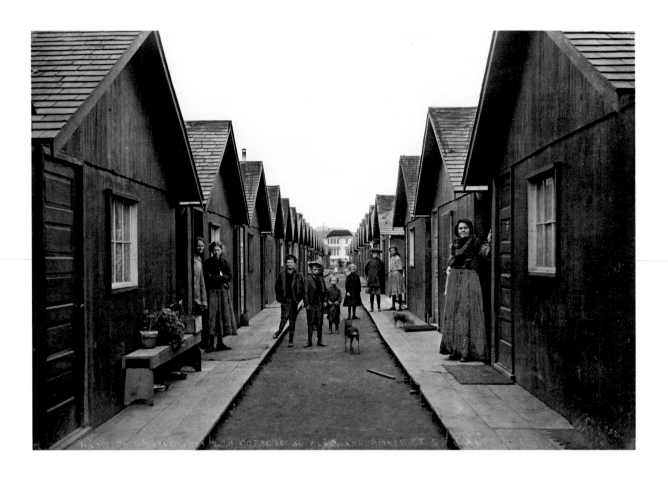

San Francisco After the Earthquake.
1906–07

"Hamilton Square has 220 cottages on Geary and Pierce St. S.F. Cal."

Cal Osbon, Fresno, California

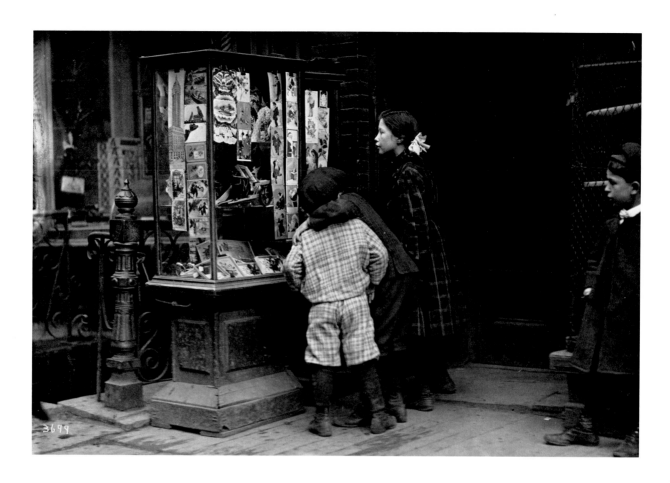

"Picking the Christmas Card for Teacher." 1910

The Pictorial News Co.

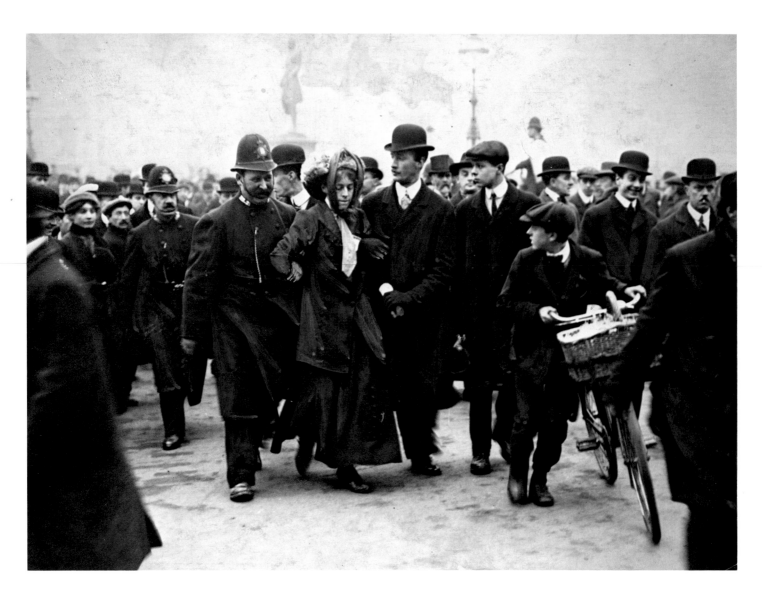

**"An Arrest when the Suffragettes Began
a Riot in Parliament, London."** 1912

Brown Brothers

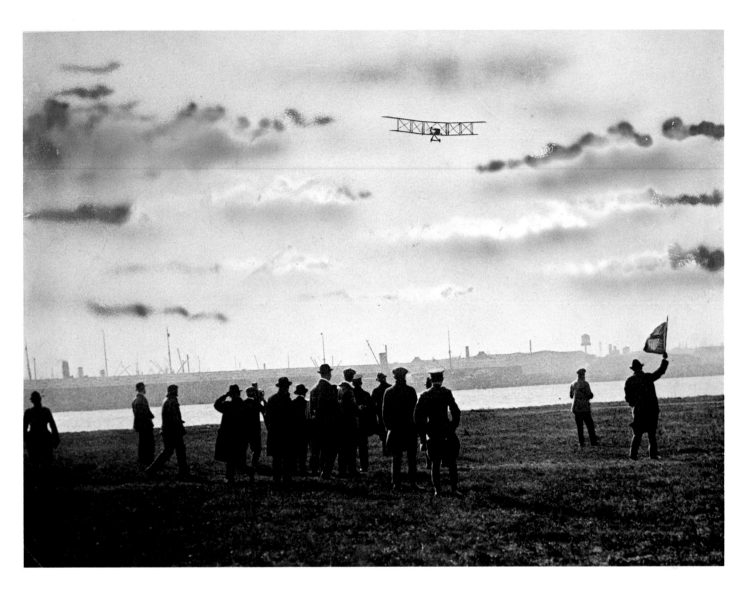

"Victor Carlstrom's Record-breaking Flight." November 3, 1916

"The finish of Victor Carlstrom's record-breaking flight from Chicago when he landed at Governor's Island in New York Harbor last Friday at 8:55 A.M., after driving the powerful 200-horsepower military biplane, 'The New York Times,' at a rate of 134 miles an hour on the last lap of the trip from Hammondsport, N.Y., to his landing place."

Underwood & Underwood

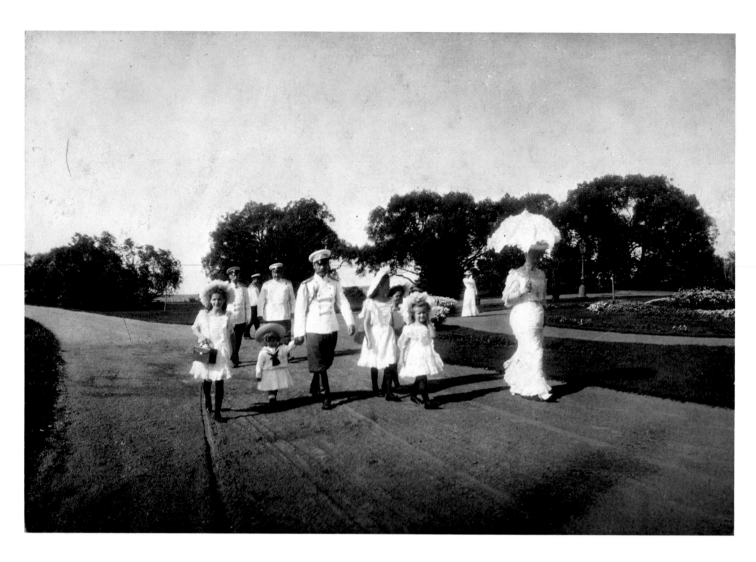

**The Russian Imperial Family on a
Summer Stroll.** 1906–08

C. E. de Hahn & Co., Tzarskoe Selo

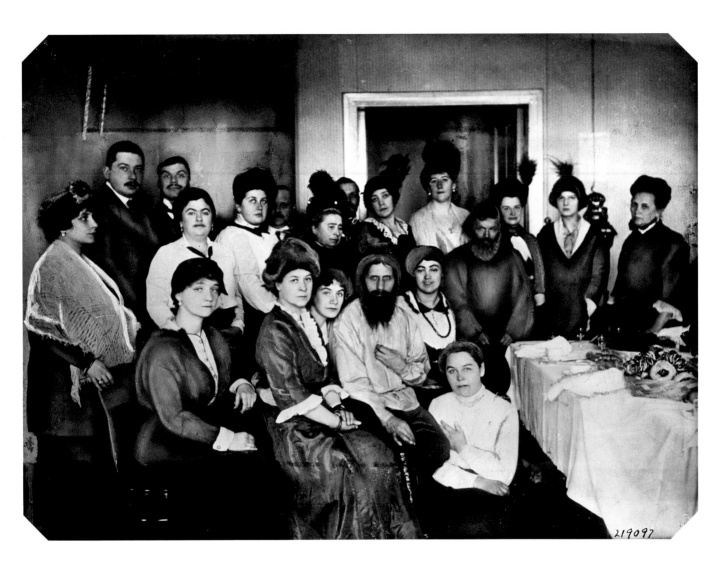

"The Famous Monk, Gregory Rasputin."
1916 or earlier

May 1917: "The famous monk, Gregory Rasputin, once a Siberian peasant, surrounded by his admirers at the Imperial Palace at Tsarsky. This man was an adventurer who under the guise of religion exercised undue and sometimes dangerous influence in high quarters. He was commonly believed to have made and unmade ministries and to have decided the fate of important measures.... He recently met his death in the palace of one of the royal princes. Publication of this photograph in Russia before the revolution would have meant exile to Siberia."

Underwood & Underwood

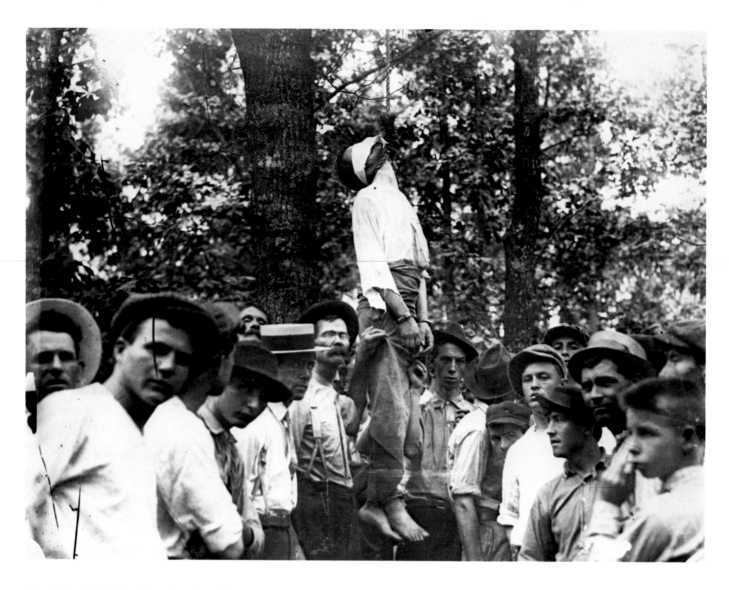

**"Leo Frank's Body Hanging to a Tree
at Marietta, Ga., After He Had Been
Lynched."** August 17, 1915

Times Wide World Photos

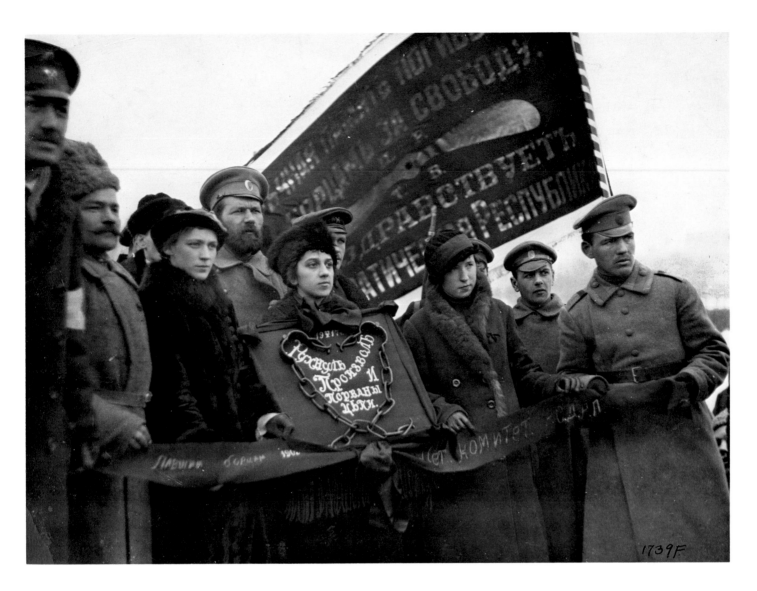

"The Chains Are Broken." 1917

"Young girls bearing in the streets of Petrograd sections of chains from the prisons of the Romanoff regime."

Daily Mirror, London

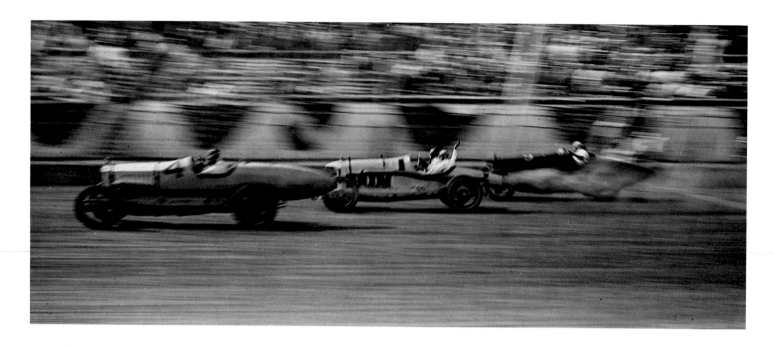

"Ralph De Palma Crossing the Finish Line." August 18, 1918

"Ralph De Palma crossing the finish line in the second race of the sweepstakes at Sheepshead Bay a week ago, with a new world's record for a ten-mile heat. Time: 5:23 4-5, or more than 111 miles an hour. Dario Resta is second and Ralph Mulford third."

Times Photo Service

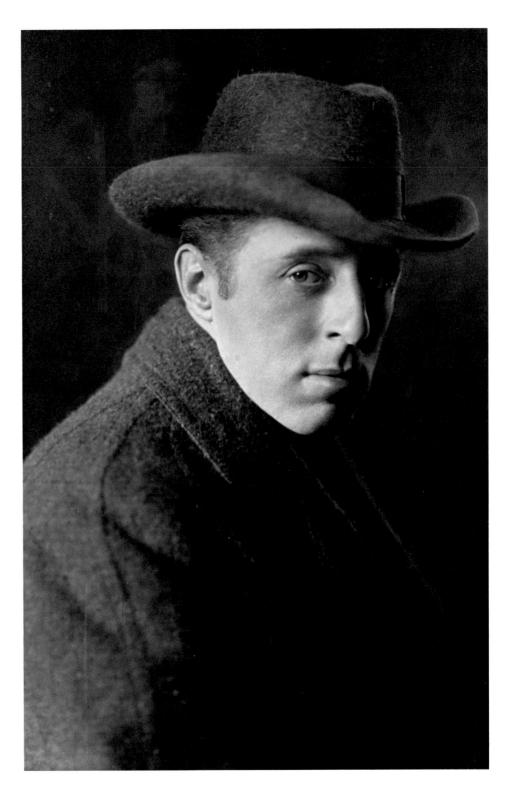

D. W. Griffith. 1919

Bangs Studio

"Day Home for Soldiers' Children, Berlin." 1915

"A playroom for the children."

Gebrüder Haeckel, Berlin

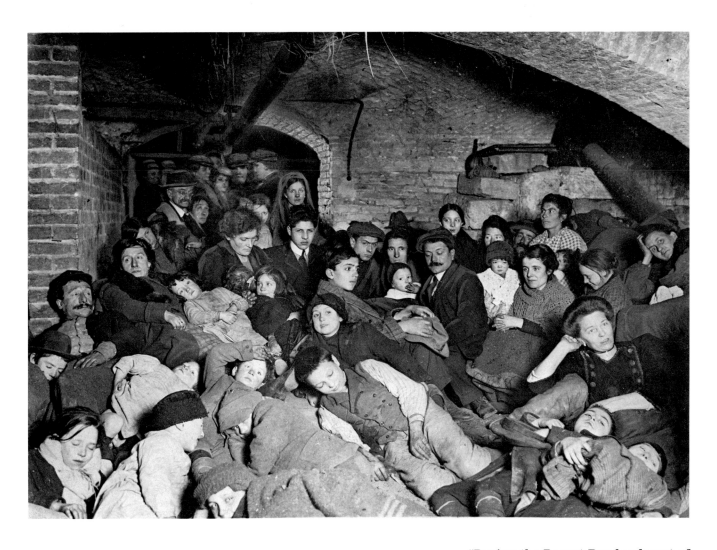

"During the Recent Bombardment of Padua." December 30–31, 1917

March 1918: "Men, women and children seek refuge in the dungeons of the famous palace of Countess Papafava, which was [opened to the] city by the Countess during the recent bombardment of Padua by Austro-German airplanes."

French Pictorial Service

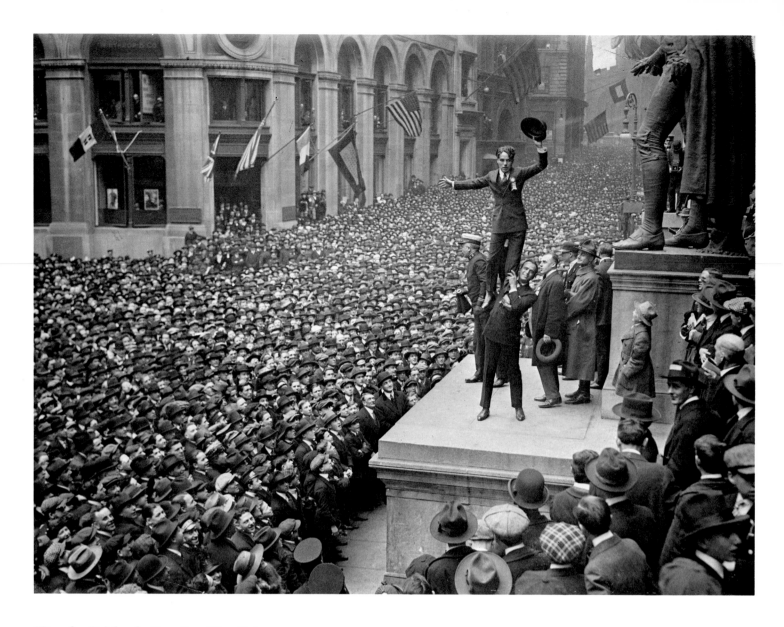

"Douglas Fairbanks Boosting 'Charlie' Chaplin to Boost the Liberty Loan in Front of the Sub-Treasury Building, All Wall Street Looking on with Approval." 1918

"The view is west on Wall, with Broadway and Old Trinity Church in the distance."

Underwood & Underwood

"Mother, Wife and Sweetheart Watching Boys of the Seventh Regiment as They Marched Away to War." 1917

Underwood & Underwood

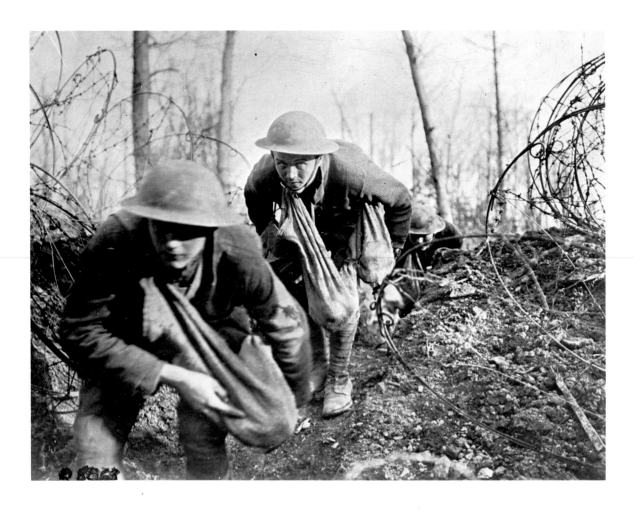

"Frenchmen and Americans Advancing into No-Man's Land with Sacks of Hand Grenades—France." 1918

Committee on Public Information

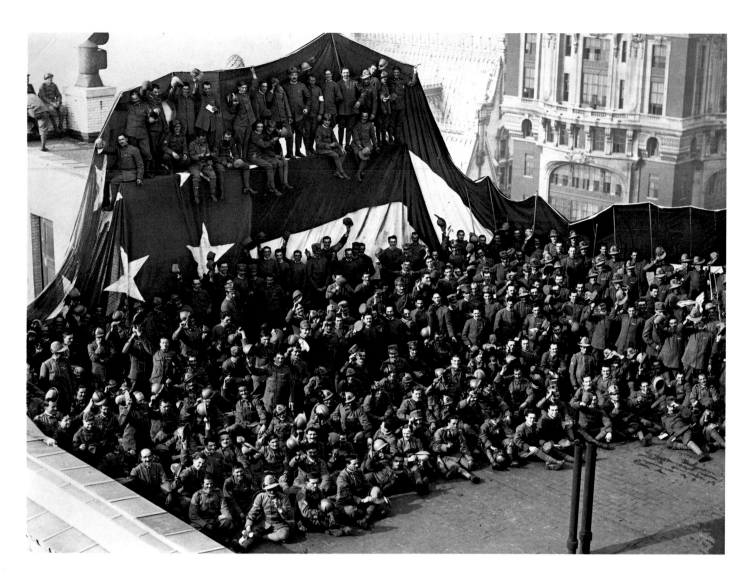

"Italy's Famous Alpini and Bersaglieri."
1918

"Italy's famous Alpini and Bersaglieri who have come to New York especially to help in putting the fourth Liberty Loan 'Over the Top.'"

Paul Thompson

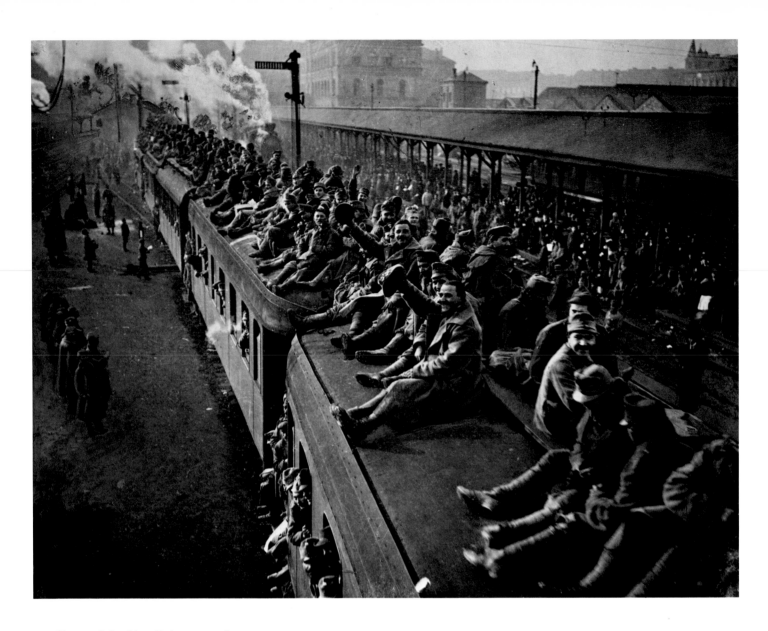

"Italian and Serbian Prisoners of War." 1919

"Italian and Serbian prisoners of war, who had been held in Hungary, leaving the railway station at Budapest for their homes with shouts of joy, every available foot of space in and on the train being occupied."

Underwood & Underwood

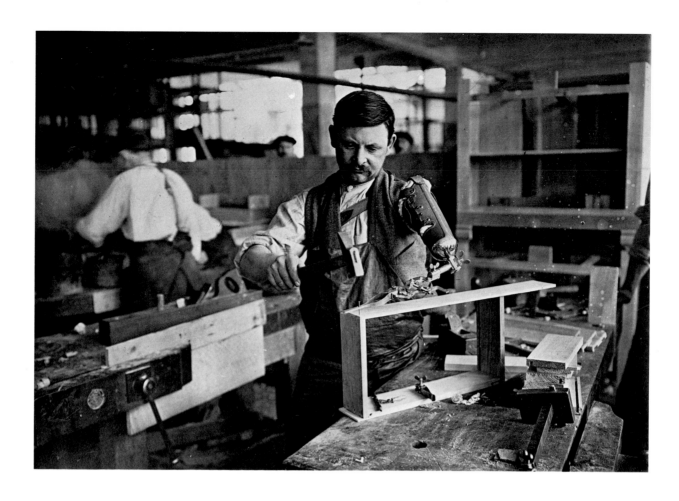

French War Veteran. c. 1919

"For a working arm, this carpenter wears a chuck into which he inserts any tools he may need. On Sundays he has an arm made in careful imitation of the one he has lost."

Red Cross Institute for Crippled and Disabled Men

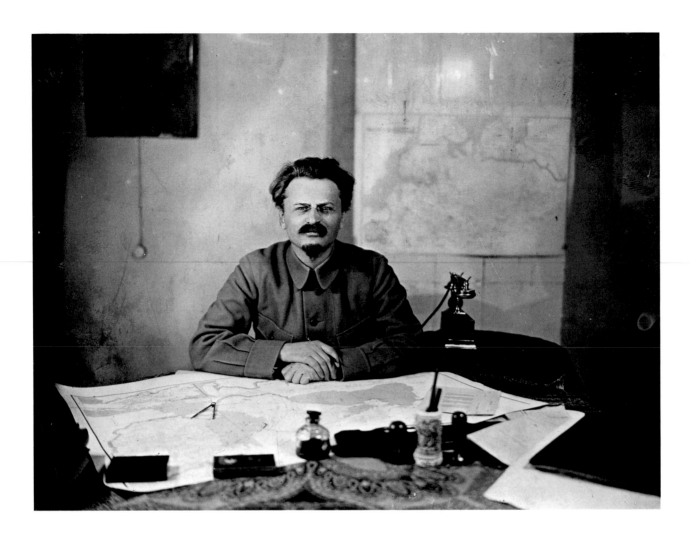

"Trotzky, Bolshevist Minister of War, Photographed Recently in His Office at Moscow." 1922

"The co-dictator with Lenin of Soviet Russia, Leon Trotzky, is here presented in a characteristic pose in his office at the War Ministry in Moscow.... Although Lenin has made some notable concessions to capitalism, Trotzky has shown no sign of recession from his extreme position. No later than Feb. 24, in speaking before the Moscow Soviet, he declared that if the coming Genoa conference should not result satisfactorily for Russia it might be necessary to 'tip the balance with blood.'"

International News Photos

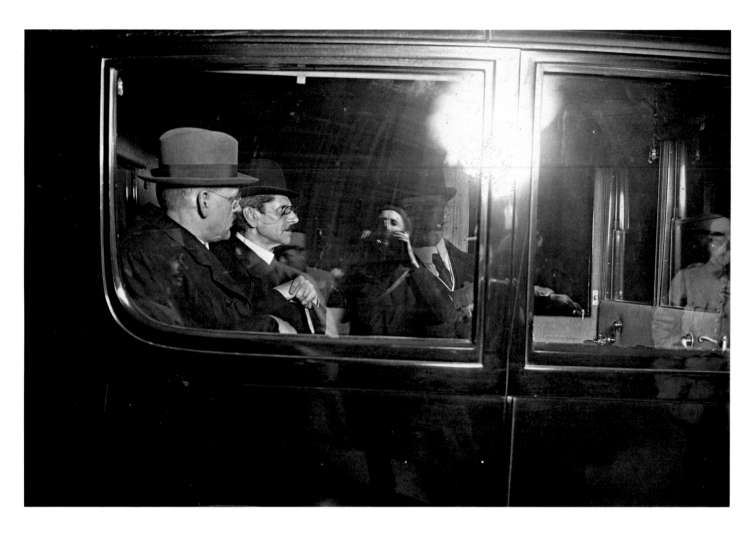

"The German Delegates, Mueller and Bell, Leaving Versailles After Having Signed the Treaty." June 28, 1919

"The portraits are remarkably clear, considering that they were taken through the glass of the car."

Underwood & Underwood

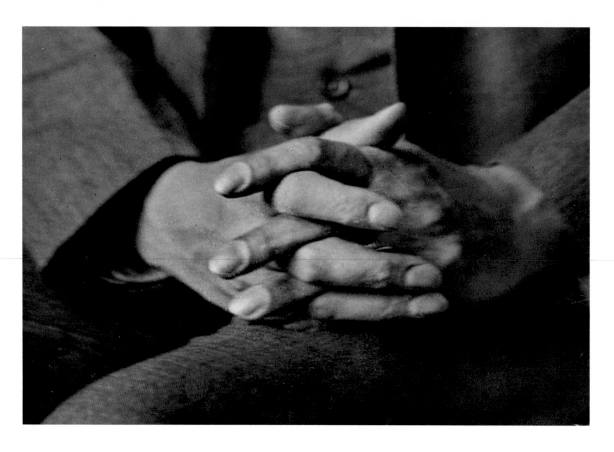

"From Which Melodies Flow." 1925

"The hands of Richard Strauss, the famous Viennese composer."

Franz Löwy / Times Wide World Photos

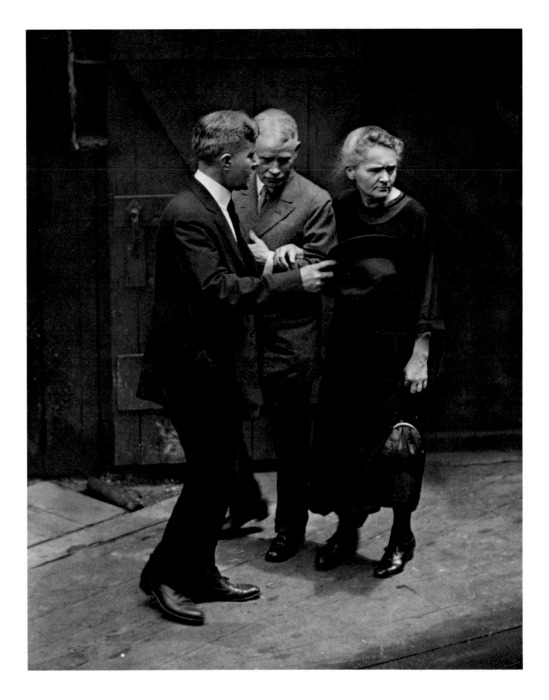

"Madame Marie Curie, Co-discoverer of Radium, at the Radium Centre of the World." 1921

"Madame Curie is here shown on an inspection tour of the plant of the Standard Chemical Company, Pittsburgh, where was produced the gram of radium presented to her by American women at a cost of $100,000. She is shown passing through the plant, escorted by James C. Gray, president of the company."

Norman M. Jeannero/Times Wide World Photos

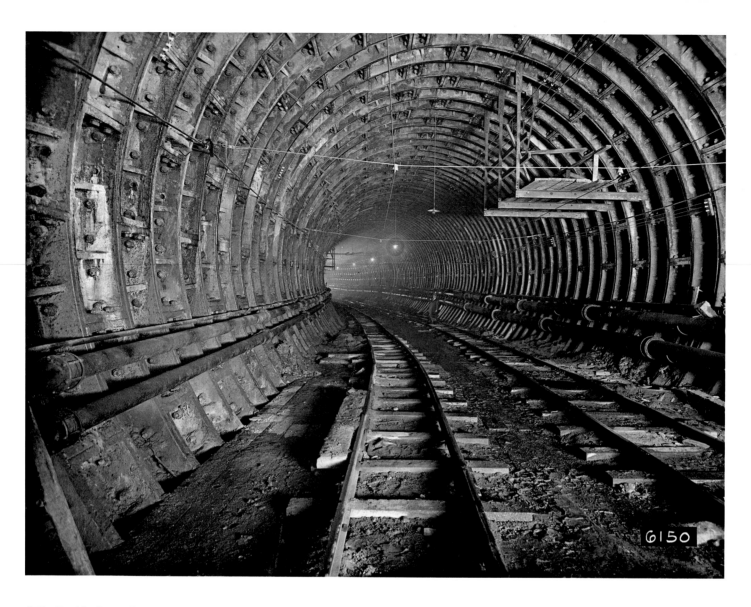

"The Inside Story." 1924

"The inside story of the New York–New Jersey vehicular [Holland] tunnel, paid for by each state in equal parts. The tunnel will have a length of 9,250 feet, constructed to care for an annual estimated traffic of 5,610,000 vehicles in both directions."

Fotograms

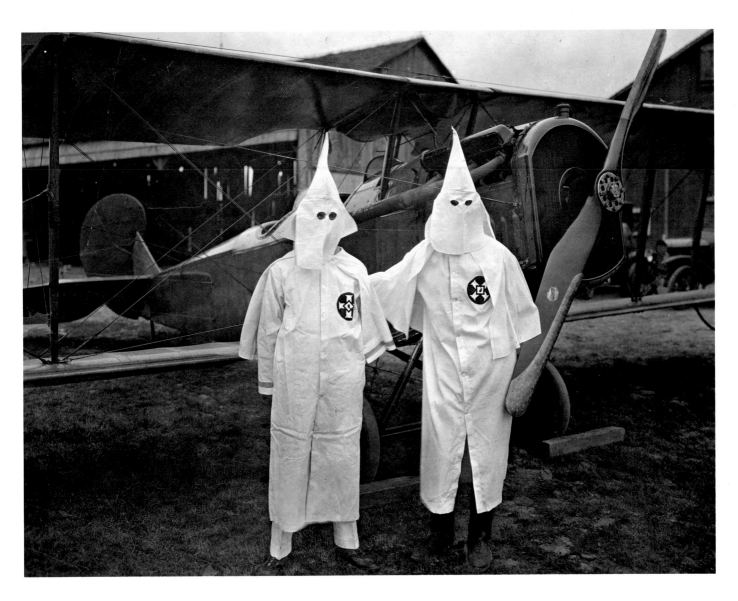

"'Invisible Empire' Takes to the Air."
1924

"Two of the hooded aviators who flew over an immense gathering of the Ku Klux Klan at Dayton, Ohio, on the occasion of a Klan reception to Imperial Wizard Evans."

Doty/Times Wide World Photos

"Houdini Exposes Spirit Trickery to New York Clergymen." February 3, 1925

"Harry Houdini, author, lecturer and master magician, today gave a lecture to members of the New York clergy and their congregations under the auspices of the New York Federation of Churches. The meeting was held at the New York Hippodrome. Houdini is devoting most of his time to exposing alleged spiritualists who are imposing on the public. He is shown here demonstrating a method that is used in communication. William B. Millard, General Secy. of the Federation, is aiding in the demonstration. While Houdini's 'foot' is held by Mr. Millard he shows how it is possible to ring a bell."

Times Wide World Photos

"Artificial Lightning Made in a Laboratory." 1928

Westinghouse Electric and Manufacturing Company

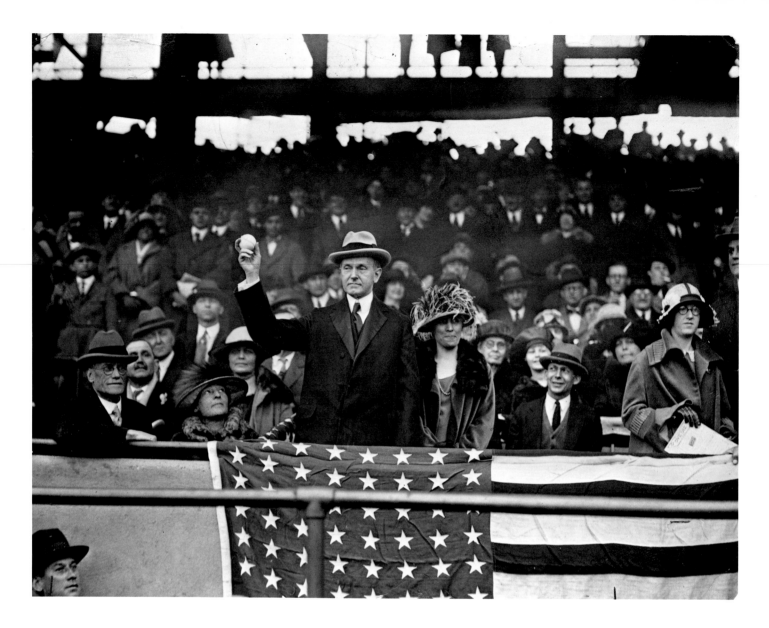

**"President Coolidge Opens the Base-
ball Season in Washington."** April 20,
1924

"Tossing out the first ball in the game
between the Senators and the Athletics."

Times Wide World Photos

"Heroes of the World's Series." 1929

"Al Simmons (left) and Jimmy Foxx whose batting was a prime factor in the victory of the Athletics over the Cubs, autographing baseballs for juvenile adorers at San Francisco, Cal., where they are playing with local teams."

Times Wide World Photos

"Italians Whose Conviction Has Resulted in a Wide Radical Plot to Kill Americans in Europe." 1921

"Nicola Sacco and Bart Vanzetti, the two men convicted in Massachusetts court are it is said at the bottom of a plot by the Communists to take retaliatory measures against U.S. officials thruout Europe. The bomb that was recently sent to Ambassador Herrick was to be the first move by the Communists against American officials. Sacco and Vanzetti were tried for murder in Mass. The trial started May 31st and led to conviction of the two men July 14th."

International News Photos

"The Best Show of the Season in New York City." 1927

"The new Sherry-Netherland Hotel a blazing beacon for miles as the scaffolding above the thirty-second story burned itself out, the first real skyscraper fire which the thousands in the street below had ever seen."

Times Wide World Photos

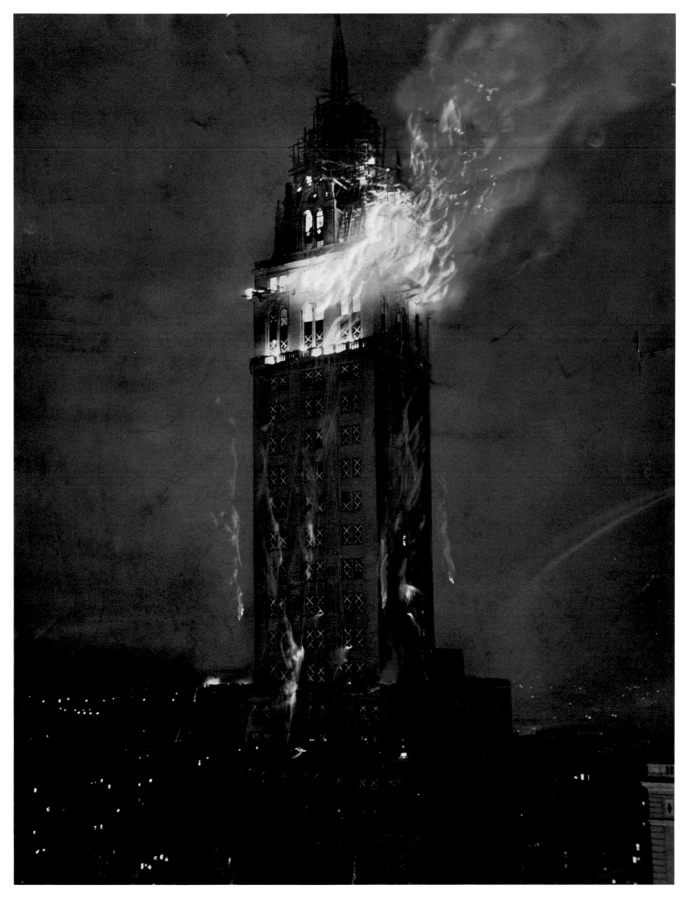

"Mrs. Ruth Snyder as She Looks Today." April 1927

"Long Island City: A posed photograph of Mrs. Ruth Snyder, co-defendant with Henry Judd Gray in the murder trial now in progress at the Queens County Courthouse where she was brought while the selection of the jury went on. Note the semi-widow effect of sober black worn by Mrs. Snyder."

Times Wide World Photos

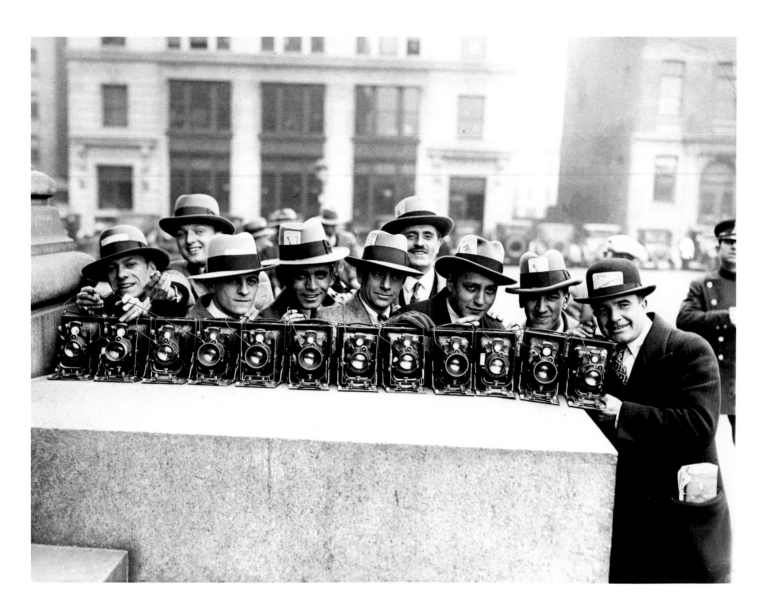

"Selection of Jury Delays Snyder Trial." April 1927

"Long Island City: Cameramen lined up before the Queens County Courthouse where the trial for murder of Mrs. Ruth Snyder and Henry Judd Gray is now in progress."

Times Wide World Photos

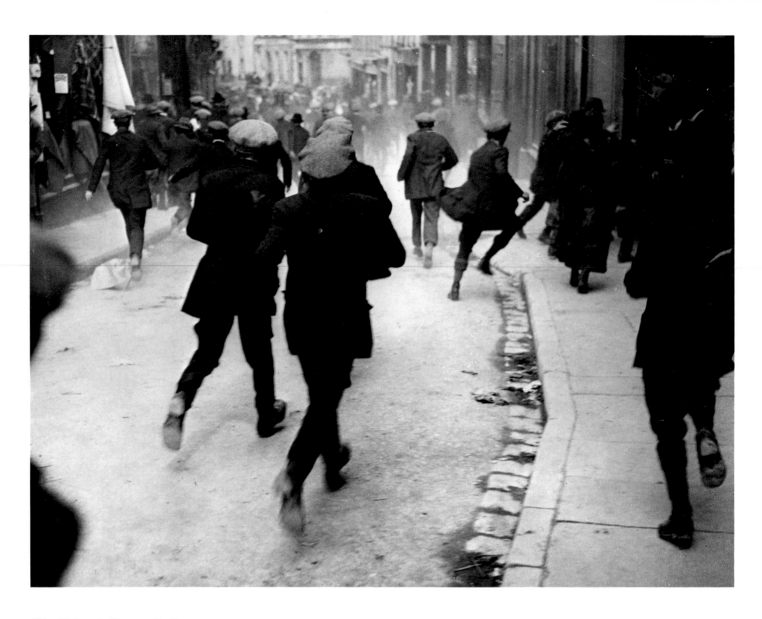

"De Valera's Dramatic Reappearance and Arrest." 1923

"Eamon de Valera, the Irish Republican leader, was arrested by Free State troops whilst speaking at an election meeting at Ennis, Co. Clare, yesterday. De Valera, who had been in hiding for over a year, made his reappearance at Ennis to open his Republican election campaign. Almost immediately after he rose to speak, the troops, accompanied by an armoured car, appeared on the scene and dispersed the huge crowd by discharging volleys of rifle shots over the heads of the crowd, and many people were injured in the stampede which followed this dramatic move. The picture shows the frantic rush for cover when the shooting began."

Pacific & Atlantic Photos

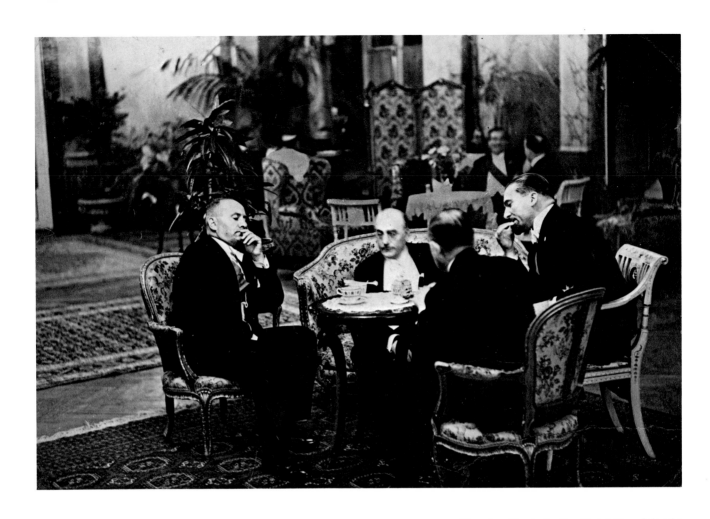

Evening Party in the Hotel Excelsior in Rome. August 1931

Left to right, Benito Mussolini, German Chancellor Heinrich Brüning, German Foreign Minister Julius Curtius, and the Italian Foreign Minister Dino Grandi.

Dr. Erich Salomon/Pix Inc.

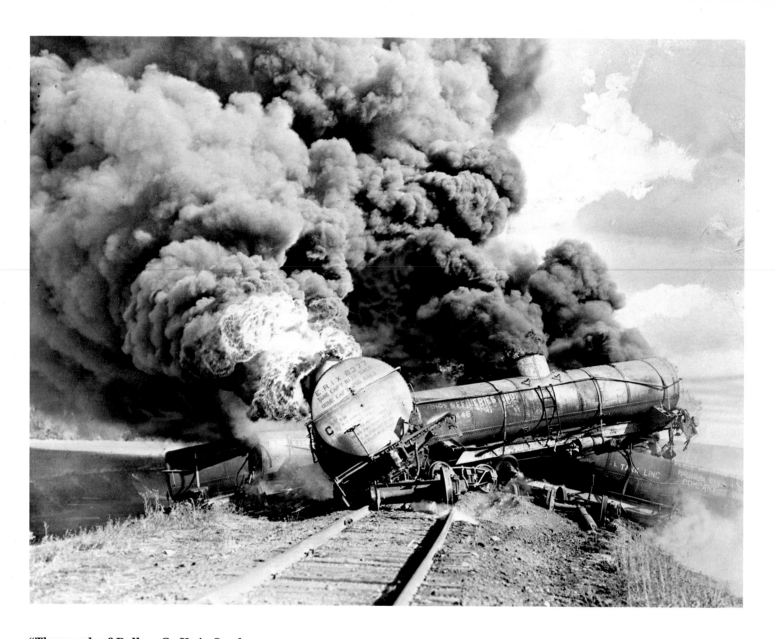

"Thousands of Dollars Go Up in Smoke in Kansas." 1928

"The blazing wreck of a train of twenty-seven cars filled with gasoline, which burned after a smash near Zyba."

Times Wide World Photos

"Just Before the Waves Closed over the Vestris." November 12, 1928

"Battling angry seas and a strong wind, rescue ships picked up 206 survivors of the ill-fated Vestris, which sank off the coast of Virginia, on Nov. 12th, from a cause as yet undetermined. U.S. Navy ships have been ordered to remain on the scene of the disaster to search for the 115 persons still missing. Seven have been reported dead."

Fred Hansen/Pacific & Atlantic Photos

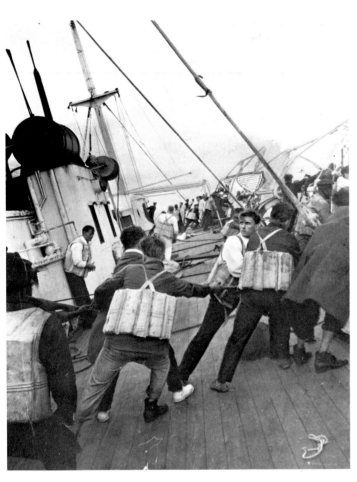

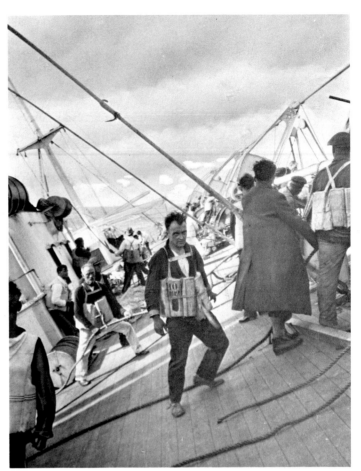

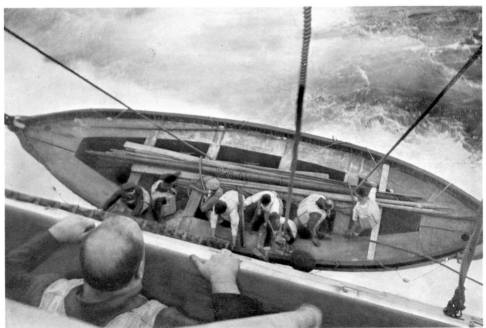

"Mrs. Cornelius Vanderbilt."
November 21, 1932

"With Lady Julia Duff, a niece of the Earl of Lonsdale, arriving at the Metropolitan for the first opera of the season."

Times Wide World Photos

"A Mexican Artist Records His First Impressions of San Francisco." 1930

"Diego Rivera, who has been commissioned to execute a series of murals for the Stock Exchange Building, with his wife [Frida Kahlo] at the Golden Gate."

Times Wide World Photos

"Mob Foiled in Attempted Lynching."
1934

"E. K. Harris, 22-year-old Negro, alleged attacker of a 14-year-old white girl whose trial at Shelbyville, Tenn. precipitated a riot, shown with a part of the National Guard escort which battled a mob to prevent his capture. For more than a month after the alleged attack occurred, Harris was held in jail in Nashville, Tenn. He had been back in Shelbyville only a few hours when the mob formed and attacked the courthouse three times. Two were killed in the fighting. Circuit Judge T. L. Coleman declared a mistrial and Harris was spirited away to Nashville disguised as a National Guardsman."

Associated Press

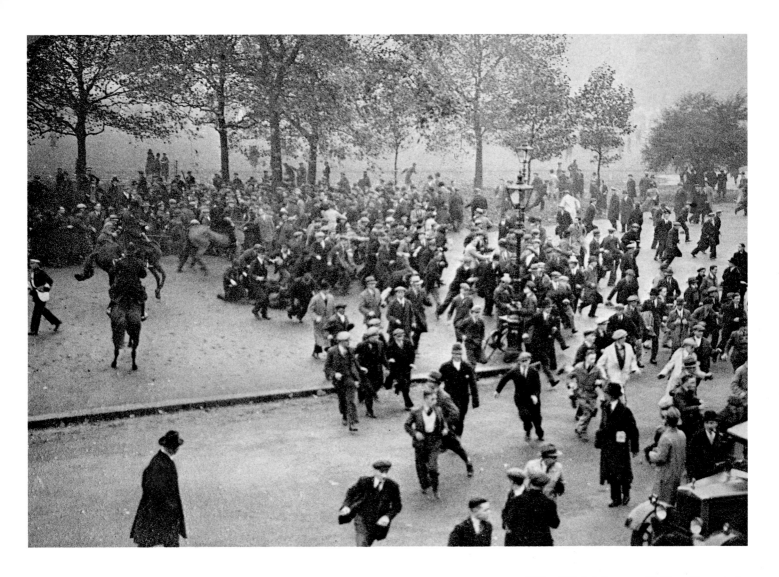

"The Flight from a Police Charge in London." 1932

"A group of rioters taking to flight as the 'Bobbies,' of whom 5,000 were assigned to the job, started clearing the streets of the thousands of 'Hunger Marchers' who had concentrated in the capital to press their demands and whose mass meeting in Hyde Park occasioned serious disorders."

Times Wide World Photos

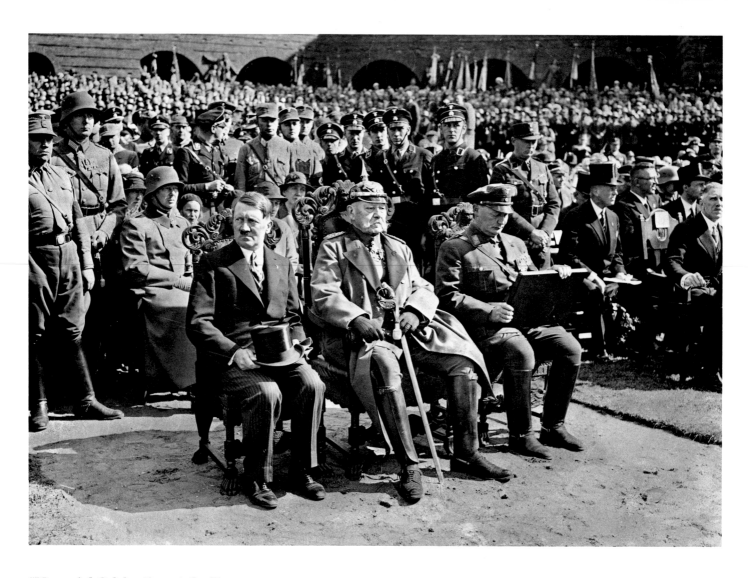

"Memorial Celebration at the Tannen-berg Monument." August 27, 1933

"Tannenberg, East Prussia, Germany: A solemn celebration arranged by the German government took place at the Tannenberg monument which was erected in memorial to the famous battle by which East Prussia was liberated from the Russians during the world war by Hindenburg.... Left to right, Reichschancellor Adolf Hitler, Reichspresident Paul von Hindenburg and Prussian Ministerpresident Hermann Goering during the celebration."

Times Wide World Photos

"A Unanimous 'Ja' for the Leader." August 19, 1934

"Reichsfuehrer Hitler appears at a window of the Chancellery in Berlin to acknowledge the cheers of an immense crowd which gathered to get a sight of him on the day of the elections called to confirm him in supreme power in the Reich."

Times Wide World Photos

"The Poor Children of Berlin Share in Hitler's Birthday Party." April 20, 1934

"A cake weighing 150 pounds, which was sent to Hitler by the Berlin Bakers Union on the Chancellor's 45th birthday, is divided among as many children as possible."

Times Wide World Photos

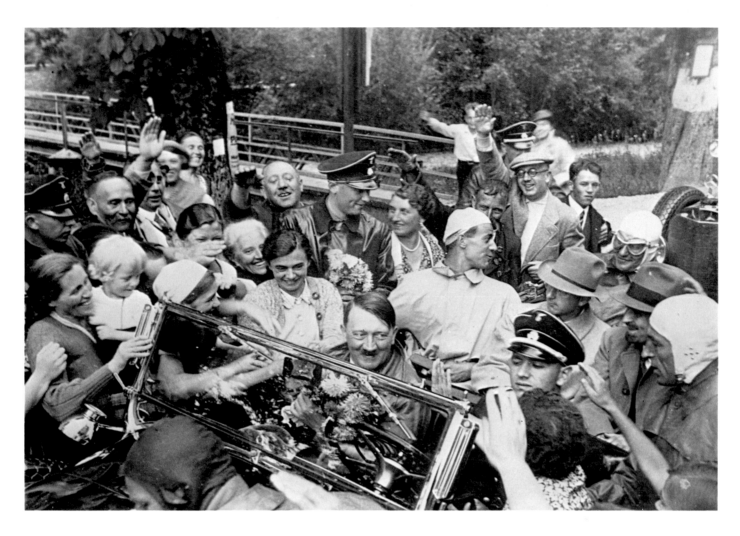

"Peasants Cheer Hitler." 1934

"German peasants crowd about Adolf Hitler's car to get a good view of their leader as he enters Berchtesgaden to give a speech in connection with the convention of the National Socialist Party. Even the baby smiles. Der Fuehrer is quite popular."

Associated Press

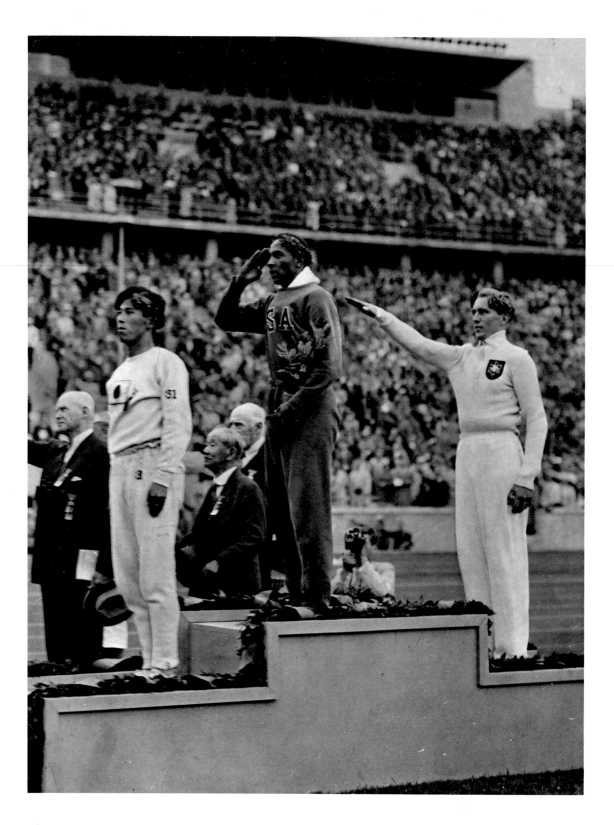

The Winner in Broad Jump. 1936

Olympic Games, Berlin: Jesse Owens,
U.S.A., won the broad jump ahead of Lutz
Long, Germany, and Tajiman, Japan.

Anthony Camerano/Associated Press

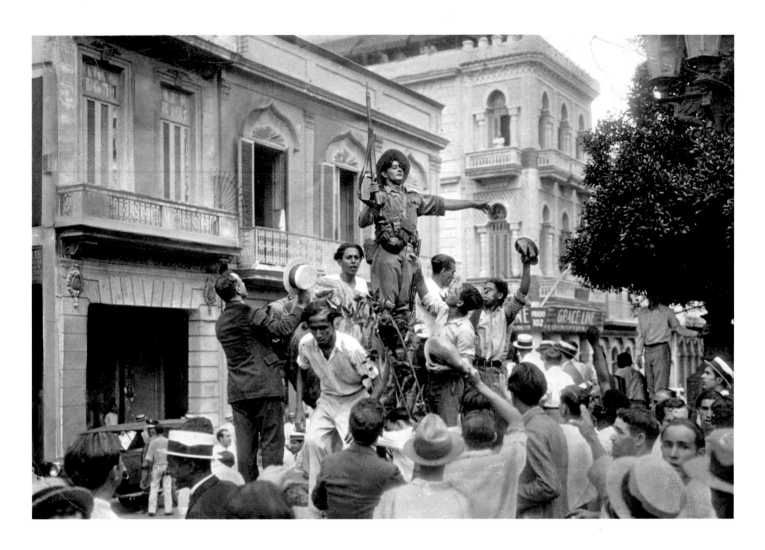

"Revolution Triumphs in Cuba."
August 12, 1933

"The slayer of Colonel Antonio Jiminez, head of the secret police, is acclaimed in Havana as one of the heroes of the uprising which drove President Machado into exile during the three days of riots throughout the island."

Sammy Schulman/International News Photos

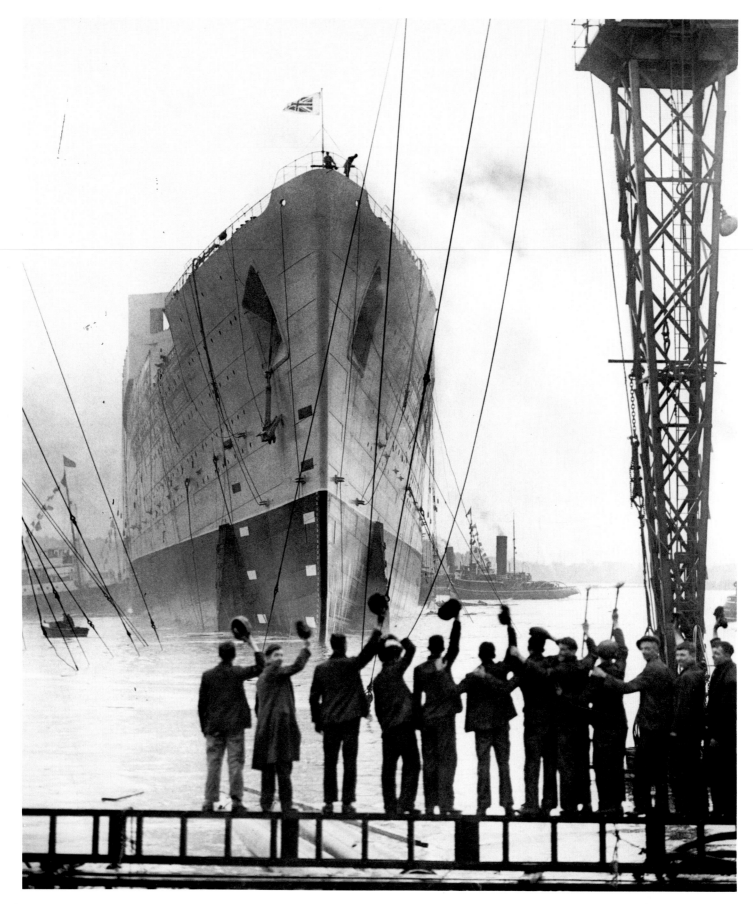

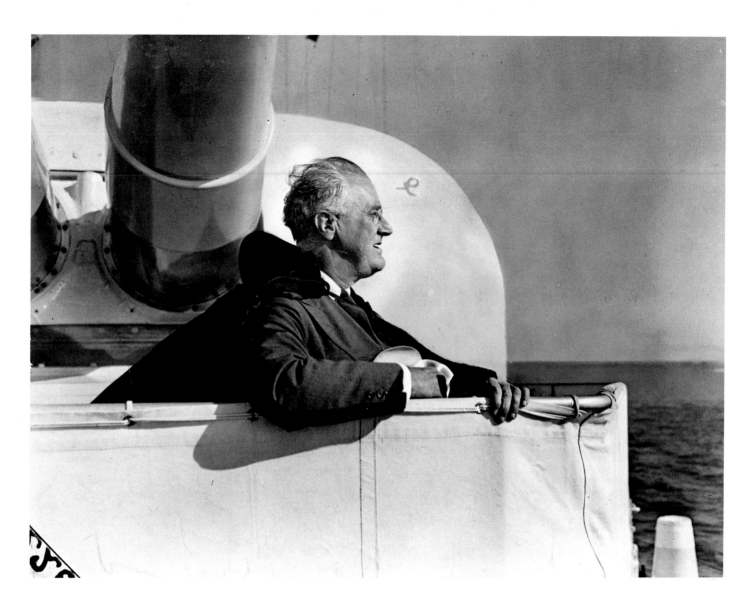

"F. D. R. Reviewing Fleet off San Francisco." July 16, 1938

Joe Rosenthal/Times Wide World Photos

"Giant Liner Launched and Named 'Queen Mary.'" September 26, 1934

"'Queen Mary' is the name of the proud new ship which until now has been known only as '534.' The Queen revealed the secret of the name this afternoon, when she launched from John Brown's famous yard at Clydebank the mightiest thing that man has ever made to float upon the waters. It is estimated that 250,000 people saw the launch."

Times Wide World Photos

"A Recent Portrait of Miss Earhart."
1932

The New York Times Studio

"The Shortest Day in the Year in the Far North." December 22, 1935

"A photograph taken from the new Federal Building at Fairbanks, Alaska, showing the position of the sun every twenty minutes from 9:52 o'clock on the morning of Dec. 22 until it disappeared at 2:04 P.M. The double sun was caused by atmospheric conditions. In the foreground are the snow-covered houses of Fairbanks."

J. C. P. Skottowe/Times Wide World Photos

"Einstein Offers New View of Mass-Energy Theorem." December 28, 1934

"Pittsburgh, PA.: Albert Einstein, famous scientist, who today gave to 400 American scientists the treat of watching him remodel his universe. A piece of chalk was his only tool as he gave his new view of mass-energy theorem on the small stage in the circular auditorium of the Carnegie Institute of Technology's little theatre here. He is shown here explaining his formula to a group of reporters following his lecture."

Norman M. Jeannero/Times Wide World Photos

"Mr. and Mrs. Joe Louis Out for a Stroll." September 25, 1935

"The Detroit fighter and his bride acclaimed by crowds as they walked through a Harlem street yesterday."

Times Wide World Photos

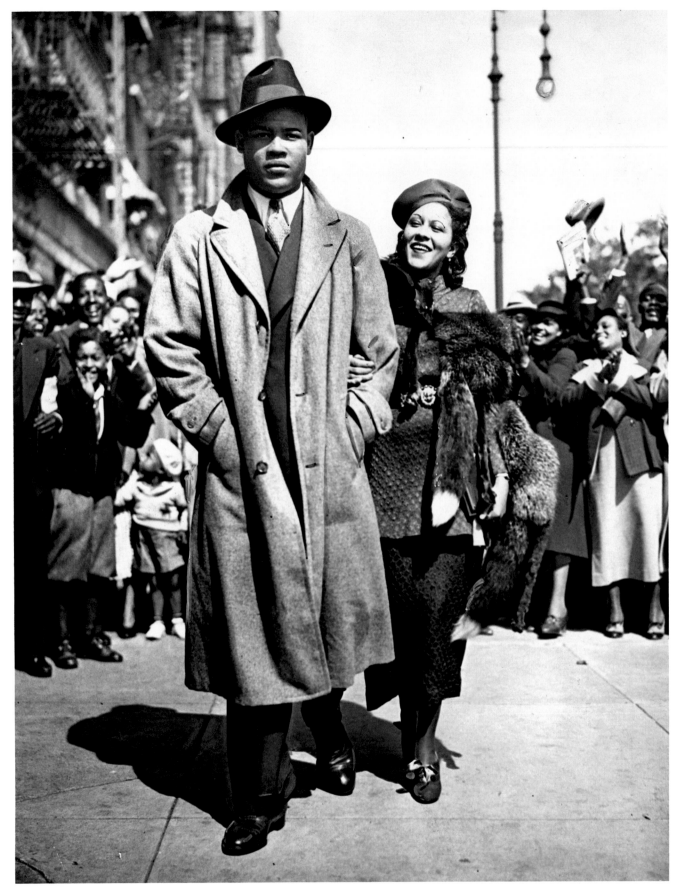

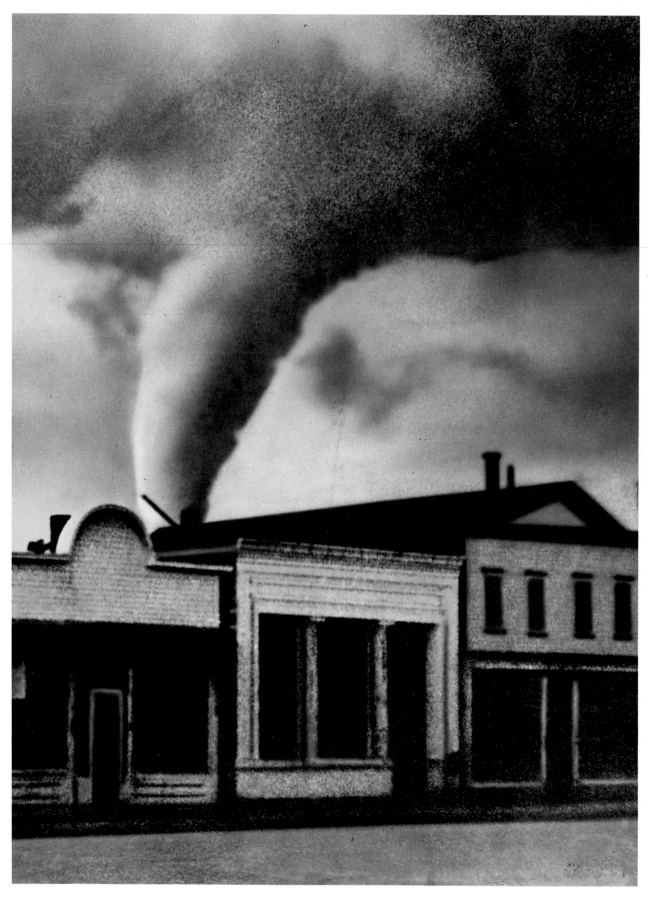

"The Portent of Coming Disaster." 1938

"A tornado, photographed as it moved across the sky toward White, S.D., by a cameraman who was the only person who did not take shelter in a cyclone cellar. None of the buildings shown in the picture was damaged, as they were not in the direct path of the tornado."

International News Photos

"Dr. F. G. Benedict's Latest Apparatus for Measuring Metabolism." 1935

"Dr. F. G. Benedict's latest apparatus for measuring metabolism—the process of converting food into energy and tissue. He has found that old women, whether they are thin and underweight or fat and overweight, do little more than vegetate. Their heat production is almost at the irreducible minimum of a healthy, normal person of average age."

Photographer unknown

**"The Mayor and a Baby Exchange
Smiles."** December 8, 1938

"Mr. La Guardia at dedication of a child
health station in Brooklyn."

Times Wide World Photos

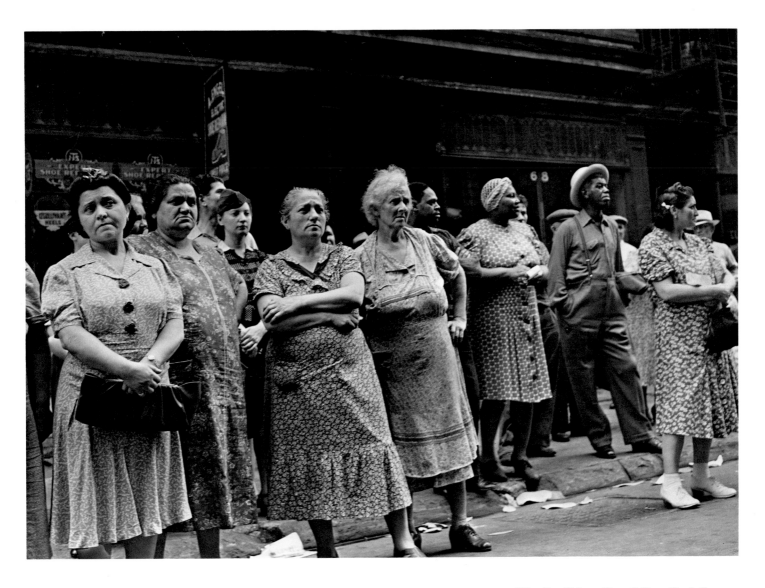

"On the Sidewalks of New York."
June 21, 1942

"Part of the audience at the folk festival held yesterday at Cannon and Rivington Streets."

Sam Falk/The New York Times

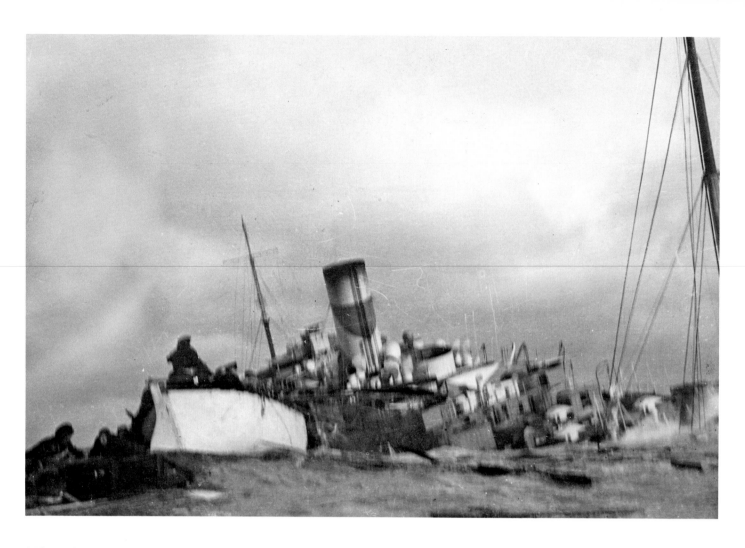

"The Rajputana Founders." May 1941

"The 16,644-ton Rajputana founders as the last lifeboat pulls away. Close to the lifeboat is a raft loaded with survivors."

Associated Press

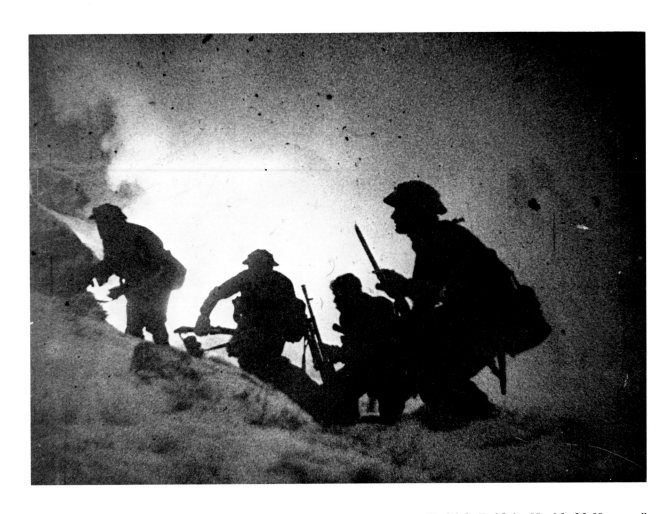

"British Raid in Nazi-held Norway."
December 29, 1941

"Advancing under the cover of a smoke screen during the attack, which occurred on Dec. 29."

Times Wide World Photos

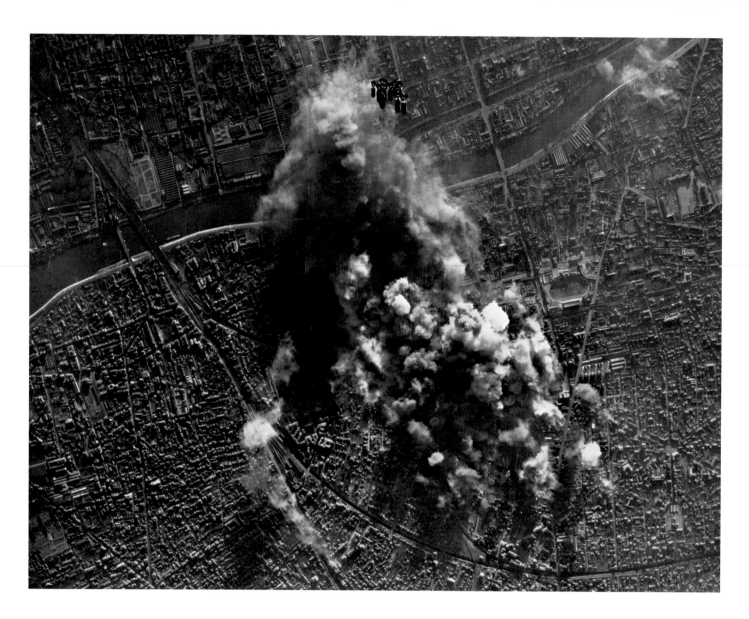

Over Paris. 1943–44

"Here the Eighth Air Force pounds the Cam ball-bearing plant and the Hispano Suiza aircraft engine repair depot in Paris. A stick of bombs can be seen falling at the top of the smoke column."

U.S. Army Air Force

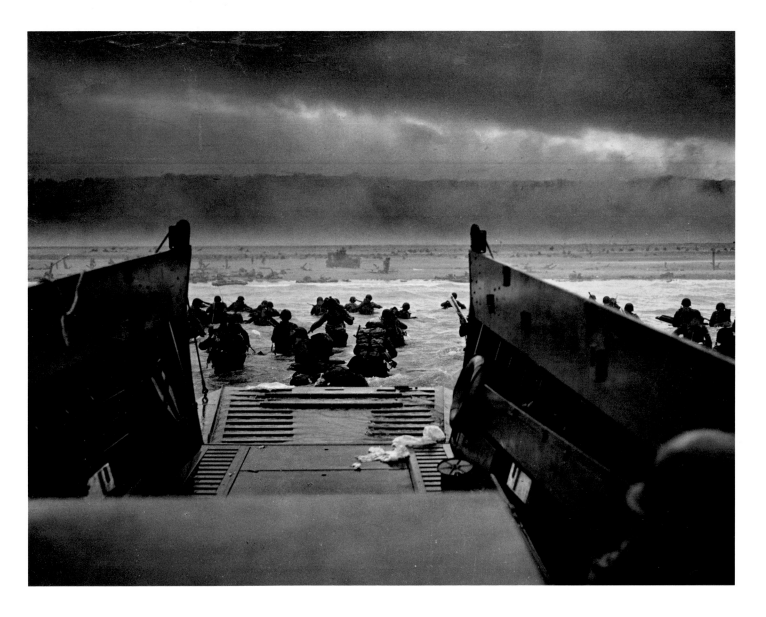

"Into the Jaws of Death." June 6, 1944

"Down the ramp of a Coast Guard landing barge Yankee soldiers storm toward the beach-sweeping fire of Nazi defenders in the D-Day invasion of the French coast. Troops ahead may be seen lying flat under the deadly machine gun resistance of the Germans. Soon the Nazis were driven back under the overwhelming invasion forces thrown in from Coast Guard and Navy amphibious craft."

U.S. Coast Guard

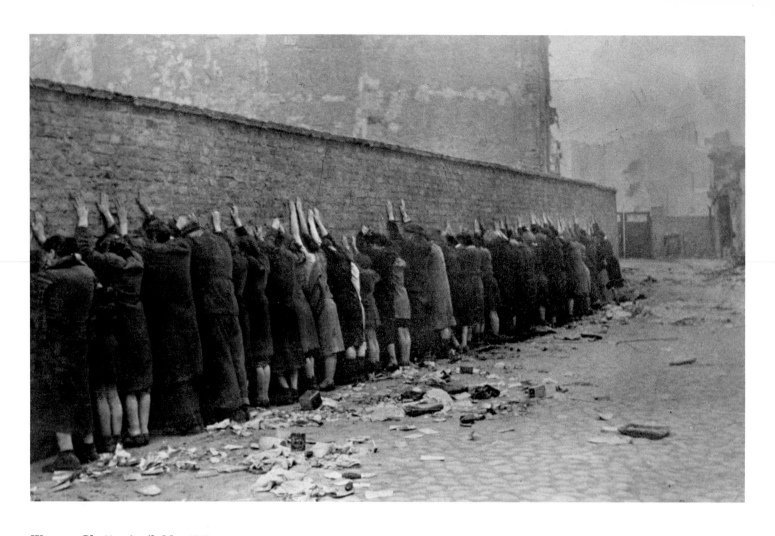

Warsaw Ghetto. April–May 1943

"Before the search."

*Stroop Report/Central Commission for the
Investigation of War Crimes in Poland*

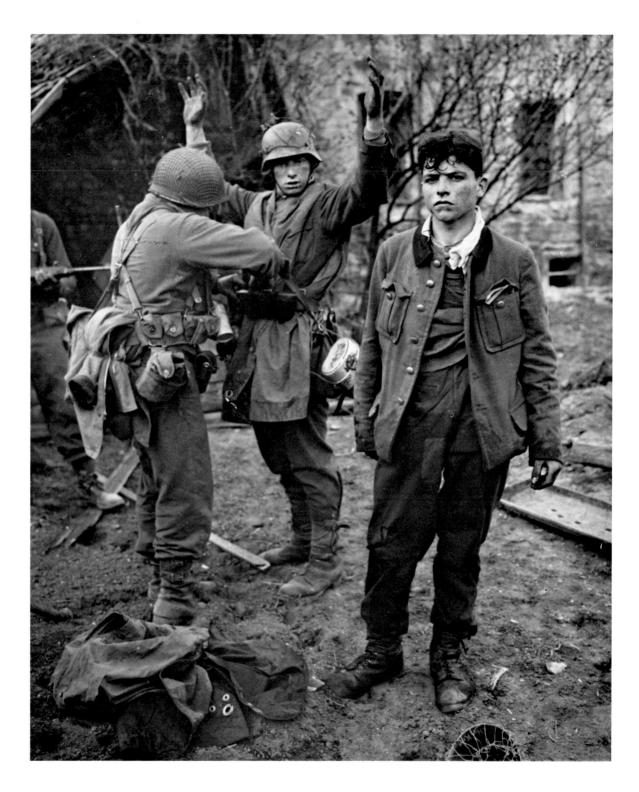

"Fritz Is Frisked." March 26, 1945

"Somewhere in Germany: While his companion gives the cameraman a typical Nazi expression, another German sniper who was wounded during a brief battle against Third Army troops, sports a look of amazement and indignation, as he is 'frisked' after their capture."

Rollins/Associated Press

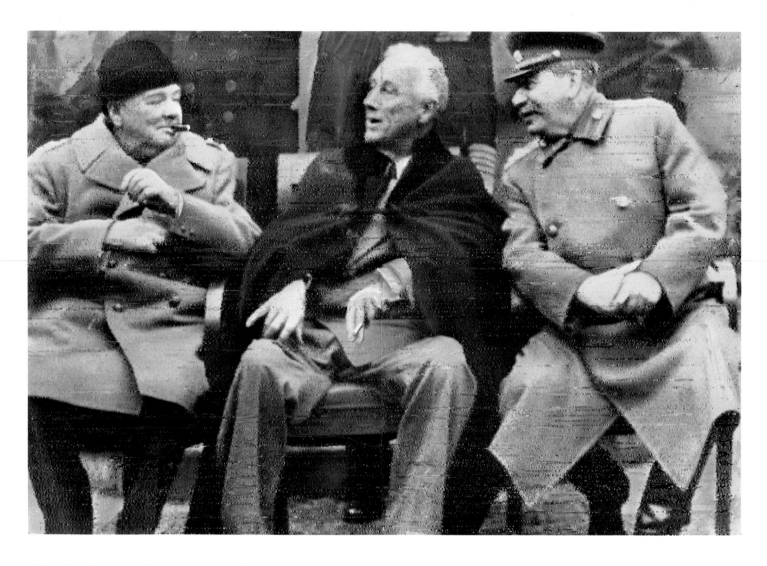

"The Big Three Meeting Again to Make Plans for the World." February 1945

"Prime Minister Churchill, President Roosevelt and Marshal Stalin on the grounds of Livadia Palace [Yalta]."

British Official Radiophoto/The New York Times

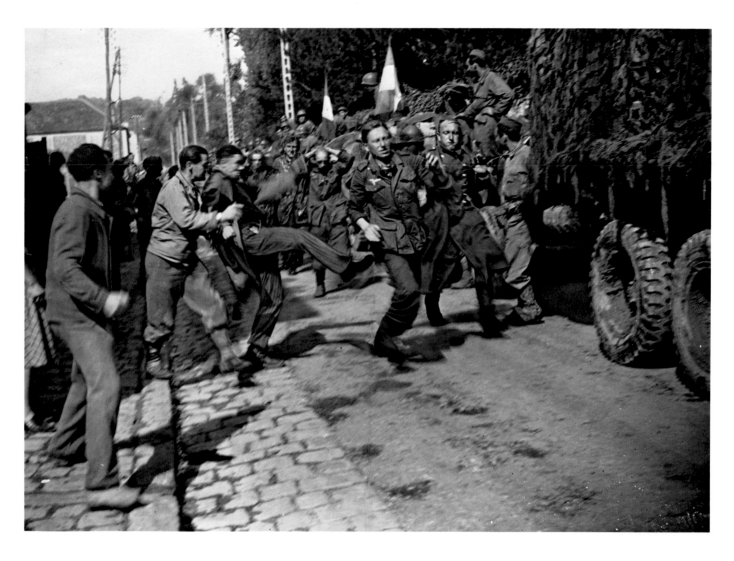

"How German Prisoners Were Received by French Patriots." August 24, 1944

May 1945: "Taken ... at Jouy-en-Josas, eleven miles from Paris, the day before the French capital was liberated this picture was just released by the censor."

Associated Press

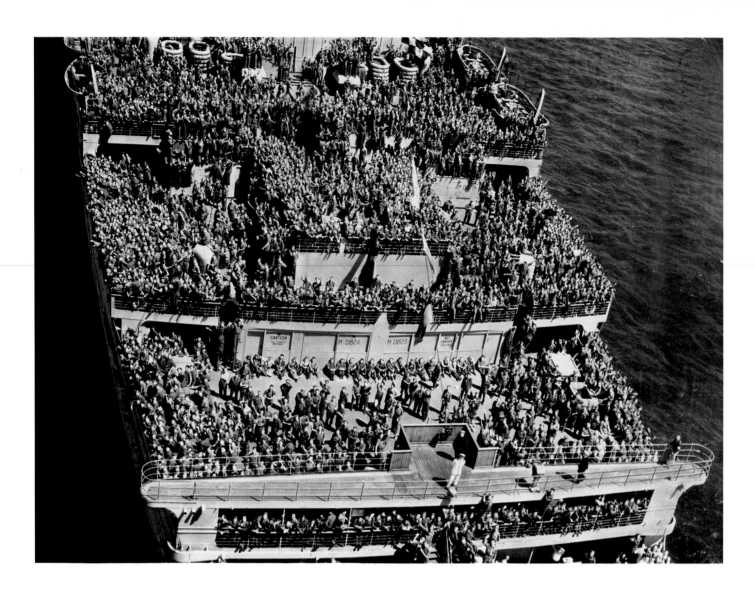

"It Was a Record Day for Allied Soldiers as 34,355 Arrived Here." July 11, 1945

"American and Canadian troops crowd the deck of the Queen Mary as she moves up the harbor."

U.S. Coast Guard via Associated Press

"A Member of the Japanese Delegation." September 2, 1945

"A member of the Japanese delegation comes aboard the U.S.S. Missouri to surrender."

U.S. Army Signal Corps

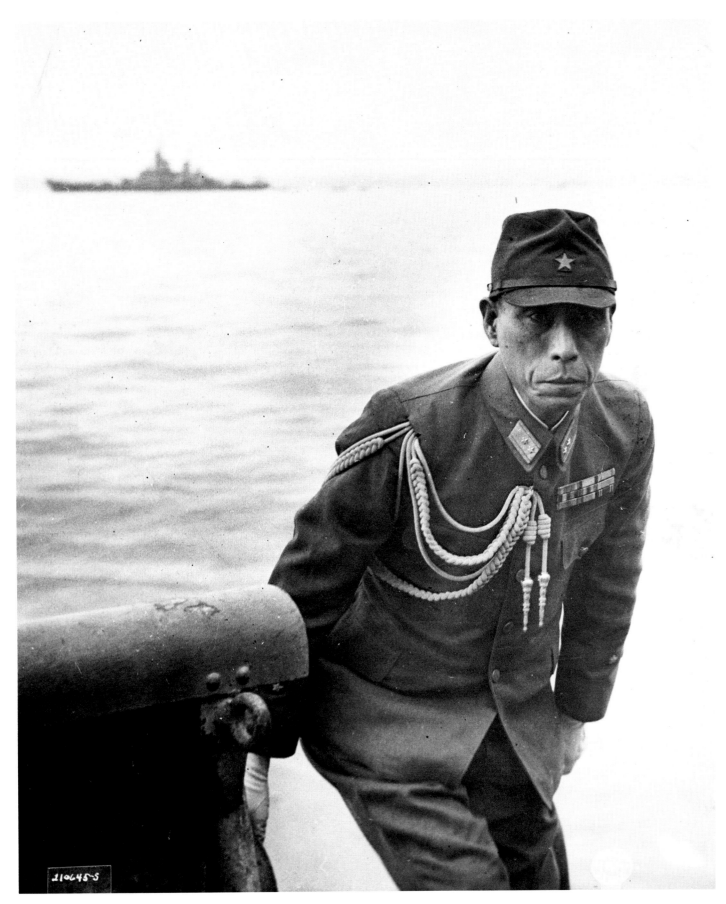

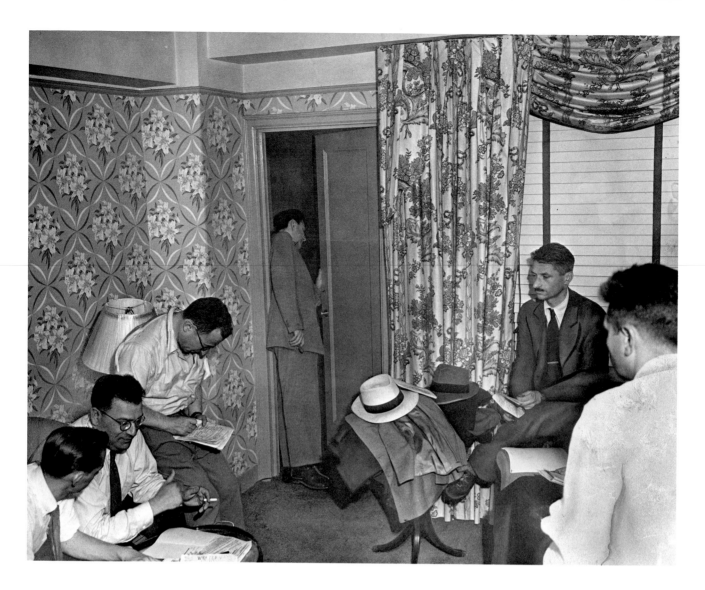

"Mystery Surrounds Interview Here on Stern Group." July 13, 1947

"Reporters listen as their questions are answered by unseen 'Mr. Hillel,' who remains hidden behind semi-opened door at the Hotel St. Moritz. Rabbi Baruch Korff, standing in the doorway, served as liaison between the press and the man described as a deputy commander of the underground organization in Palestine."

Eddie Hausner/The New York Times

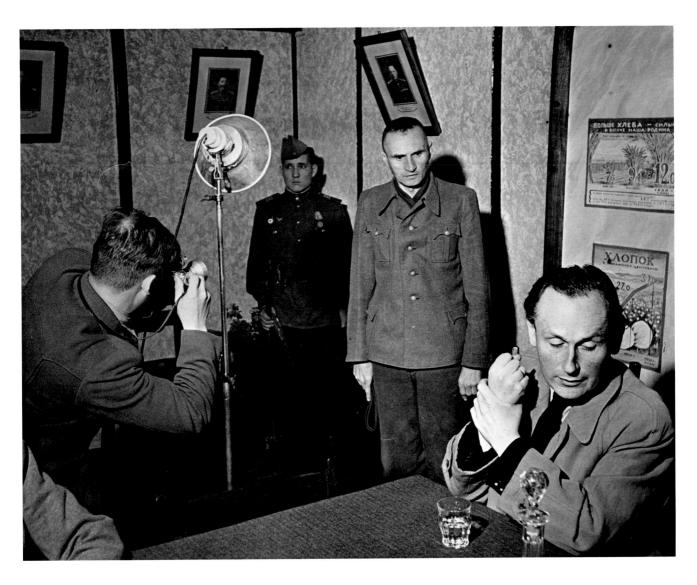

"Allied Correspondents Visit German Prison Camp in the Russian Zone." 1947

"Oranienburg, Germany: A small party of German and Allied correspondents were escorted to Sachsenhausen. There [the Russians] exhibited a group of enlisted men who have met Red justice for crimes committed on the Eastern front. They were members of the German Ninth Police Reserve Battalion, a band of 240 men, who according to the Russian conducting officer had murdered 97,000 people in Russia and Poland during the Nazi occupation.... The second prisoner, Bruno Fuchs, is answering questions with the interpreter, at the right, and a Russian photographer at left, taking pictures. Fuchs was accused of killing 1207 Soviet citizens, but he told correspondents 'it was only 800.'"

Henry Ries/The New York Times

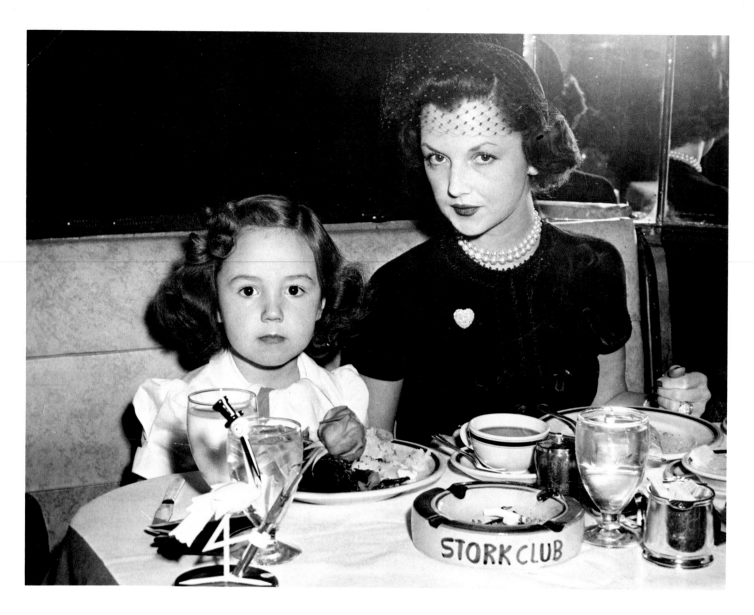

"In Footsteps of Famous Mama???"
1950–51

"Mrs. John Sims Kelly, the former Brenda D. D. Frazier, remembered as the most publicized and one of the most wealthy debutantes of any season, lunches at the Stork Club with her cute little daughter who already shows evidence of winning the glamour girl crown in the mid-1960's."

Stork Club News Service

"An Arrival for Hearing." November 7, 1947

"Washington: Howard Hughes leaving his plane at National Airport."

George Tames / The New York Times

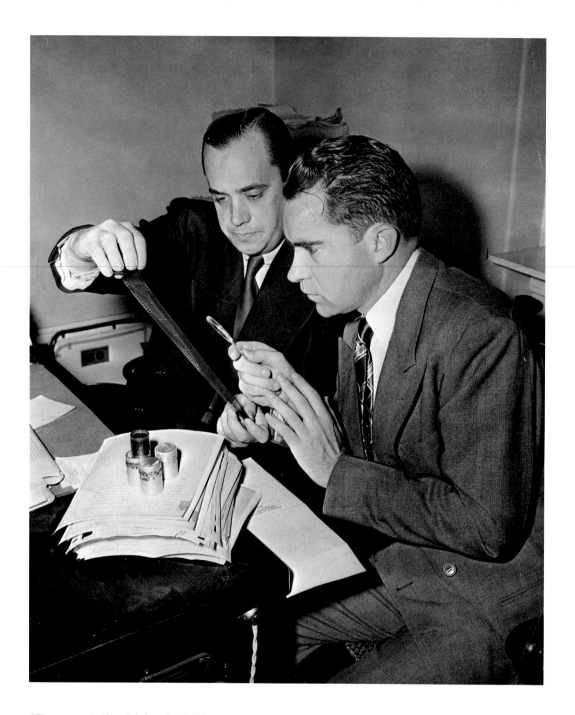

**"Representative Richard M. Nixon
of the House Un-American Activities
Committee."** December 6, 1948

"Representative Richard M. Nixon of the
House Un-American Activities Committee
viewing microfilms of secret papers found
on the farm of Whittaker Chambers, with
Robert Stripling, investigator for the Com-
mittee."

George Tames/The New York Times

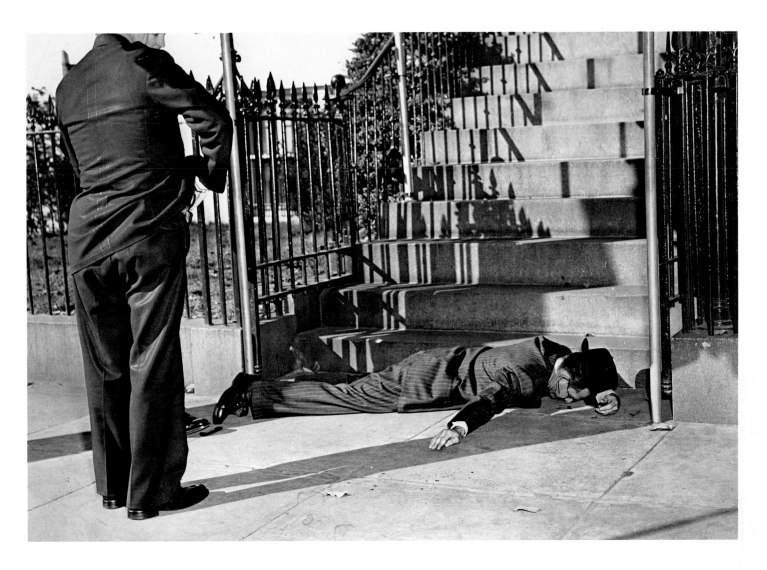

"Attempted Assassin of President Shot Down." November 1, 1950

"Oscar Collazo lying at the bottom of the steps to the Blair-Lee House as White House guard is putting his revolver back in his holster. This picture was made by a photographer of The New York Times, who was waiting to accompany Mr. Truman to a dedication ceremony at Arlington Cemetery."

Bruce Hoertel/The New York Times

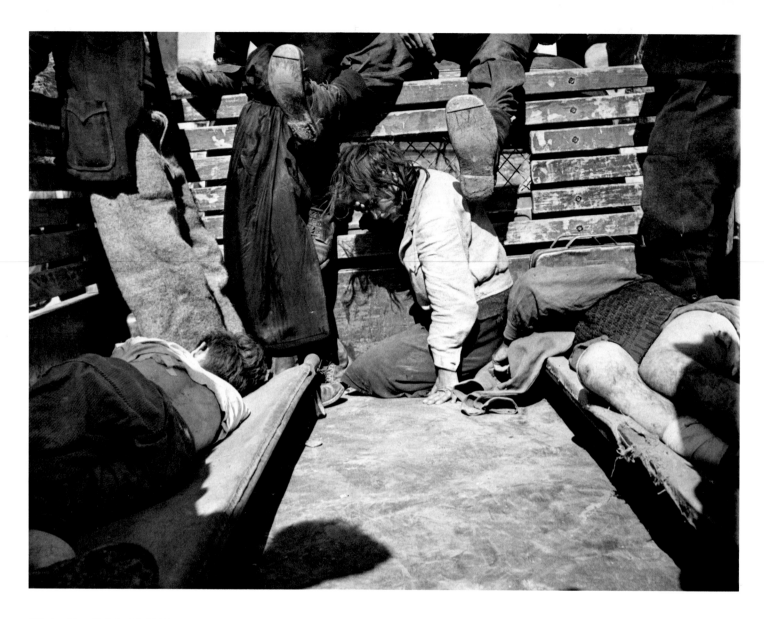

"Dejection." July 26, 1947

"A girl member of guerrilla forces opposing Greek troops in Macedonia, slumps dejectedly in a truck bringing her to Kozane after her capture, July 26, during guerrilla raid on village of Grevena in which more than 100 members of attacking force were killed. Man on stretcher at left died during trip to Kozane."

Associated Press

"Persuading Longshoremen to Return to Work." 1951

"Anthony Anastasia, in leather jacket, pushing a reluctant striker back to his job at the Brooklyn Army Base. The men returned to work, but later walked out again."

Meyer Liebowitz / The New York Times

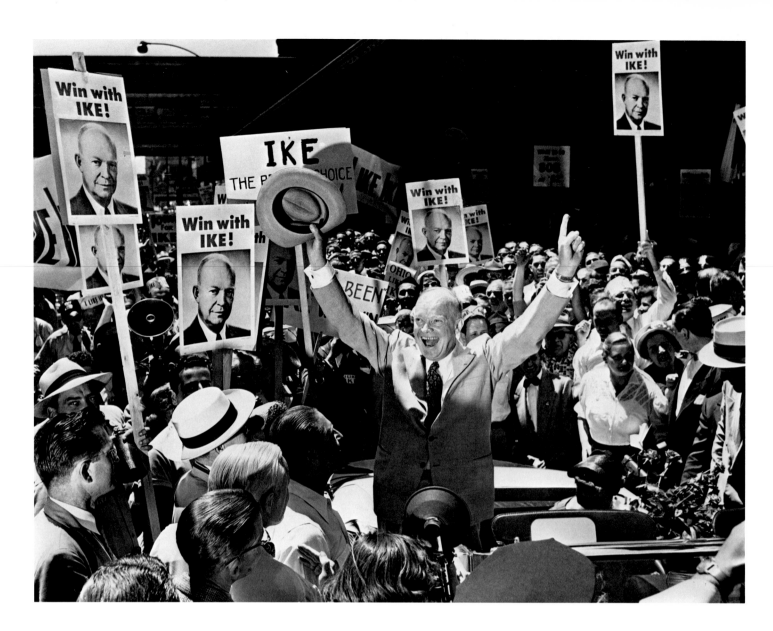

Pre-Convention Scene. July 6, 1952

Dwight D. Eisenhower arrives at the Hotel
Blackstone, Chicago.

George Tames/The New York Times

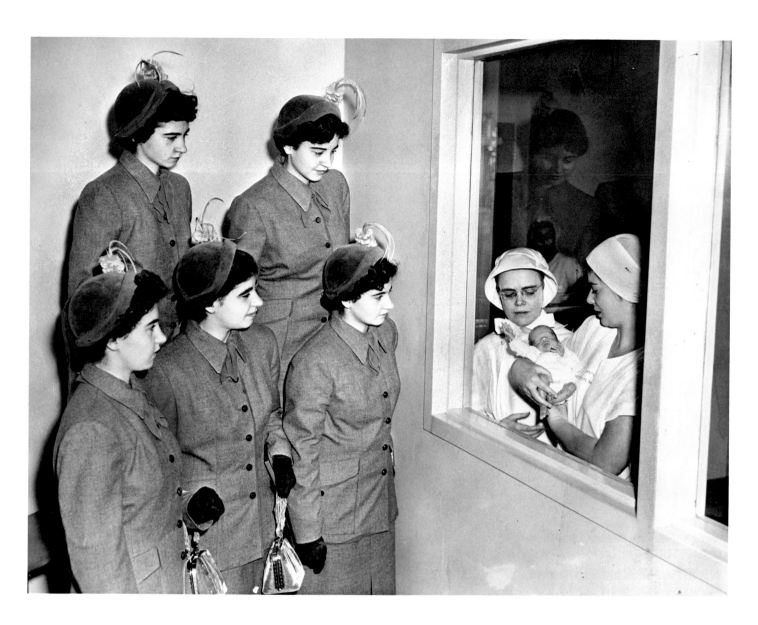

"Quintuplets Visit Infants' Ward at Hospital." October 20, 1950

"The Dionne sisters, Yvonne, Cecile and Marie in the front row and Emilie and Annette in the rear, getting a glimpse of a premature baby at St. Vincent's."

Ernie Sisto/The New York Times

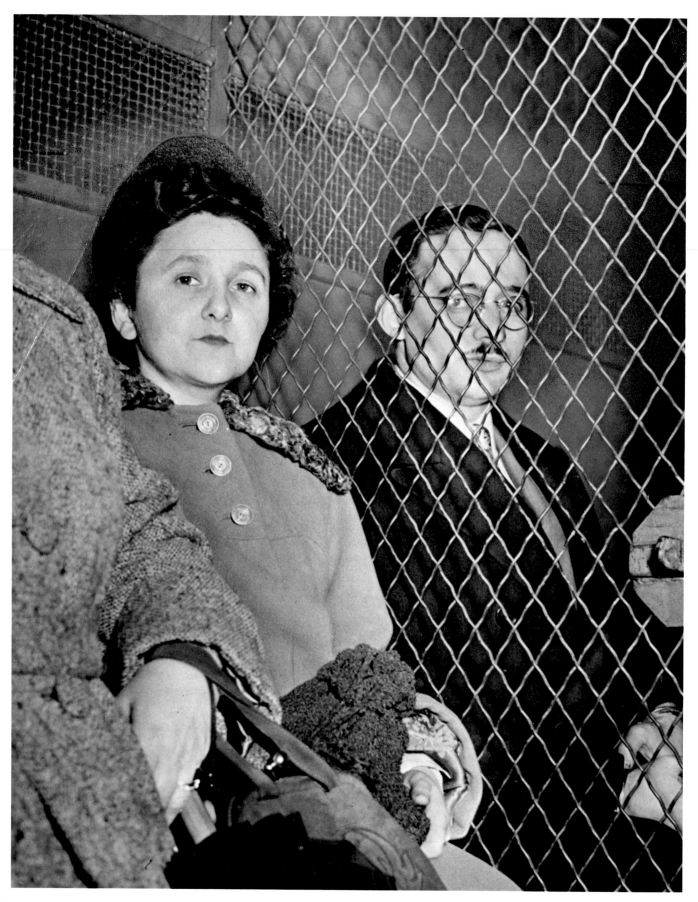

Sen. Joseph R. McCarthy and Roy Cohn. 1954

"During McCarthy-Army charges and counter-charges in Washington, D.C., Sen. Joseph R. McCarthy is shown covering the microphones in front of him as he confers with his chief counsel, Roy Cohn, right, one of the principals in the dispute."

Associated Press

"Convicted Spies on Way to Jail."
March 29, 1951

"Ethel Rosenberg, 35, and her husband, Julius, 34, are separated by wire screen as they ride to separate jails, in New York, March 29, following their conviction as traitors in the nation's first atom spy trial. Convicted with them was Morton Sobell, 33-year-old radar expert. They were accused of conspiring to deliver war secrets—including vital A-bomb data—to Soviet Russia."

Associated Press

"City Trying Rubber Paving." July 9, 1953

"Standing safely in a carefully cleared circle, Manhattan Borough President Robert F. Wagner Jr. rakes experimental paving containing rubber on the surface of First Avenue between Twenty-fourth and Twenty-fifth Streets, while Anthony DeMargo, chief engineer of the Borough President's Office, takes temperature of the mixture."

Robert Walker/The New York Times

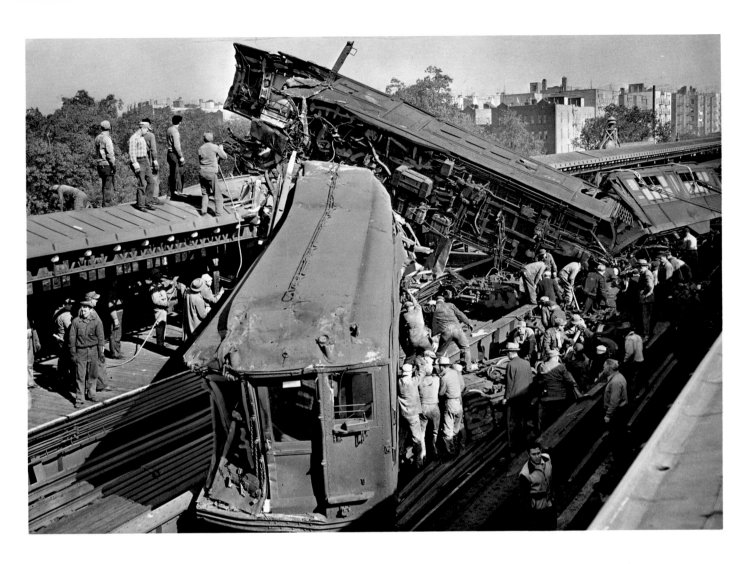

"Subway Crash." October 23, 1952

"Subway crash between two empty trains occurred this morning on the IRT Jerome Avenue line, Mosholu Parkway station."

Arthur Brower/The New York Times

"Bal d'Hiver, Paris." 1954

"Arrival of the Duke and Duchess
of Windsor."

Dominique Berretty/Black Star

**"This Photo Was Made Just Before
4 P.M."** July 24, 1959

"At Broadway and Forty-third Street,
looking east across Times Square."

Carl T. Gossett, Jr./The New York Times

119

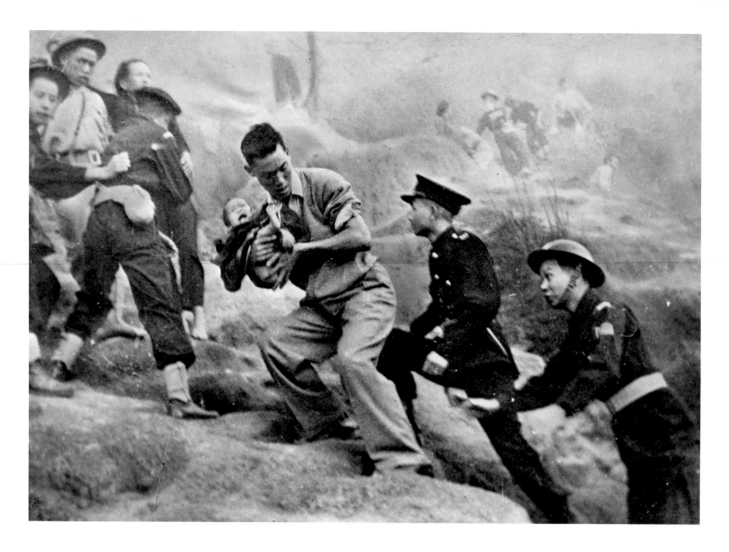

"An Escape from Death." November 24, 1954

"A father held his crying baby son as he fled from flames sweeping through a squatters' village in Kowloon, native quarter of Hong Kong, last Wednesday. Police assist him. Forty huts were destroyed and 200 persons were made homeless."

Associated Press

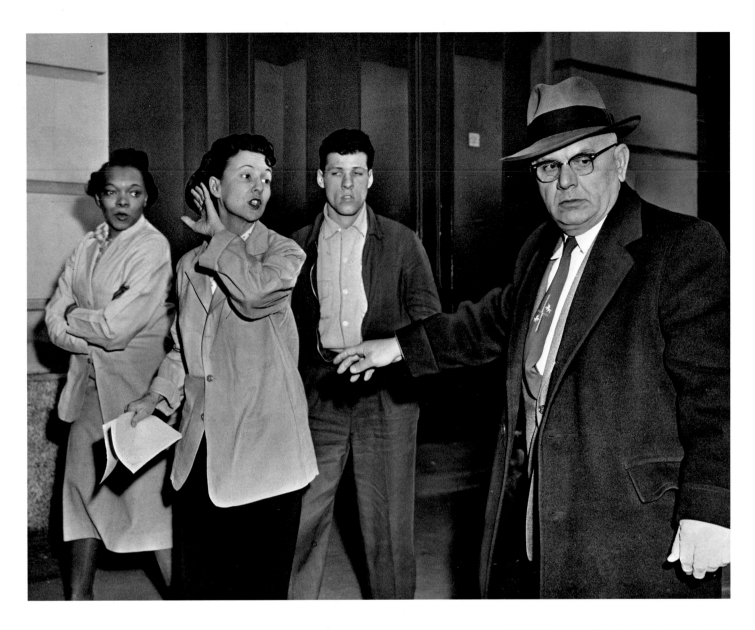

"U.S. Removes Worker Files." March 30, 1956

"Daily Worker employee protests to Treasury agent as records are taken out back entrance of newspaper, published at 35 East Twelfth Street."

Neal Boenzi/The New York Times

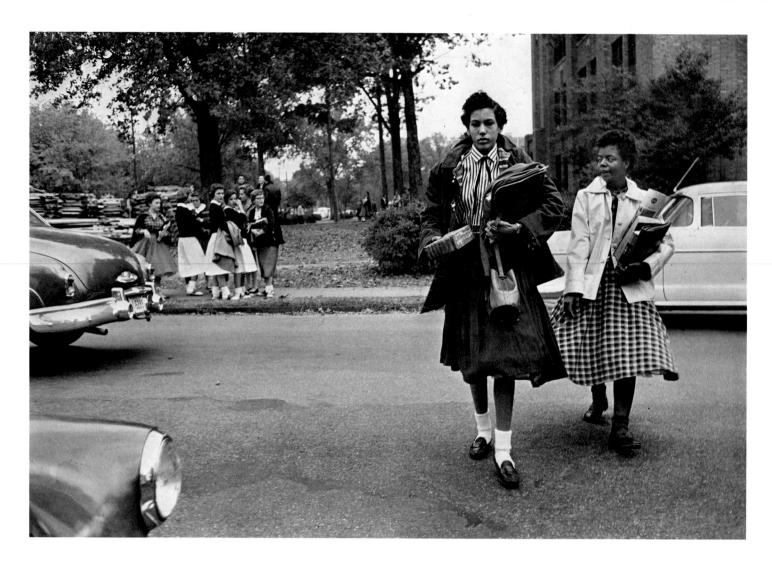

"Students." November 1957

Little Rock, Arkansas: "Carlotta Walls and Elizabeth Eckford, right, leave school. Authorities deny reports of student 'incidents' inside the school."

George Tames/The New York Times

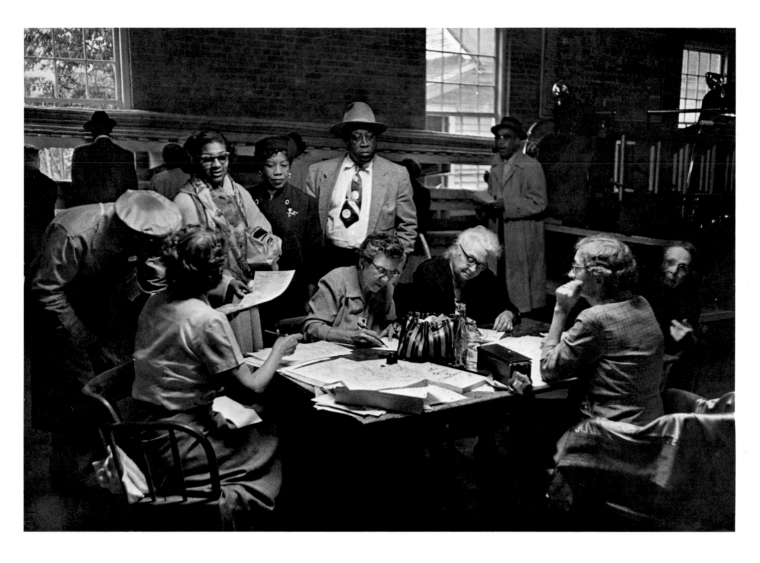

"Voters." November 1957

"At a Little Rock firehouse, Negroes vote in the city election. Negro ballots spelled the margin of victory for the 'moderates.'"

George Tames / The New York Times

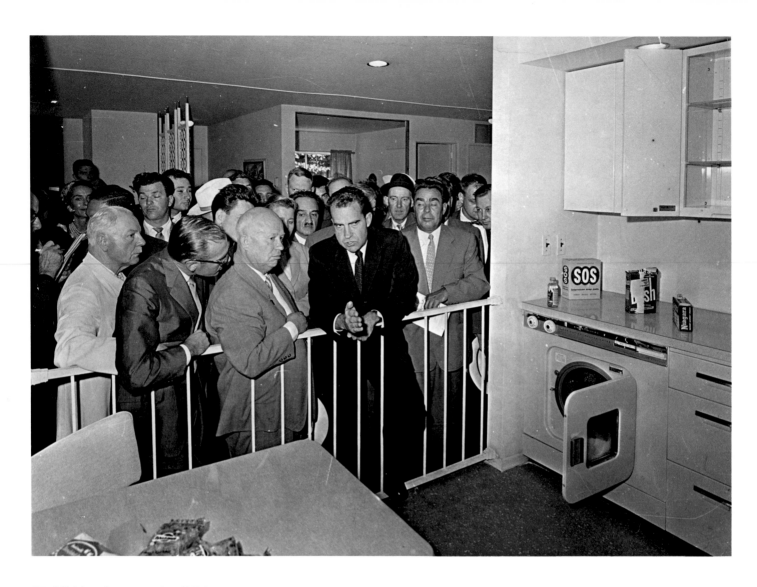

"Exhibition Conversation." July 24, 1959

"Soviet Premier Nikita Khrushchev, left, and Vice President Richard Nixon talk as they stand in front of display in kitchen area of the U.S. exhibit in Moscow's Sokolniki Park, July 24. The exhibit was formally opened this day in the Russian capital. The Vice President traded barbed comments with Soviet leader as they toured the exhibit."

Associated Press

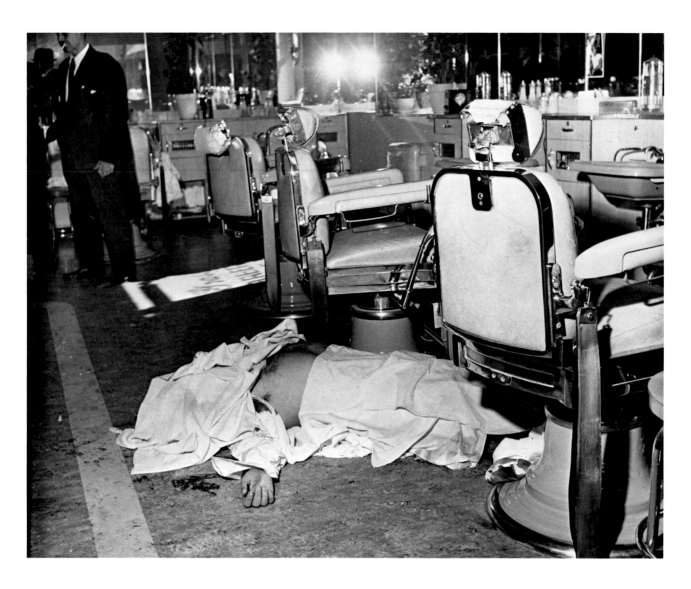

"Umberto (Albert) Anastasia Shot to Death in Barber's Chair." October 25, 1957

"At 10:20 A.M., while being shaved in the barber shop of the Park Sheraton Hotel—870 Seventh Avenue—Umberto Anastasia, once linked with Murder Inc., was shot to death by two men wearing black masks. Umberto was the brother of Brooklyn waterfront boss Anthony (Tough Tony) Anastasia, who was brought to the murder scene to identify the body."

Meyer Liebowitz/The New York Times

"Young Nebraska Girl in Custody."
January 29, 1958

"Caril Fugate, 14, appears in a state of shock as she is interrogated by sheriff's officers at Douglas, Wyo. She accompanied Charles Starkweather on a reckless 500-mile automobile flight from Lincoln, Neb. where the two were wanted by authorities in connection with nine grisly killings. Among the dead were Caril's mother, step-father and their two-year-old daughter."

Associated Press

"Accused Murderer in Wyoming Jail Cell." January 29, 1958

"Charles Starkweather, 19, whose capture in Douglas, Wyo. Wednesday afternoon ended one of Nebraska's most extensive manhunts, rests in Converse County jail cell. The youth is believed responsible for the death of possibly 10 persons in Nebraska and Wyoming."

Associated Press

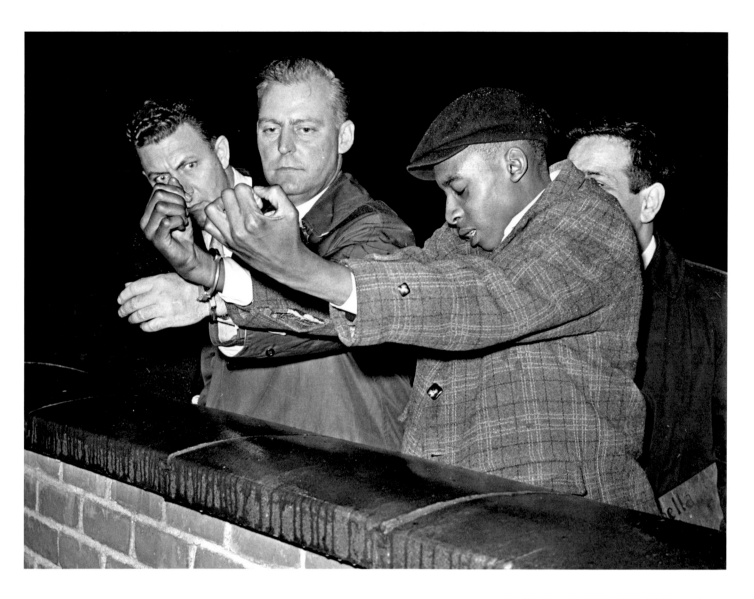

"Tells How He Killed Girl." December 5, 1962

"[A teenager] holds his hands over roof parapet of 14-story Brooklyn, N.Y., apartment building while reenacting for New York City detectives ... how he pushed [a nine-year-old girl] to her death. Police said he has admitted raping and killing the girl Dec. 4. [He] is handcuffed to Det. Joseph Cronin."

Associated Press

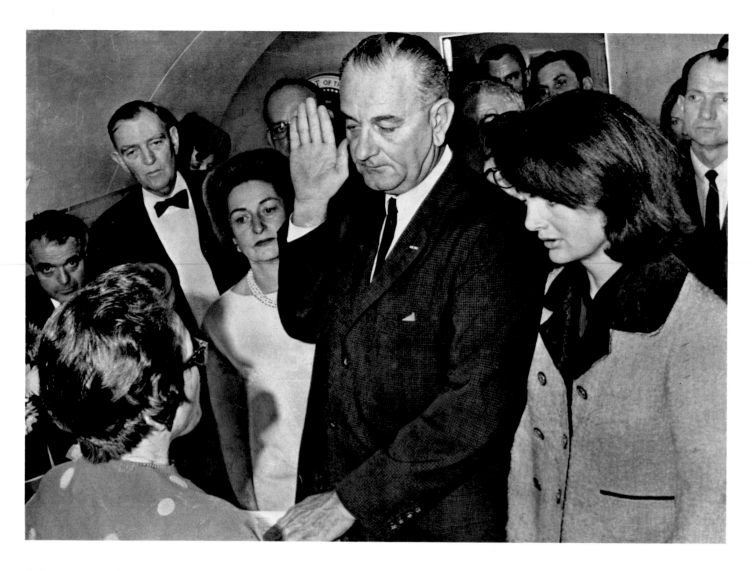

"The New President." November 22, 1963

"Lyndon B. Johnson takes oath before Judge Sarah T. Hughes in plane at Dallas. Mrs. Kennedy and Representative Jack Brooks are at right. To left are Mrs. Johnson and Representative Albert Thomas."

Capt. Cecil W. Stoughton/Official White House Photographer via United Press International

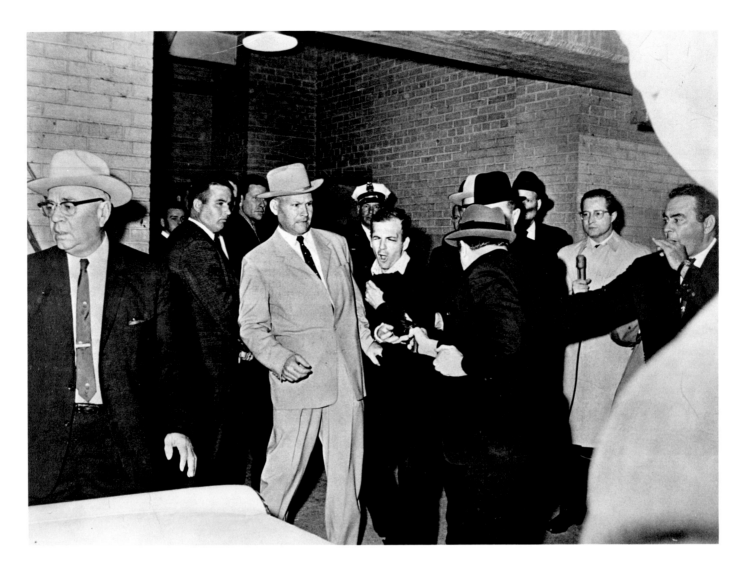

"The Moment of Impact." November 24, 1963

"Dallas, Texas: Lee Harvey Oswald (center) grimaces with pain as he is shot in the left side by Jack Ruby (right), November 24th, as Oswald is being transferred from the Dallas City Hall. Oswald is accused of slaying the late President Kennedy."

Bob Jackson/The Dallas Times-Herald via United Press International

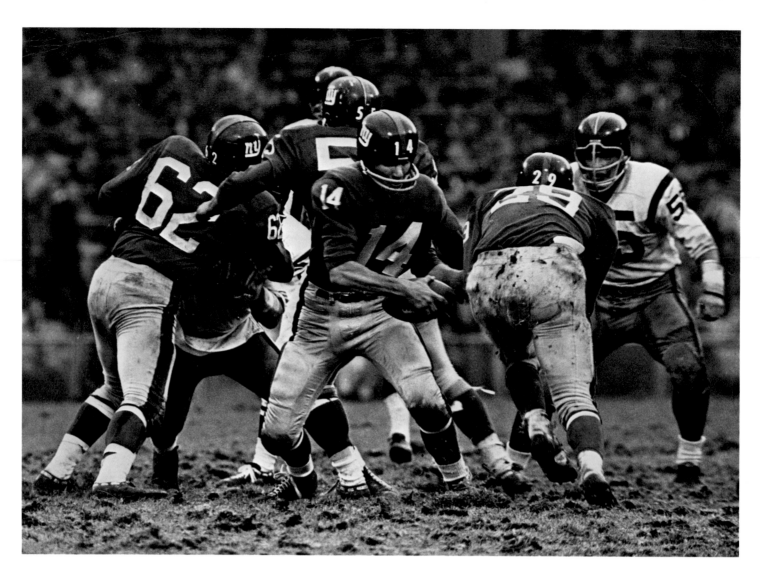

"Y. A. Tittle, #14." 1964

Y. A. (Yelbert Abraham) Tittle, quarter-
back of the New York Giants, 1961–64.

Robert Riger

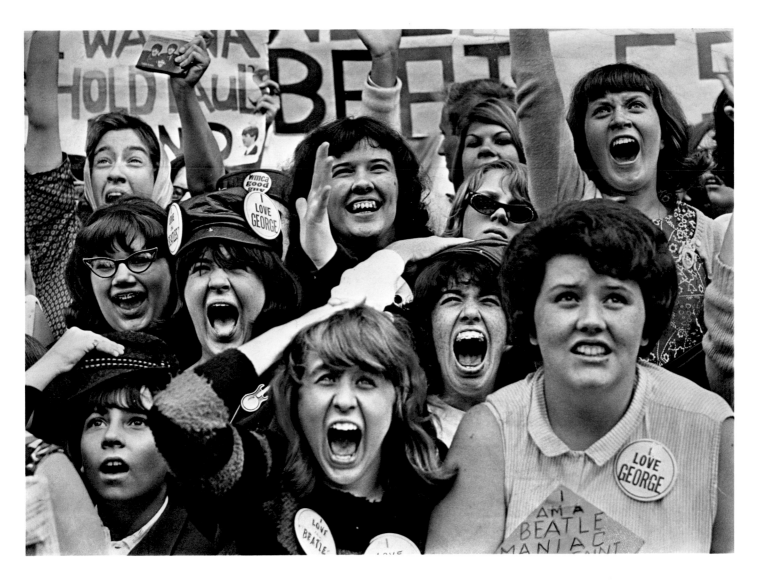

"Beatlemaniacs on the Loose."
August 28, 1964

"A group of Beatlemaniacs waiting outside Delmonico's Park Avenue and 59th Street, across the street from the hotel, hoping to see their heroes (?). The kids wave and scream at the hotel which houses the Beatles."

Carl T. Gossett, Jr./The New York Times

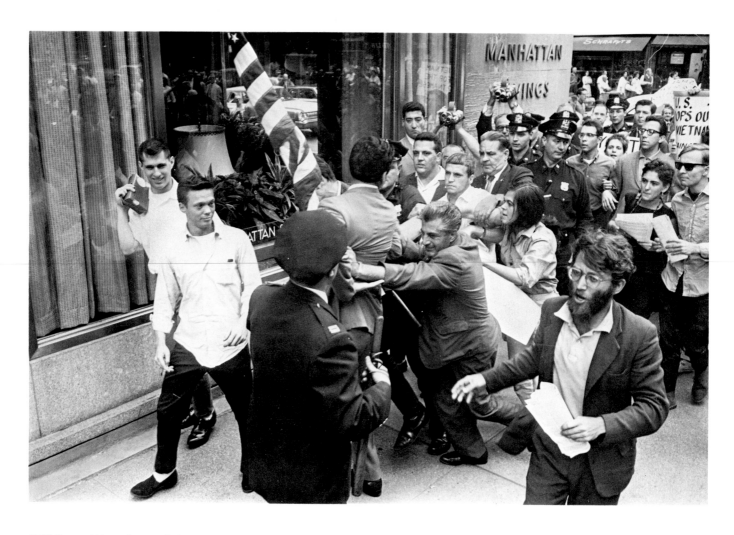

"Midtown Disturbance." August 15, 1964

"Police attempt to maintain order as leftist demonstrators against U.S. policy on Vietnam move on 47th Street near Madison Avenue toward U.N."

Jack Manning/The New York Times

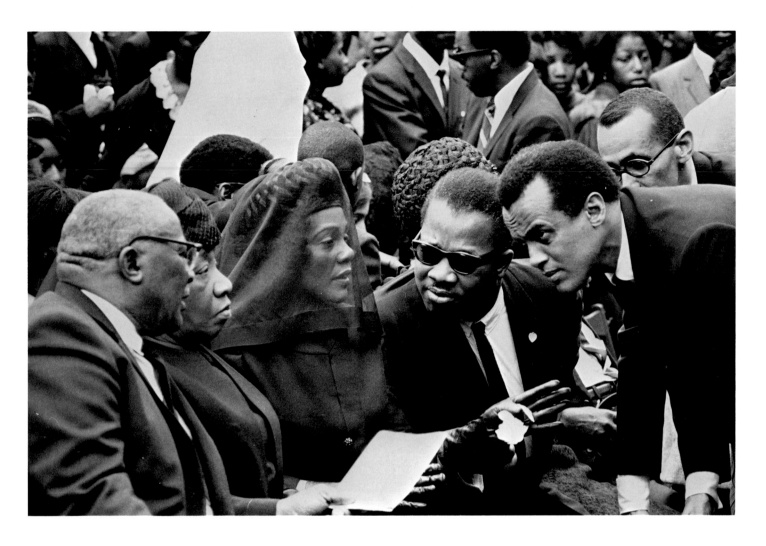

Funeral of Dr. Martin Luther King, Jr.
April 9, 1968

Atlanta, Ga.: Left to right, Reverend and Mrs. Martin Luther King, Sr., Coretta Scott King, Reverend A. D. King, and Harry Belafonte.

Don Hogan Charles/The New York Times

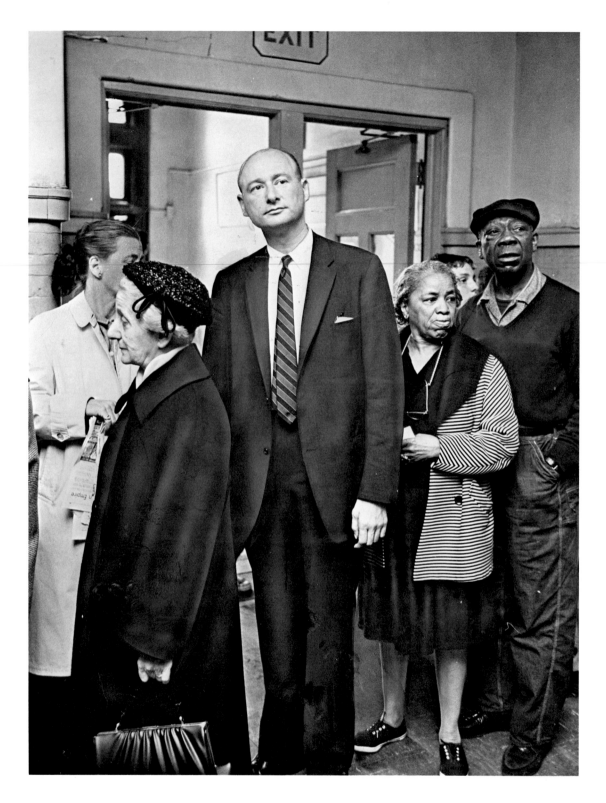

"Just Another Voter." June 2, 1964

"Edward I. Koch, candidate for Democratic district leader in First Assembly District South, waits to vote. He opposed Carmine G. De Sapio."

Eddie Hausner / The New York Times

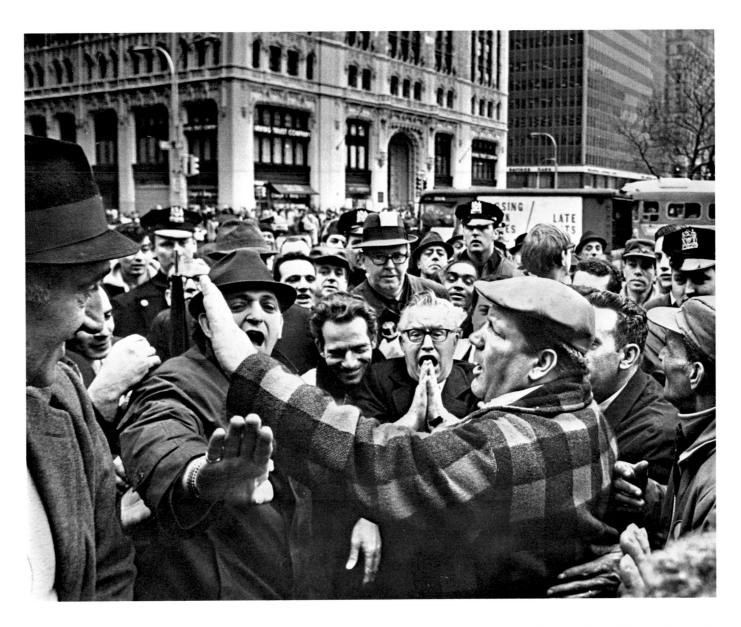

"After the Decision—'No Contract, No Work.'" February 2, 1968

"John J. DeLury, center, gesturing with hands before his face, trying to get through a crowd of sanitation men yesterday outside City Hall. Union members wanted to congratulate the leader on the decision."

Neal Boenzi/The New York Times

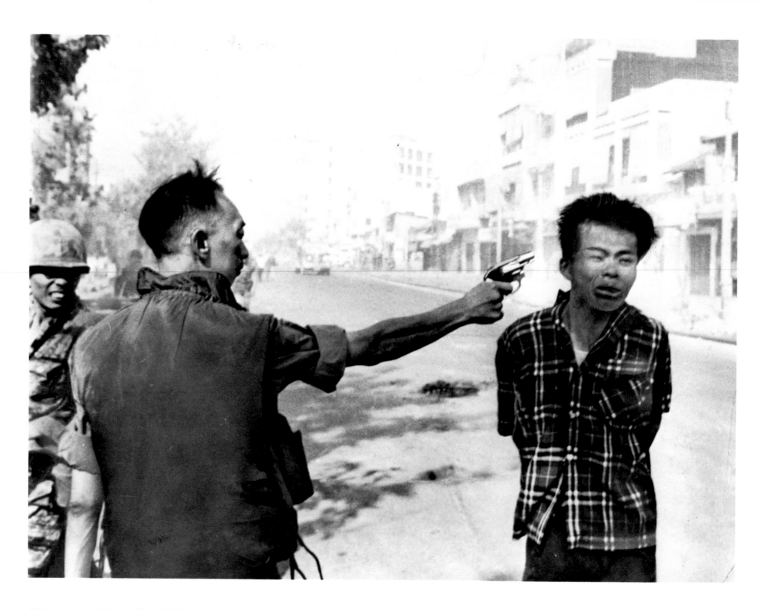

"Moment of Execution." February 1, 1968

"A Viet Cong officer grimaces at the impact of a fatal bullet from the gun shot by South Vietnamese National Police Chief Brig. Gen. Nguyen Ngoc Loan in Saigon on Feb. 1, 1968. Carrying a pistol and wearing civilian clothes, the Viet Cong guerrilla was captured near An Quang pagoda, identified as an officer, and taken to the police chief."

Eddie Adams/Associated Press

"View of Astronaut Footprint in Lunar Soil." July 20, 1969

"Apollo 11 astronauts Neil A. Armstrong, Michael Collins and Edwin E. Aldrin, Jr., were launched to the Moon by a Saturn V launch vehicle 9:32 A.M. EDT July 16, 1969 from Complex 39A Cape Kennedy, Fla. Armstrong and Aldrin landed on the Moon July 20, 1969 and, after take-off from the Moon July 21, joined Collins in the Command Module circling the Moon."

NASA

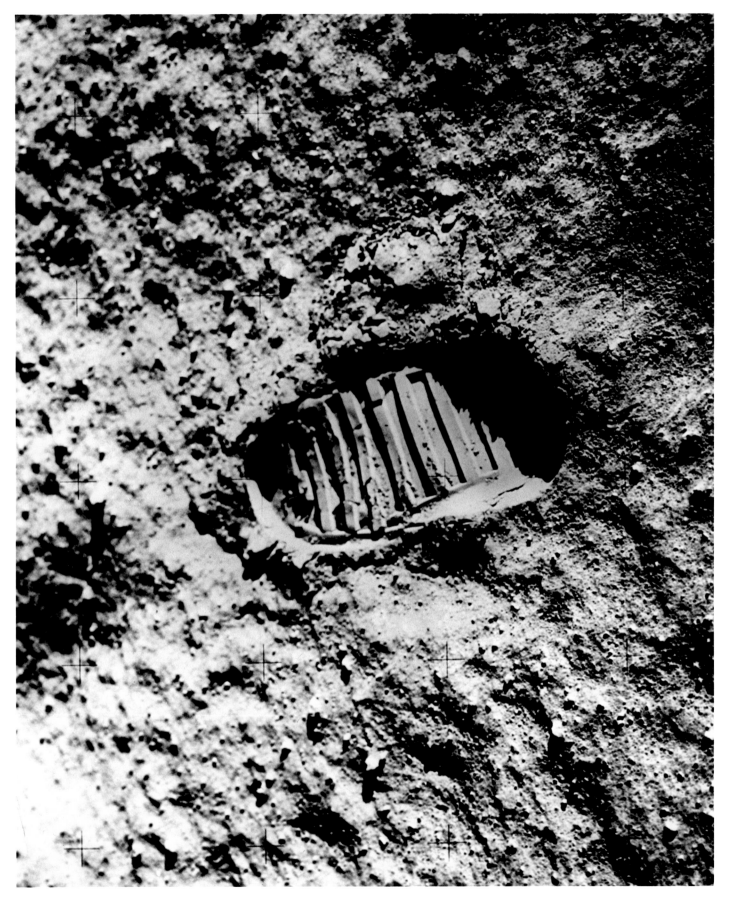

Vietnam. April 1968

"As fellow paratroopers aid wounded buddies, a paratrooper of A Company, 101st Airborne Division, guides a medical evacuation helicopter into a gap in the heavy foliage for a pickup of casualties."

Art Greenspon/Associated Press

"The Return of Andy Warhol." 1968

"The pop artist and maker of marathon movies with two members of his so-called Velvet Underground, Viva (left) and Ultra Violet. Though still recovering from gunshot wounds inflicted by an ex-Undergrounder, Valerie Solanas, Warhol is about to orbit himself in another realm of self-expression."

Sam Falk/The New York Times

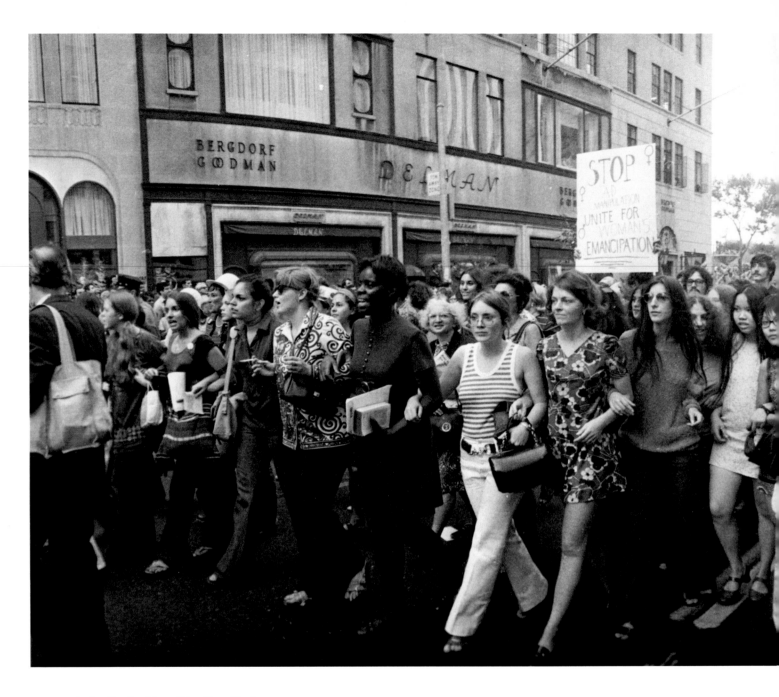

Women's Strike for Equality, New York.
August 26, 1970

William E. Sauro/The New York Times

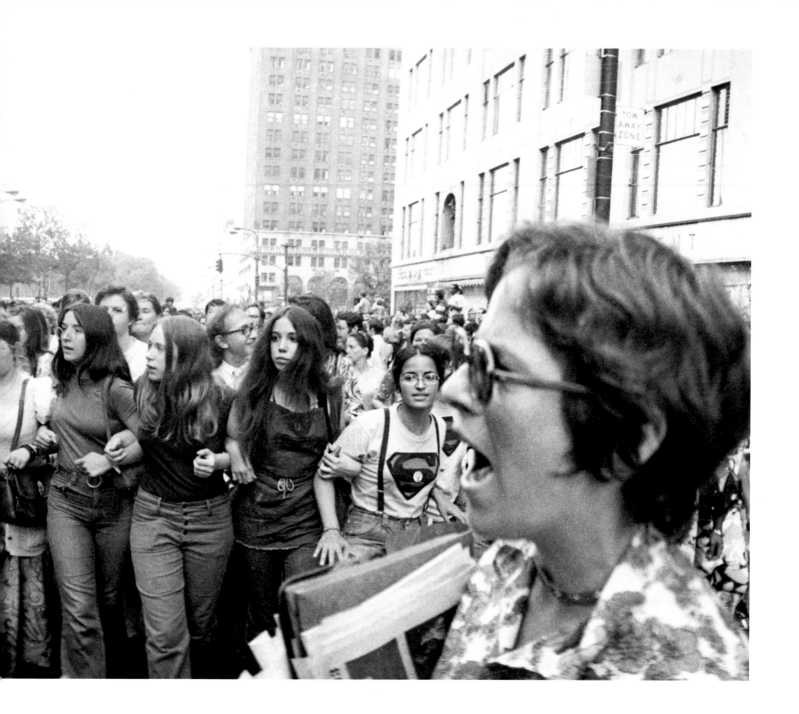

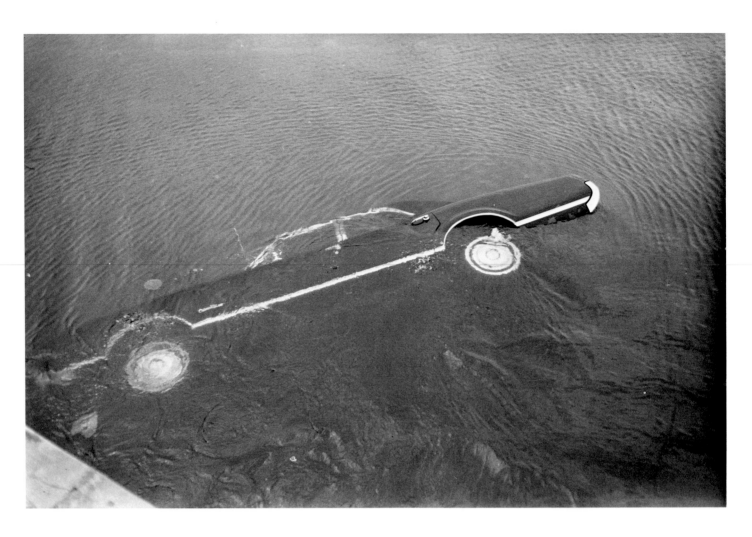

**Kennedy Car off Bridge to Chappa-
quiddick Island, Mass.** July 19, 1969

John Hubbard/Black Star

"Stream of Blood." May 4, 1970

"Kent, Ohio: Blood flowing from a dead
student's head tells the story of a deadly
confrontation between students of Kent
State University and National Guardsmen
today."

*John Filo/Valley Daily News via Associated
Press*

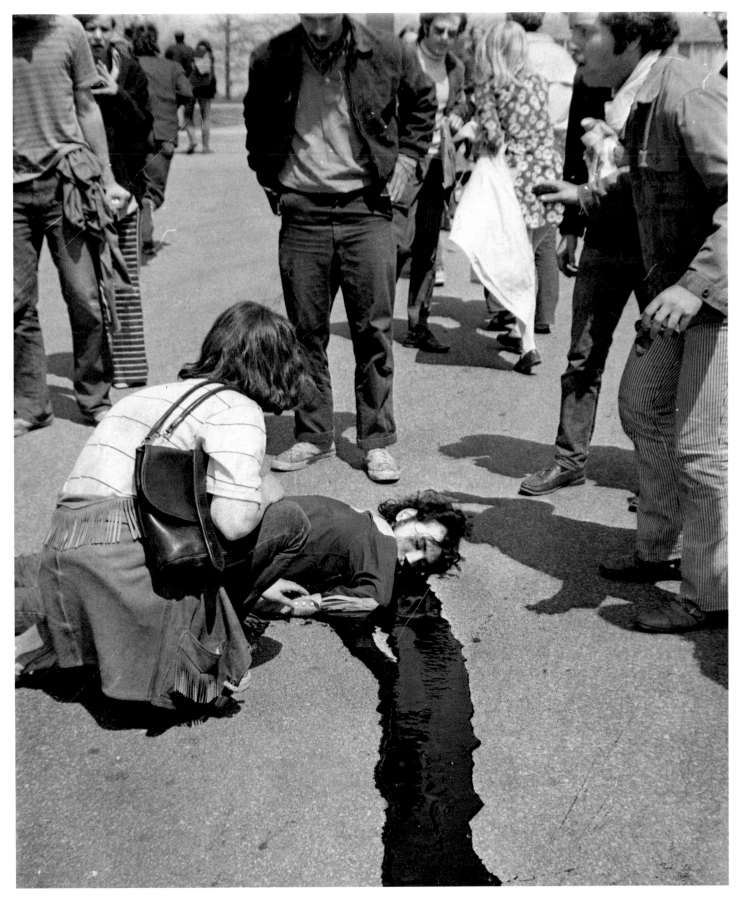

Miss Teenage America. 1971

"Ft. Worth, Tex.: Miss Teenage Columbus, O., Mary C. Fitzpatrick with mouth wide open, has just been named Miss Teenage America for 1972. First runnerup is Mary A. Grabavoy, Miss Teenage Aurora, Ill."

United Press International

"Uniting Their Thoughts." 1971

"U.S. Ambassador George Bush, right fore-
ground, huddles with aides during Secu-
rity Council debate at U.N. on Somalia
resolution on Israeli-occupied Jordanian
sector of Jerusalem. The resolution was
adopted, Sept. 25, by a council vote of 14–0
that Israel halt changes in the status of the
Jordanian sector."

Ray Stubblebine/Associated Press

"Lindsay Tours Garment District."
September 17, 1972

"Mayor Lindsay as he toured the garment district. His guide was Sol Nemowitz, the fashion district's man in City Hall."

Librado Romero/The New York Times

"Knicks-Lakers at Garden." May 8, 1973

"Bill Bradley losing control of the ball as he tried drive around Wilt Chamberlain in Tuesday night's game."

Larry C. Morris / The New York Times

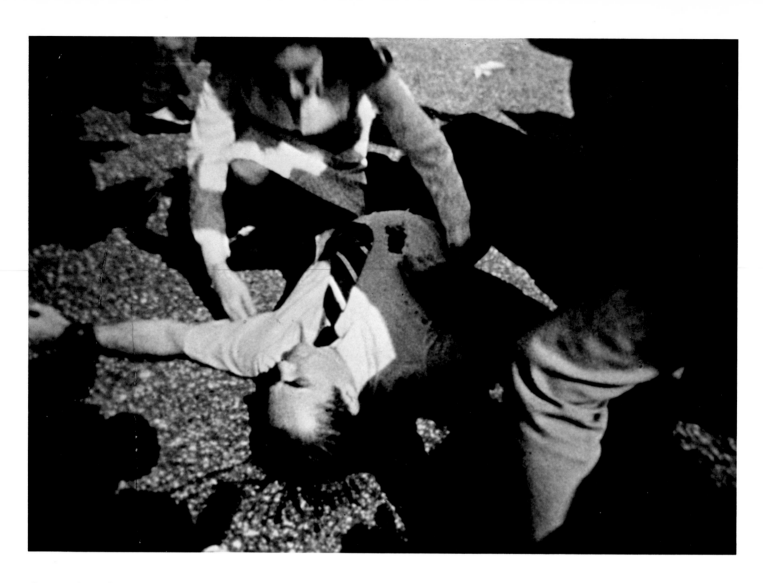

**George C. Wallace Wounded After
Assassination Attempt.** May 15, 1972

*Mike Lien/The New York Times, from CBS
News*

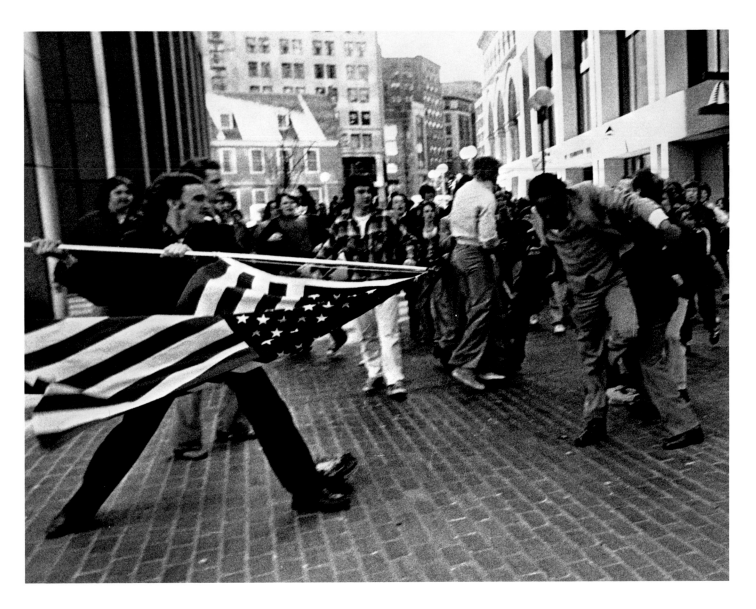

"Violence in Boston." April 5, 1976

"Antibusing demonstrators near City Hall hold Ted Landsmark, executive director of the Boston Contractors Association, while others attempt to strike him with a flag. Mr. Landsmark, who is black, was attacked en route to a City Hall meeting by white students and their parents boycotting school."

Stanley J. Forman/Boston Herald American via Associated Press

"Johnny Weissmuller Giving His Old Jungle Cry for Mayor Beame and Buster Crabbe." September 10, 1976

"[Weissmuller and Crabbe] were honored at City Hall after their election to the World Body Building Guild Hall of Fame."

Neal Boenzi/The New York Times

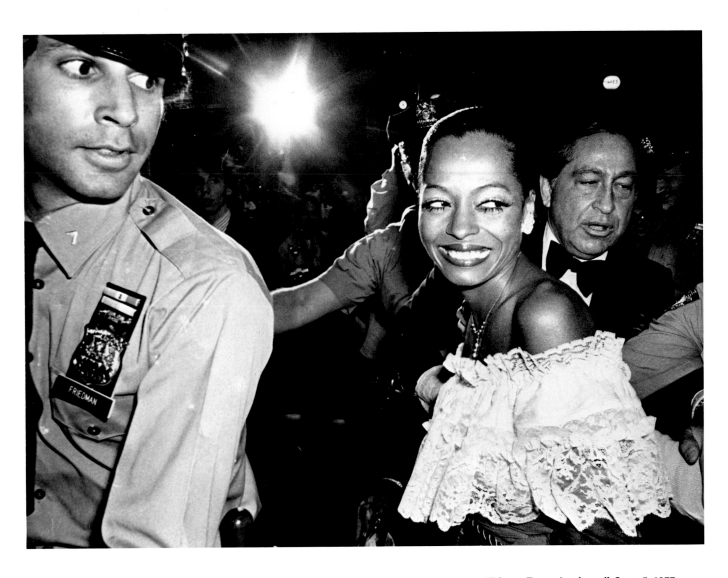

"Diana Ross Arrives." June 5, 1977

"Diana Ross arrives at the Shubert Theater in New York Sunday night, June 5, for the annual presentation of the Tony Awards."

Richard Drew/Associated Press

"Mario M. Cuomo Getting a Hug."
September 20, 1977

"Mario M. Cuomo getting a hug from his
son Christopher yesterday morning as
daughter Madeline read election results [of
his defeat in the mayoral primary] in the
morning newspaper."

Barton Silverman/The New York Times

"Rain Raises Fears of Flooding."
January 25, 1978

"Pedestrians in Times Square wading through a puddle as heavy rains began yesterday. The rain was expected to continue today, melting much of the snow and causing fears of flooding."

Barney Ingoglia/The New York Times

Pope John Paul II Moments After Being Shot. May 13, 1981

"Pope John Paul II, with blood on his left hand, being comforted by aides moments after being shot yesterday as he rode through St. Peter's Square at the Vatican."

Arture Mari/L'Osservatore Romano, Vatican City, via United Press International

"City Opens Its Heart to Freed Hostages." January 30, 1981

"Motorcade moving up Broadway to City Hall Plaza. The view here is south from Cortlandt Street."

Chester Higgins, Jr./The New York Times

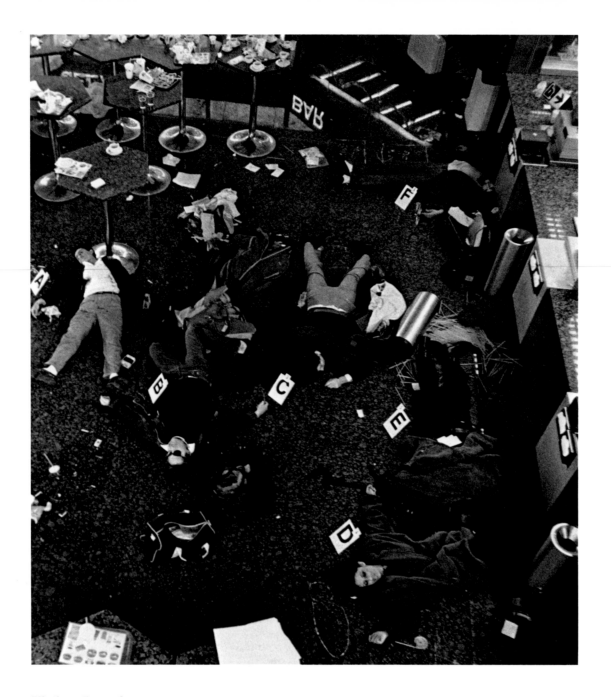

Victims. December 27, 1985

"Seven bodies of men and women on ground at international lounge at Rome's Leonardo da Vinci airport … killed by a commando of Arab rebels. First at left, marked with 'A,' is an unidentified Arab rebel killed by police during the attack at passengers with grenades and submachine gun. The commando killed 13 people and injured 50."

Reuters

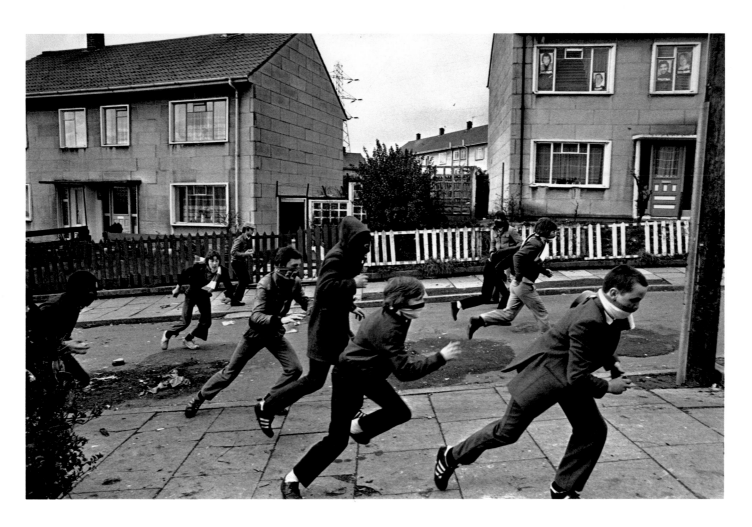

"Riots Erupted Throughout Belfast."
May 5, 1981

"Riots erupted throughout Belfast the day
Bobby Sands died after a 66-day hunger
strike."

Gilles Peress/Magnum Photos, Inc.

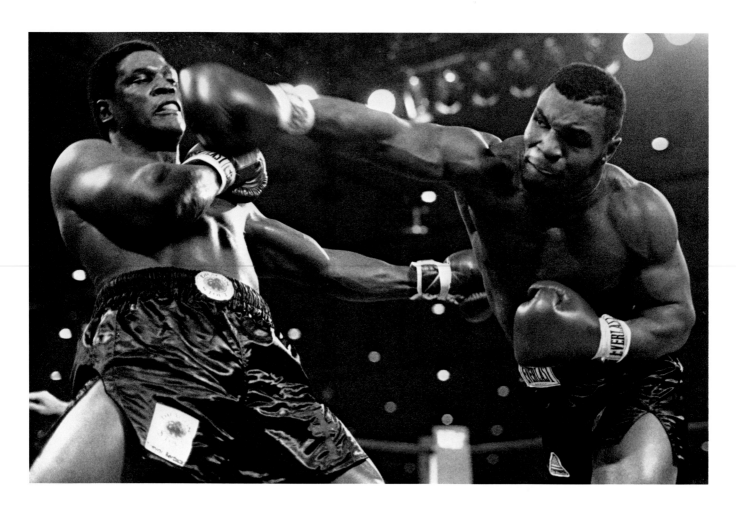

"Deliverance." November 22, 1986

"Mike Tyson, right, delivers a powerful blow to Trevor Berbick in the second round Saturday night in Las Vegas. Tyson became the youngest heavyweight champion shortly after with a TKO."

Douglas C. Pizac/Associated Press

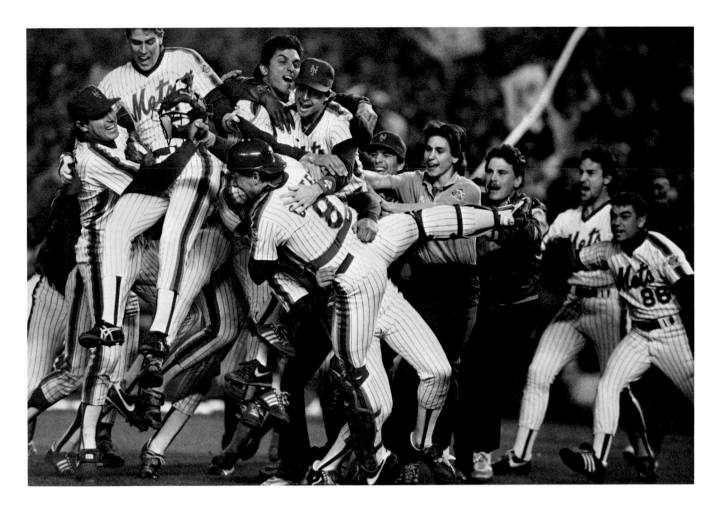

World Series Champions. October 27, 1986

"Gary Carter clasping Jesse Orosco with his left hand and Ray Knight, most valuable player of the series, with his right after Mets won the championship."

Larry C. Morris/The New York Times

"At the Save the Children Party."
November 1981

"Imelda Marcos with Francis Kellogg and
Marylou Whitney."

Bill Cunningham / The New York Times

"Trial Suspended as Bakker Is Committed for Tests." August 31, 1989

"Jim Bakker being escorted from his lawyer's office in Charlotte, N.C., after he was committed for psychiatric testing. His psychiatrist said the evangelist was suffering from hallucinations, and his Federal fraud and conspiracy trial was suspended."

Chuck Burton/Associated Press

"Photo Emerges after Khomeini's Frenzied Funeral." 1989

June 20, 1989: "A photograph taken June 6 at the funeral in Iran of Ayatollah Ruhollah Khomeini and made available to The Associated Press in London yesterday. The emotional outpouring at the funeral reflected both Iranians' grief over the death of the leader who seemed to embody their revolution and the emphasis Shiite Muslims place on martyrdom and death."

Associated Press

"For All, East and West, a Day Like No Other." November 11, 1989

"West Berlin demonstrators tearing down part of the Berlin Wall as East Berlin guards looked on. The guards later put the section back up."

Keith Pannell/Mail on Sunday, London, via Reuters

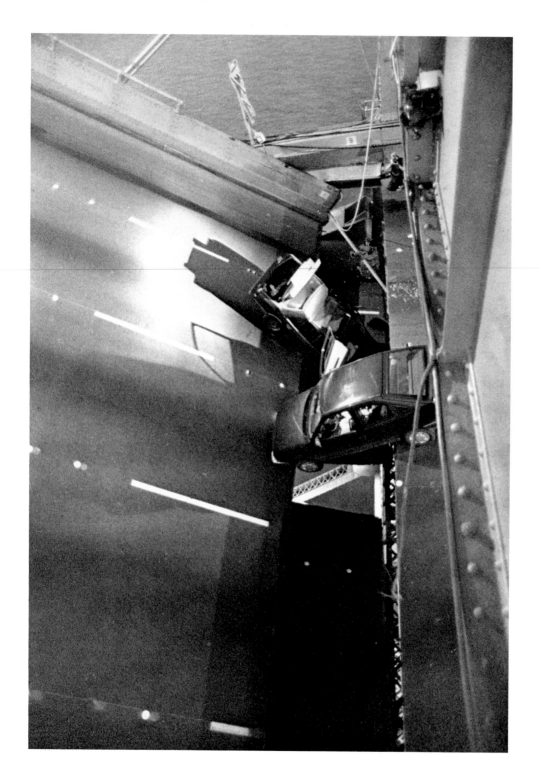

"Earthquake in Northern California."
October 17, 1989

"Wrecked cars that fell off a collapsed section of the Bay Bridge between San Francisco and Oakland during the earthquake."

Kent Porter/The Press Democrat, Santa Rosa, California, via Associated Press

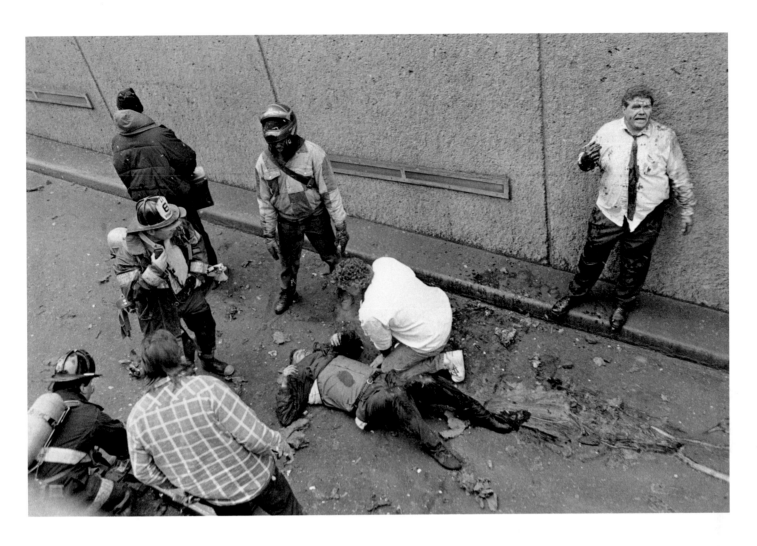

World Trade Center Bombing. February 26, 1993

"A man lay injured from the blast on the ramp leading to the underground garage at Vesey and West Streets."

Marilynn K. Yee/The New York Times

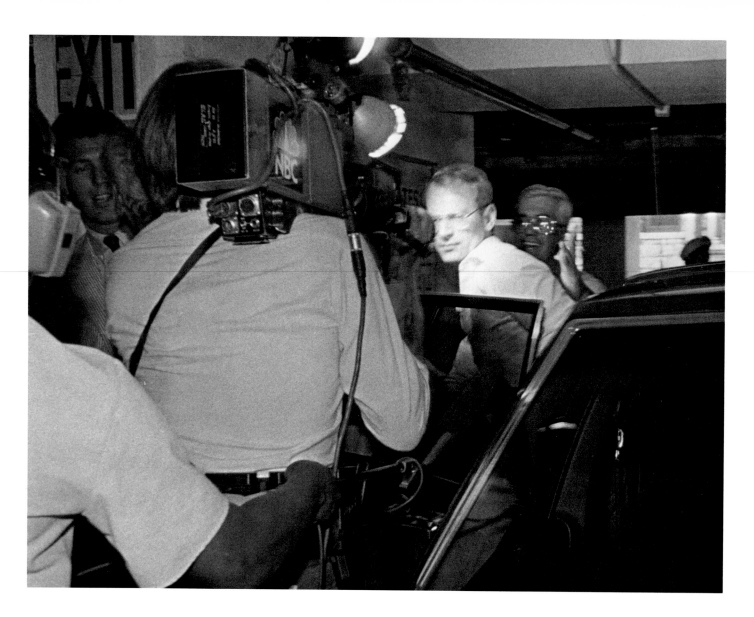

**"Bernhard H. Goetz as He Arrived
Home."** June 16, 1987

"Bernhard H. Goetz was acquitted by a
jury yesterday of the attempted murder of
four teen-agers on a Manhattan subway
train in December 1984. But the jury con-
victed him of illegal weapons possession
for the gun used in the shootings."

Marilynn K. Yee/The New York Times

"Protest on Hold." September 17, 1990

"A Kansas City, Mo., police officer holds an
ACT-UP protester in place while waiting
for handcuffs to arrive. The group of AIDS
activists were protesting a medical con-
vention Monday, claiming the group of
doctors are trying to prevent the use of
alternative treatments for their disease."

Cliff Schiappa/Associated Press

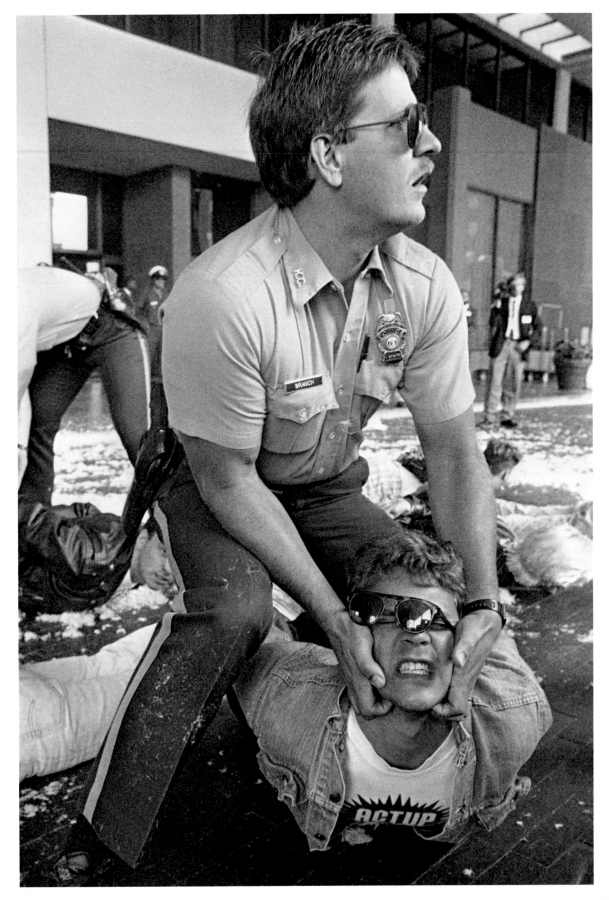

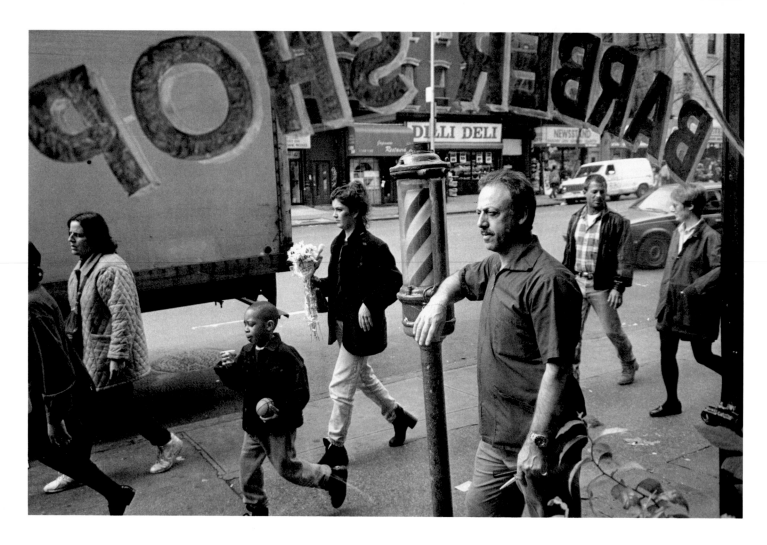

"For a Moment, Leaving a Fast Clip to Others." 1995

April 20, 1995: "Thoughts of flowers and other spring delights pass briskly by Tony Vita on a warm day as he leans against his Rossillo Vita Barber Shop, at 46th Street and Ninth Avenue. Today is expected to be sunny and mild."

Edward Keating/The New York Times

"Lakers at the Knicks." March 10, 1992

"Knicks' John Starks taking a shot above the head of the Lakers' Sam Perkins in the first half."

Barton Silverman/The New York Times

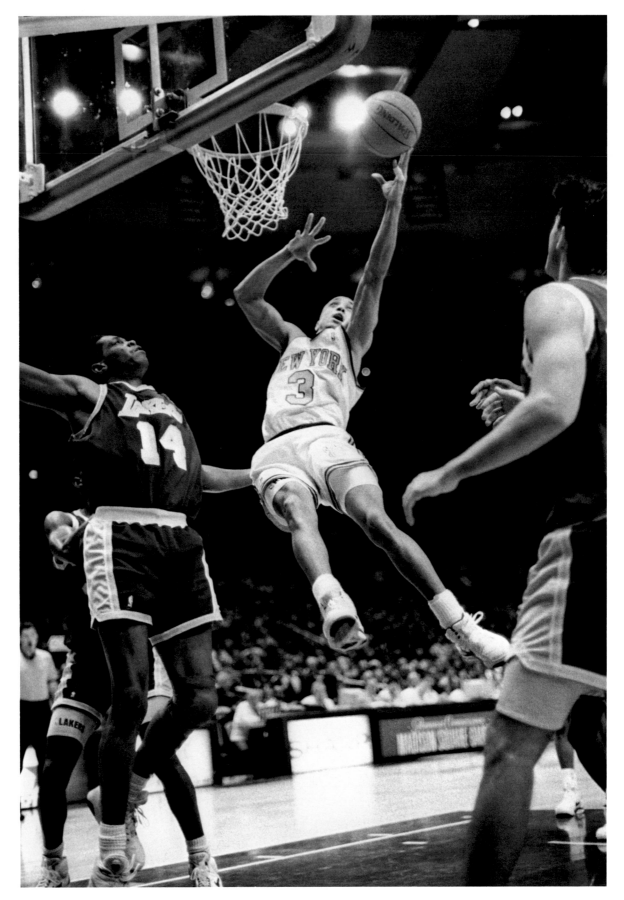

"Two Youths Arraigned on Charge of Scrawling Hate Graffiti." July 16, 1993

"Philip Argiros, left, and Robert A. Rolston were arraigned yesterday on charges that they painted anti-Semitic messages on Commack High School's athletic field last month. They left the Fourth Precinct in Hauppauge, L.I., for arraignment."

Glen Pettit for The New York Times

Sarajevo. October 9, 1995

"Sarajevans gathered to mourn a Bosnian Muslim soldier yesterday at Lion cemetery, as the hours ticked toward a cease-fire that never came."

Fehim Demir/Agence France-Presse

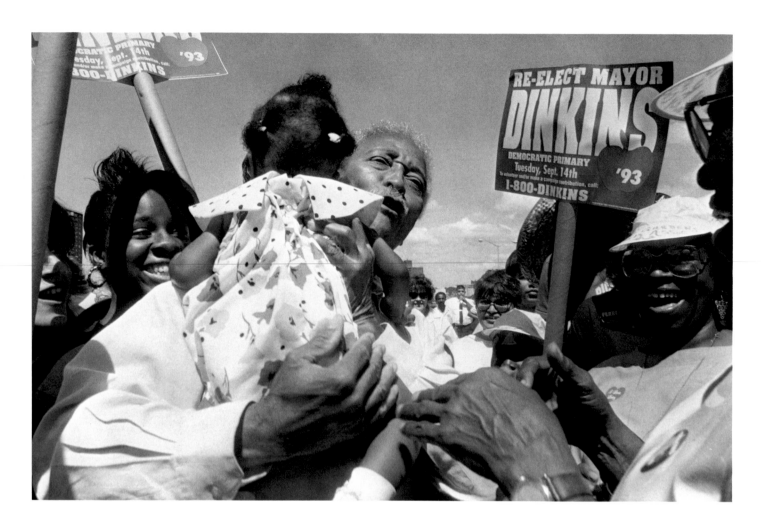

**David Dinkins Campaigns for
Re-election.** August 21, 1993

"As he arrived to attend the rededication
of a small park in the Clason Point section
of the Bronx, Mayor Dinkins was greeted
by supporters."

Susan Harris for The New York Times

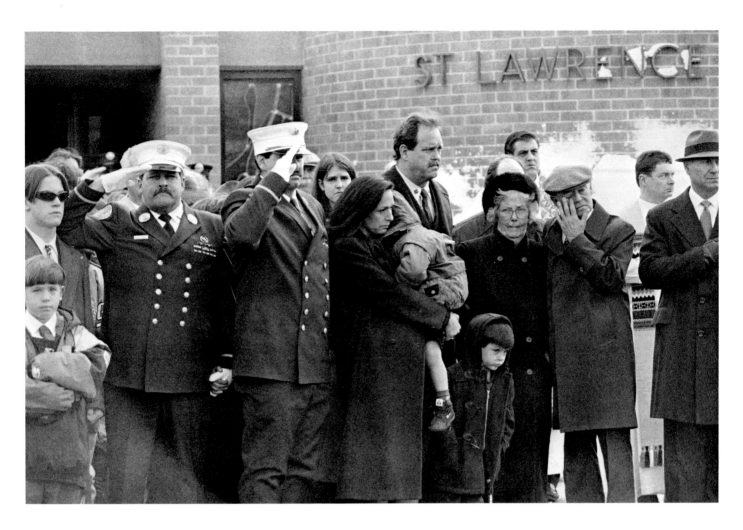

"A City Firefighter's Funeral, in Agonizing Replay." January 10, 1996

Sayville, Long Island, New York: "After the funeral of Firefighter John B. Williams, his wife, Jean, held Matthew, 2. With her, besides another son, James, 4, are Mr. Williams's parents and his brother Ralph."

Vic DeLucia/The New York Times

MID-WEEK PICTORIAL

AN ILLUSTRATED WEEKLY

PUBLISHED BY The New York Times COMPANY

VOL. X., NO. 7. OCTOBER 16, 1919.

PRICE TEN CENTS

HUGE THRONG BEFORE NEW YORK TIMES BUILDING WATCHING THE TIMES REPRODUCTION, PLAY BY PLAY, OF BASEBALL CONTEST BETWEEN CINCINNATI REDS AND CHICAGO WHITE SOX FOR THE WORLD'S CHAMPIONSHIP.

(© Brown Bros.)

Chronology

This synoptic chronology provides a frame of reference for the evolution of newspaper photography in general and at *The New York Times* in particular. Entries principally concerned with the *Times* are in italic type. Emphasis is given to key technological innovations and their applications in the newspaper industry. A short list of sources and related books follows the chronology, which is based largely on research by Virginia Dodier of The Museum of Modern Art and Margarett Loke of *The New York Times*.

At the beginning of the nineteenth century newspaper production was a workshop craft, whose essential techniques had changed little since Gutenberg's invention of moveable type in 1454. By the end of the nineteenth century newspaper production had evolved into a modern factory process, thanks mainly to the advent of mechanical power, the triumph of rotary over flat-bed printing, and the invention of typesetting machines. Further innovations at the turn of the century, which made it possible to reproduce photographs in the newspaper, thus coincided with the rise of modern mass-circulation newspapers.

1810 Daily press capacity of a leading New York newspaper: 900 copies.

1832 The *New York Daily Advertiser* is the first newspaper in the United States to install a steam-driven press. Invented in Germany by Frederick Koenig, the press is capable of printing 2,000 papers per hour.

1839 January 6 — The *Gazette de France* reports the invention of photography.

1840 Daily press capacity of a leading New York newspaper: 21,000 copies.

1842 May — The first weekly picture newspaper, the *Illustrated London News*, is launched by Herbert Ingram. Initially, illustrations are wood engravings based on artists' drawings, not on photographs. On May 28, 1842, the *News* publishes pictures

representing Queen Victoria holding the infant Prince of Wales on her lap in the nursery, provoking protests against invasion of privacy.

1844 May 24 — Samuel F. B. Morse sends the first telegraph message.

1848 May — The Associated Press, a news-sharing cooperative of six New York newspapers—the *Herald*, the *Courier and Enquirer*, the *Journal of Commerce*, the *Tribune*, the *Sun,* and the *Express*—is formed, giving each paper equal access to news dispatches received through the city's sole telegraph wire.

1850 Daily press capacity of a leading New York newspaper: 35,000 copies.

1851 *September 18 — The New-York Daily Times, founded by Henry Jarvis Raymond and George Jones, publishes its first issue.*

1853 The *New York Illustrated News*, financed in part by P. T. Barnum, commences publication under the direction of Henry Carter (a.k.a. Frank Leslie), a former chief of the engraving room at the *Illustrated London News*. The newspaper survives for less than a year but is succeeded in 1855 by *Frank Leslie's Illustrated Newspaper*. As does its London counterpart, the paper reproduces hand-drawn illustrations; eventually many of these are derived from photographs.

1855 Roger Fenton's photographs of the Crimean War are reproduced as wood engravings in the *Illustrated London News*. The original photographs are exhibited and sold in London upon Fenton's return in July. Fenton's example helps to inspire Mathew S. Brady and others to embark on ambitious campaigns to document the American Civil War (1861–65) in photographs. Nevertheless, illustrated periodicals continue to rely on sketches.

1860 Daily press capacity of a leading New York newspaper: 77,000 copies.

Cover of *The New York Times Mid-Week Pictorial* (October 16, 1919).

1860s The introduction of stereotype plates and rotary web presses increases the speed of newspaper production. In the stereotype process a flexible mat, molded from a completed flat page of type, is used as the mold for a curved metal plate. The curved metal stereotype plates, which can be produced in multiples, are then fitted to the cylinders of the rotary press.

Although the Foudrinier process for making paper in a continuous roll or "web" was patented in 1807 and brought to the United States in 1827, sheet-fed presses prevailed until the late 1860s, when leading newspapers began to install presses capable not only of printing from the uncut roll of paper but also of "perfecting," or printing both sides of the paper simultaneously.

1868 June 23 — Christopher Latham Sholes patents the first typewriter.

1870 Daily press capacity of a leading New York newspaper: 85,000 copies.

1876 At the *Philadelphia Times*, R. Hoe & Company installs a press fitted with an attachment capable of folding approximately 15,000 newspapers per hour. Previously, newspapers were folded by hand. For many years, however, the capacity of folding machines lags behind rising press capacity.

1876–77 Alexander Graham Bell patents the telephone.

1880 Daily press capacity of a leading New York newspaper: 147,000 copies.

1880 March 4 — The *New York Daily Graphic*, founded in 1873, is the first newspaper to publish a photographic halftone: "A Scene of Shantytown, New York," from a photograph by Henry J. Newton. Labeled as a "Reproduction Direct from Nature," it appears in a two-page pictorial spread illustrating "Fourteen Variations of the Graphic Process." However, photographic halftones would not begin to appear regularly in any newspaper for nearly two decades.

1883 January 2 — The first widely sold hand-held camera, the Patent Detective camera, is patented by its inventor, William Schmid of Brooklyn, New York.

1886 Ottmar Mergenthaler of Baltimore introduces the Linotype machine, which sets type mechanically. The invention increases the speed of typesetting to a level compat-

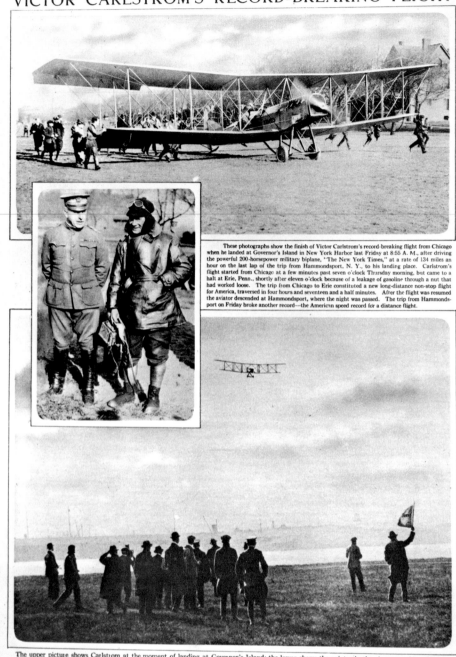

THE NEW YORK TIMES MID-WEEK PICTORIAL

THURSDAY, NOVEMBER 9, 1916.

VICTOR CARLSTROM'S RECORD-BREAKING FLIGHT

These photographs show the finish of Victor Carlstrom's record-breaking flight from Chicago when he landed at Governor's Island in New York Harbor last Friday at 8:55 A. M., after driving the powerful 200-horsepower military biplane, "The New York Times," at a rate of 134 miles an hour on the last lap of the trip from Hammondsport, N. Y., to his landing place. Carlstrom's flight started from Chicago at a few minutes past seven o'clock Thursday morning, but came to a halt at Erie, Penn., shortly after eleven o'clock because of a leakage of gasoline through a nut that had worked loose. The trip from Chicago to Erie constituted a new long-distance non-stop flight for America, traversed in four hours and seventeen and a half minutes. After the flight was resumed the aviator descended at Hammondsport, where the night was passed. The trip from Hammondsport on Friday broke another record—the American speed record for a distance flight.

The upper picture shows Carlstrom at the moment of landing at Governor's Island; the lower shows the aviator in the air approaching the landing-place; in the panel are Major-General Leonard Wood (left), who officially received the aviator, and Carlstrom (right), just after he landed. (Photo © by Underwood & Underwood.)

ible with the speed of rotary presses, thus establishing the necessary conditions for the modern era of mechanized newspaper production.

1887 In Germany Adolf Miethe and Johannes Gaedicke invent flashlight powder. Placed in a metal tray and ignited by an explosive cap, it produces a brilliant burst of light. A less combustible mixture is produced in the United States by Henry G.

Page from *The New York Times Mid-Week Pictorial* (November 9, 1916). The lower photograph is reproduced on page 33.

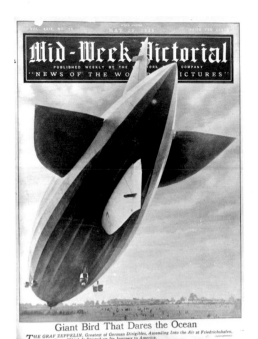

Cover of *The New York Times Mid-Week Pictorial* (May 25, 1929).

Piffard and is used by Piffard, Jacob Riis, and Richard Hoe Lawrence to make indoor photographs. Hand-drawn illustrations after photographs by Piffard and Lawrence are published to accompany Riis's article, "Flashes from the Slums: Pictures Taken in Dark Places by the Lightning Process," in the New York *Sun*, February 12, 1888.

1888 George Eastman introduces the Kodak, a simple roll-film camera, to what would become a vast amateur market.

1890 Daily press capacity of a leading New York newspaper: 300,000 copies.

1891 August 23 — The first photographic halftone to appear in a mass-circulation newspaper is published by the New York *Morning Journal*. Because high-speed rotary presses cannot accommodate the halftone process, the picture is printed separately and inserted into the paper.

1892 April — Walter Scott & Co. install the first four-color rotary press in the United States at the *Chicago Inter-Ocean*. The following year the company installs a five-color rotary press at the New York *World*. Other newspapers, eager to boost circulation, also soon introduce color in the comics and other illustrations, giving rise to the epithet "yellow journalism."

1895 The Bain News Picture Service, the first photographic agency in the United States, is established. • *Collier's Weekly* adds "An Illustrated Journal" to its title and begins to make extensive use of photographic halftones.

1896 The Underwood & Underwood photographic agency is established. • Guglielmo Marconi patents a radiotelegraphy transmitting and receiving system, which he brings to the U.S. in 1899.

1896 *August 18 — Adolph Simon Ochs, the thirty-eight-year-old publisher of the* Chattanooga Times, *purchases* The New-York Times. *The newspaper's daily circulation stands at 9,000. Ochs initiates improvements in the paper's design and printing and increases the number, size, and complexity of its illustrations.*

1896 *August 19 — The first edition of the* Times *under Ochs is published. A "Business Announcement" on the editorial page declares that under the new publisher the paper*

will "give the news impartially, without fear or favor."

1896 *September 6 — The* Times *publishes the first issue of its illustrated Sunday magazine. On page one are the first photographic halftones to appear in any part of the* Times: *portraits of Stephen A. Douglas and John Bell, both candidates for the presidency in 1860.*

1896 *December 1 — The hyphen in* The New-York Times *is dropped from the masthead.*

1897 January 21 — The New York *Tribune* successfully adapts photomechanical reproduction to the requirements of its high-speed rotary web perfecting presses. Photographic halftones, an occasional novelty before this achievement, soon become a regular feature in mass-circulation newspapers.

1897 *July 4 — The* Times *Sunday magazine reproduces forty-two photographs of Queen Victoria's Jubilee.*

1898 February 15 — The battleship U.S.S. *Maine* is blown up in Havana harbor and "Remember the *Maine*" soon becomes a rallying cry in the Spanish-American War, declared in April 1898. Hearst's *Journal* and Joseph Pulitzer's *World* compete fiercely for readers, making extensive use of illustrations derived from photographs in their dramatic coverage of the war. Photography is thus enlisted in a wave of sensationalism aimed at boosting circulation.

1898 *October 10 — The* Times *drops the price of its weekday and Saturday editions from three cents to one and drastically reduces the number of illustrations. These measures address a precipitous decline in circulation due to the inability of the* Times *to compete with the* Journal *and the* World *in their lavish coverage of the Spanish-American War. Within twelve months, daily circulation of the* Times *rises from 25,726 to 76,260 copies.*

1899 *September 10— The* Times *cuts the price of its Sunday edition from five cents to three. In a further effort to cut costs, the paper suspends publication of the illustrated Sunday magazine.*

1900 Daily press capacity of a leading New York newspaper: 1,000,000 copies. • Approximately forty percent of the illustra-

tions in New York daily newspapers are photographic halftones.

1900 *January 28 — The first photograph to appear in the* Times *outside the Sunday magazine is reproduced as part of a real-estate advertisement for an apartment building.*

1901 *June 2 — The* Times *resumes publication of the Sunday magazine.*

1904 *February 14 — Carr Vattel Van Anda, the forty-year-old assistant managing editor of the* Sun, *becomes the managing editor of the* Times. *Over the next two decades he plays a leading role at the newspaper.*

1904 *February 28 — A photograph illustrating a* Times *news story is printed for the first time in the newspaper proper, that is, outside the Sunday magazine. Appearing in the second section of the newspaper, the picture is a radiograph accompanying a story on radioactive metals. Sports photographs—group portraits of teams—also soon appear in the* Times *for the first time.*

1904 *April 8 — New York City's Long Acre Square, extending from Forty-second to Forty-seventh Street at the intersection of Broadway and Seventh Avenue, is renamed Times Square.*

1904 *April 14 — The first on-the-spot wireless dispatch—a* Times *exclusive in the United States—reports the opening salvos of the Russo-Japanese War.*

1905 In Munich Alfred Korn invents a system for transmitting photographs by wire.

1905 *January 1 — Overnight, the* Times*'s twenty-seven Mergenthaler Linotype machines are moved from 41 Park Row to the Times Tower at Broadway and Forty-second Street in Times Square. Already in place are eleven new Linotype machines and four Hoe octuple presses, which can throw off, fold, and count 144,000 sixteen-page papers per hour.*

1905 *January 22 — The* Times *introduces a four-page Sunday broadsheet pictorial section, printed on a superior grade of paper to achieve photographic reproductions of higher quality.*

1905 *September 17 — The Sunday pictorial section is expanded to eight pages, and its coverage of domestic and international news grows. Although photographs remain rare*

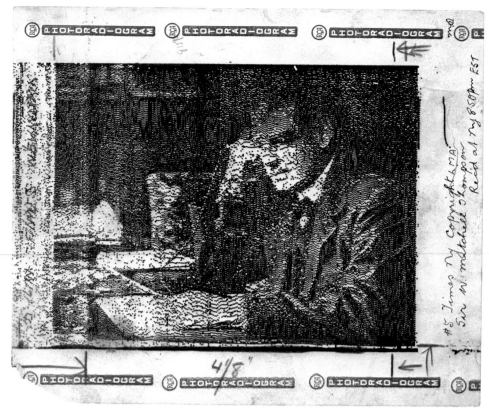

Sir W. Mitchell Thompson. c. 1926. *RCA Photoradiogram.*

in the principal news section, they proliferate in the Sunday feature sections.

1907 June 21 — United Press (UP), later United Press International (UPI), is founded by Edward Wyllis Scripps to transmit news dispatches by wire. Agencies such as UP and the AP are the principal sources of up-to-the-minute news stories before the advent of radio.

1907 *October 18 — The* Times *is the first newspaper to receive a regular news-service dispatch by radiotelegraphy, from the Marconi Wireless Telegraph Company.*

1910 *The number of photographs in a typical edition of the* Times *is approximately one-third the average for the major New York daily newspapers. • John Metzger, a member of the* Times *advertising department and an amateur photographer, makes a photograph of a dress to illustrate an advertisement, at the request of the advertiser. Eventually he becomes the newspaper's first staff photographer.*

1910 *May 30 — A photograph appears on the front page of the* Times *for the first time. The picture shows aviator Glenn H. Curtiss taking off from Albany on the first non-stop flight to New York City. The* World *had inspired the flight by offering $10,000 to the first*

"Captain Richard H. Ranger—Inventor."
1924. "The inventor examining a photograph which has just been made by the receiving equipment following the [radio] transmission of the original photograph. Note the delicate mechanism required at the receiving end." *Thomas Coke Knight/RCA.*

"An Unhappy Landing High on a Mountain Side in the Snow-blanketed Adirondacks." December 31, 1934. *Associated Press.* The first photograph to be transmitted over the AP Wirephoto network, on January 1, 1935.

person to make it, but had tired of Curtiss's delays. At the Times, *however, managing editor Van Anda prepared his paper's scoop by hiring a train, from which* Times *reporters and a photographer from the Pictorial News Company followed Curtiss's progress.*

1910 November — The first newsreel, the Pathé Weekly (later known as Pathé News), is produced by Herbert Case Hoagland.

1912 The Folmer and Schwing division of Eastman Kodak introduces the Speed Graphic camera. Using four-by-five-inch sheets of film, it produces large negatives, rich in precise detail. Fitted with a flash-gun, it becomes the standard camera of the press photographer from the late 1920s through the 1950s.

1913 *February 3 — Outgrowing the Times Tower, the* Times *moves its main operations to the Times Annex on 229 West Forty-third Street, to this day its principal location.*

1914 *April 5 — Making the first use of new rotogravure presses imported from Germany, the* Times *issues a special section of reproductions of thirty-eight paintings in the Altman Collection at The Metropolitan Museum of Art. A note in the newspaper states that the high quality of the rotogravure reproductions "encourages the belief that this new method of printing will be in the future very freely employed in the production of this newspaper."*

1914 *September 9 — The* Times *launches the rotogravure* Mid-Week Pictorial War Extra, *making use of a massive outpouring of photographs issued throughout the Great War in Europe by agencies such as Underwood & Underwood and Brown Brothers. The twenty-four page publication is sold separately at newsstands for ten cents. On November 5, 1914, a* Times *advertisement urges, "START A COLLECTION OF WAR PICTURES. Start now to collect these magnificent illustrations of current history, the camera's story of churches in ruins, soldiers in trenches, sacked villages, fleeing refugees, armies on the march, faithfully portraying, week after week, the progress of the war. They will be treasured in years to come as no other souvenir of the conflict."*

1915 *February 11 — The* Times *drops the words "War Extra" from the* Mid-Week Pictorial, *which soon includes photographs on a wide range of themes.*

1916 *The average daily circulation of the* Times *for the year is 331,918; Sunday, 377,095.*

1917 *The New York Times News Service is founded.*

1919 June 26 — America's first picture tabloid, the New York *Daily News* (initially the *Illustrated Daily News*), commences publication.

1919 *October 1 — The Times Wide World Photos syndicate is established to make photographs, to gather them for the* Times *from many sources around the world, and to distribute them to other newspapers. By the late 1920s Times Wide World Photos has bureaus in Boston, Chicago, Washington, London, Paris, Frankfurt, Rome, and Vienna. C. M. Graves is named director and John Metzger is named production manager of Times Wide World Photos. Previously, as the* Times's *sole picture editor, Graves was responsible for purchasing photographs from agency sources.*

Early 1920s Wire transmission of photographs begins between London and New York, over the Bartlane Cable system.

1921 August 5 — French inventor Edouard Belin demonstrates the Belinogramme system for wireless transmission of photographs.

1922–25 *The* Times's *staff of photographers grows with the hiring of William Eckenberg (1922), Ernie Sisto (1923), and Sam Falk (1925).*

1923 March 3 — The first issue of *Time* magazine is published.

1924 May 19 — Photographs are transmitted for the first time over American Telephone and Telegraph Company lines, from Cleveland, Ohio, to New York City.

1925 In Germany the Leitz company markets the Leica, a compact, hand-held camera that uses 35mm roll-film originally manufactured for the motion-picture industry. Although 35mm cameras rapidly become popular with European photojournalists, they do not begin to replace the Speed Graphic in American newspaper photography until the 1950s.

1925 April 4 — AT&T's Telephoto service, the first commercial system for transmitting

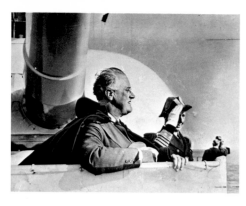

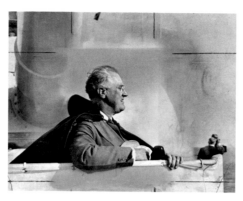

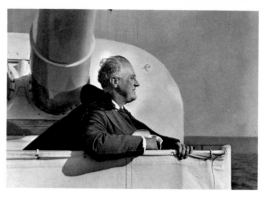

photographs over telephone wires, opens with links in New York, Chicago, and San Francisco. Access to the single line in each city is limited and expensive, and results of transmissions are often blurry.

1926 *May 1 — The first commercial radio photograph transmitted from London appears on page one of the* Times. *It is a picture made three days earlier at a dinner held in honor of the Marquess of Reading, the retiring Viceroy of India. Because of inclement weather the transmission requires nearly two hours, although trial transmissions had been as brief as twenty minutes.*

1926 *May 29 — The first aerial photograph made at the North Pole, by Lieutenant Commander Richard E. Byrd, is transmitted from London to New York by radio and appears on page one of the* Times.

1927 The Associated Press News Photo Service is initiated. It delivers photographs to newspapers by train or airplane.

1928 *June 29 — The* Times *installs a high-speed Wood press capable of printing 50,000 thirty-two-page newspapers per hour.*

1930 Flashbulbs (with a range of ten to twelve feet) are introduced to the U.S. market by General Electric.

1933 June — AT&T's Telephoto service, opened in 1925, is discontinued after sustaining heavy financial losses.

1935 January 1 — The Associated Press Wirephoto network is inaugurated, transmitting photographs of New Year's celebrations to forty-seven metropolitan newspapers throughout the country. The network enables rapid nationwide exchange of news photographs and establishes links with picture services in Europe, South America, and Australia.

1935 *February 14 — Only a day after the Navy dirigible* Macon *explodes in San Francisco, pictures of the survivors are reproduced in the* Times. *The first photographs transmitted over regular long-distance telephone lines, they bear a new* Times *credit line: "WWW Photo" (Wide World Wired Photo). The creation of Wide World Wired Photos has arisen from Ochs's concern during the previous year that the impending inauguration of the AP Wirephoto network would adversely affect Times Wide World Photos, which had no wirephoto facilities. Ochs's son-in-law, Arthur Hays Sulzberger, proposed that the* Times *develop its own facsimile system using ordinary telephone lines. G. V. Dillenback, who subsequently designed the system with Austin G. Cooley under contract with the* Times, *was testing his transmitter in San Francisco when the* Macon *exploded.*

Before wire transmission, photographs were sent to the United States from Europe by ship. In New York harbor, speed boats hired by Times Wide World Photos, the International News Service, UPI, and other agencies, distinguished from one another by the colors of their banners, retrieved packets of photographs dropped from the incoming ships. Even after the advent of wirephotos, incoming ships from Europe remain important for photographers, who are dispatched regularly to make pictures of arriving celebrities.

1935 *April 8 — Adolph S. Ochs dies at age seventy-seven.* Times *daily circulation is approximately 465,000; Sunday, 713,000.*

1935 *May 7 — Arthur Hays Sulzberger becomes president and publisher of the* Times.

1936 *October 3 — The* Mid-Week Pictorial *makes its last appearance as a* Times *publication, having been sold to Monte Bourjaily.*

1936 November 23 — The first issue of *Life* magazine is published.

"F.D.R. Reviewing Fleet off San Francisco." July 16, 1938. *Joe Rosenthal/Times Wide World Photos.* Three prints of the same photograph, altered by airbrush retouching; all appeared in the *Times* between 1938 and 1945 (see page 79).

"The Louisiana 'Kingfish' Ready for the Fray." June 21, 1932. "Senator Huey P. Long talking with reporters and full of fight over a delegation contest." *Times Wide World Photos.* The radical cropping of the photograph is common in newspaper use.

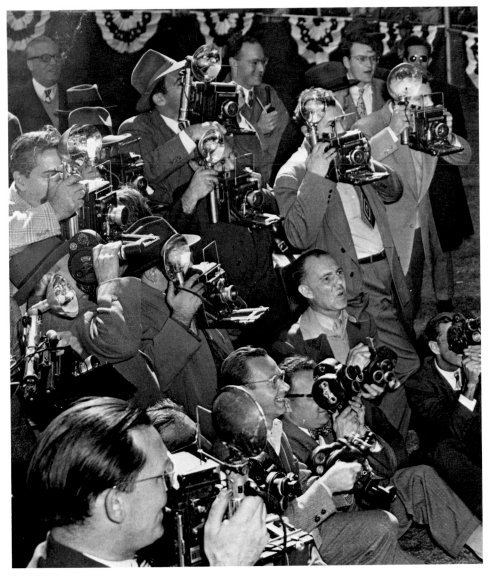

"Press Photographers at Work." 1949. *The New York Times*. Detail of a photograph showing photographers and cameramen covering the appearance of an unidentified politician at a baseball game. The still cameras are Speed Graphics.

newspapers and other publications around the world.

1940 Photographs now occupy approximately one-third of the news and editorial space of the typical metropolitan daily newspaper in the United States.

1941 *July 25 — Times Wide World Photos is sold to the Associated Press. Following the sale, the Times Facsimile Corporation is founded. During World War II, Times Facsimile supplies the Allies with equipment for the transmission of pictures of attack targets.*

1942 *February 15 — The* Times*'s Sunday rotogravure section is made part of the Sunday magazine.*

1945 *At the conclusion of World War II, the* Times *reopens its European photo bureaus and develops the Times Photo Service, which offers five-by-seven-inch news photographs to*

1946 The National Press Photographers Association is founded. • Ten thousand television sets are sold in the United States.

1947 *October 18 — The* Times *Picture Library—161 filing cabinets holding more than two million photographs—is moved to the eighth floor of the new Forty-fourth Street building abutting the Times Annex. The* Times *staff of photographers now numbers eleven. In addition to Eckenberg, Sisto, and Falk, they are Pat Burns (hired 1926), George Alexanderson (1929; stationed in China), Arthur Brower (1935), George Tames (1945; stationed in Washington, D.C.), Meyer Liebowitz (1945), Carl T. Gossett, Jr. (1946; stationed in the Middle East), Frederick Sass (1946), and Eddie Hausner (1946). At least six photographers are out on the street each day, four assigned to news stories, two covering sports events. The picture desk now includes the day and night picture editors and three caption writers.*

1948 *With a staff of more than one hundred, the* Times *Facsimile Corporation is the world's largest manufacturer of facsimile equipment.*

1949 One million television sets are sold in the United States.

1950 *Lacking adequate space to store negatives, the* Times *returns them to current staff photographers; the majority of unclaimed negatives are destroyed. • The* Times*'s commercial picture service in Europe, maintained for nine years following the sale of Times Wide World Photos, is discontinued.*

1951 Ten million television sets are sold in the United States.

1951 *November 28 — For the first time, all* Times *daily photographers are assigned to a single story. At 10:33 A.M., "Red Alert" is sounded for the first city-wide daytime air raid drill in the event of a nuclear attack.* Times *photographers fan out through the city and a picture by each appears in the following day's paper, including one on the front page.*

1953 *January 20 — From a basement darkroom in the State Department building, twenty-eight photographs of President Dwight D. Eisenhower's inauguration are*

filed by telephone facsimile transmission to the Times *photo lab in New York. The photo credit, appearing for the first time the next day, is "The New York Times Facsimile Transmission."*

1954 *February 1 — John Radosta becomes picture editor of the* Times. *Although staff photographer Sam Falk occasionally uses smaller, roll-film cameras, the four-by-five-inch Speed Graphic sheet-film camera, introduced in 1912, remains the standard in newspaper photography. Conscious of the success, in* Life *and* Look *magazines, of photographs made with 35mm roll-film cameras, such as the Contax and Leica, and 120 roll-film cameras, such as the Rolleiflex, Radosta encourages his photographers to adopt the smaller cameras.*

1956 *March 31 — Average daily circulation of the* Times *for the preceding six months is 570,693; Sunday, 1,230,067.*

1956 Wire-service photographers switch from four-by-five-inch to 35mm camera formats during the 1956 presidential conventions, in response to the candid style of reporting that has become popular in the magazines.

1957 Russell A. Kirsch and colleagues at the National Bureau of Standards construct a drum scanner that translates a photographic image into digital code. They are able to store the code in a computer's memory and to program the computer to produce oscilloscope displays derived from the code.

1960s Photocomposition ("cold type") begins to replace Linotype composition ("hot metal") in newspaper production, radically increasing the speed of typesetting. The innovation accompanies and hastens the advent of offset lithography as the standard process for printing large metropolitan newspapers. In the prior letterpress process, the ink is carried on metal forms in relief. In offset lithography, the ink is carried by a photosensitized plate mounted on one cylinder and transferred (hence "offset") to a rubber blanket mounted on a second cylinder, which in turn transfers the ink to paper.

1960 August 18 — A photograph of President Eisenhower, radioed from a dish antenna in Cedar Rapids, Iowa, to the satellite Echo 1, one thousand miles away, is received by AP Wirephoto equipment in Dallas,

Texas. It is the first photograph to be transmitted via satellite.

1961 *April 24 — Orvil E. Dryfoos becomes publisher of the* Times.

1962 July 10 — The United States launches AT&T's Telstar satellite, which enables live transmission of pictures between the United States and Europe.

1963 *June 21 — Arthur Ochs Sulzberger becomes publisher of the* Times.

1967 *February 21 — Until this date a period followed the name of* The New York Times *on the masthead.*

1967 *May 29 — John Morris replaces John Radosta and becomes the* Times's *first picture editor with extensive prior experience in photojournalism. His tenure spans eight years. For the first time, the picture editor not only furnishes photographs to the news editors but is granted a role in choosing which pictures are used in the main news section as well as on the front page of the second section.*

In order to reduce the picture desk's dependence on photographs from the AP and UPI, Morris begins to assign both staff and freelance photographers to page-one stories and to persuade editors to make room for larger spot-news photographs. Previously,

"Time Exposure." 1957. "Between them (left to right) Bill Eckenberg, Ernie Sisto, Sam Falk, Pat Burns and Mike [Meyer] Liebowitz have 162 years of shutter-snapping for The Times. They rigged their own shot." *The New York Times.* The cameras are Speed Graphics.

"World Series Coverage." October 1956. "Little Leaguer Ricky Brower tense beside his father, Art Brower." *The New York Times.* The Big Bertha camera, used by *Times* photographers for baseball photographs, such as those by Ernie Sisto and Pat Burns on pages 110–113.

"Rough Stuff." August 1968. "[*Times* photographer] Bart Silverman [center], chasing after riot pictures [at the Democratic National Convention], is intercepted by Chicago's blue-helmeted cops and shoved into paddy wagon." *Don Hogan Charles/The New York Times.*

the Times *occasionally printed individual credits to staff photographers; Morris establishes such credits as the norm.*

Within two years Morris moves the staff photographers and their darkroom from The New York Times *Photo Studio on the ninth floor to the newsroom on the third floor. For decades the Photo Studio, with its own stable of photographers, has operated as a commercial portrait studio and has made fashion and feature photographs for the Sunday magazine and style sections, as well as portraits for the daily news sections.*

1967 *September 18 — The* Times *introduces a new design of the front page of the second section. Prepared by Arthur Gelb, metro editor, George Cowan, senior designer, and John Morris, the new design favors large, dramatic pictures.*

1968 *August 26 — The* Times *assigns five staff photographers—Neal Boenzi, Don Hogan Charles, William E. Sauro, Barton Silverman, and George Tames—to cover the Democratic National Convention in Chicago. Prior conventions have been covered by a single photographer.*

1969 President Nixon's press office coins the phrase "photo opportunity" to describe the brief, highly controlled sessions at which press photographers are permitted to make pictures of the president.

1969 The New York Times *Photo Studio discontinues its commercial operations but con-*

tinues to make pictures for the newspaper and to perform darkroom work for Times staff photographers until the mid-1990s.

1970 *September 21 — The* Times *henceforth devotes the page opposite the editorial page to commentary, often by writers not associated with the paper. The Op-Ed page frequently includes illustrations, occasionally photographs.*

1973 The U.S. Defense Advanced Research Projects Agency initiates a research program aimed at developing communications protocols that would enable networked computers to communicate across multiple, linked networks. The system of networks that emerges from the program comes to be called the Internet.

1976 *Reporters and editors at the* Times *begin using computer terminals linked to each other through a mainframe computer.*

1976 *March 31 — Average daily circulation of the* Times *for the preceding six months is 841,476; Sunday, 1,475,430.*

1976 *April 30 — Introducing the Weekend entertainment section on Friday, the* Times *begins the transformation of the daily editions from two sections to four.*

1976 *September 7 — The* Times *is redesigned. The new six-column format, replacing the previous eight-column page, favors expanded use of photographs.*

1977 The AP introduces Laserphoto. New receiving devices use lasers to print photographs transmitted over the Wirephoto network. Dispensing with the chemistry and time-consuming processing steps required by earlier devices, Laserphoto makes prints on 3M dry silver paper, on which the image is formed by a brief application of heat.

1978 *July 3 — The* Times *completes its conversion from Linotype to photocomposition. At the same time, the newspaper switches from letterpress printing to offset lithography.*

1978 *November 14 — With the inauguration of Science Times, the* Times *completes its transformation of the daily editions from two sections to four. The sections are A, for international and national news; B, for metropolitan and general news, fashion, and family features; D, for business and financial*

 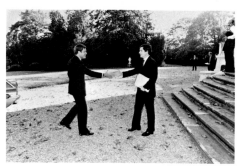

news; and C, devoted to a different theme each day: Sports Monday; Science Times on Tuesday; Living on Wednesday; Home on Thursday; and Weekend on Friday. The front page of the C section features large photographs or other illustrations.

1980 *August 18 — The first national edition of the* Times *is printed in Chicago. The newspaper is composed in New York, transmitted via microwave link to the* Times *printing plant in Carlstadt, New Jersey, and then via satellite to the* Southtown Economist *plant in Chicago. The national edition subsequently is printed as well in California, Florida, Georgia, Ohio, Texas, and Washington.*

1981 The IBM Personal Computer and the Microsoft MS-DOS operating system are introduced. By means of modems, users of IBM PCs and other small computers are soon able to communicate with each other over ordinary telephone lines. • Sony demonstrates a prototype of the Mavica, the first still-video camera. It captures the image electronically and records it in an analog format, which must be converted to a digital format in order to be processed by a computer. Although the Mavica has limited market success, it paves the way for higher-resolution digital cameras.

1982 The AP introduces Laserphoto II, the first network capable of transmitting photographs by satellite, as well as over ordinary telephone land lines and microwave links. Designed to facilitate the distribution of photographs in color, the network requires half an hour to transmit three black-and-white separations of the color image, which correspond to the cyan, magenta, and yellow plates used in color printing. Laserphoto II operates side-by-side with the existing Laserphoto network until both are superseded by the PhotoStream system in 1991.

1982 September 15 — Gannett launches *USA Today*, the first major newspaper to

make extensive use of color photography and graphics. Popular with both advertisers and readers, its high-quality color reproductions soon encourage other newspapers to expand their use of color. Conceived as a national newspaper without a regional focus, *USA Today* soon is printed simultaneously in different locations from page files transmitted from the newspaper's headquarters in Arlington, Virginia.

1983 The AP patents a small digital image scanner whose portability facilitates the transmission of photographs from remote locations.

1984 Apple Computer introduces the Macintosh, the first popular personal computer using bit-mapped display technology and an operating system built around a graphical user interface, rather than the more limited character-based operating and display systems used by the IBM PC and other desktop computers. Able to handle photographic images, graphics, and a wide variety of type fonts, the Macintosh soon plays a pivotal role in the rise of computer graphics and digital imaging.

1985 Adobe Systems introduces the PostScript computer language, which is able to communicate precise digital descriptions of computer-generated type fonts, graphic elements, or page layouts to a variety of output devices, including laser printers and the imagesetters that expose the negatives from which newspaper printing plates are made. • The Aldus Corporation (acquired by Adobe in 1994) introduces PageMaker software for the Macintosh. Incorporating PostScript capability and provided with Adobe PostScript type fonts, PageMaker enables the Macintosh to function as a full-fledged typesetting and page-layout system. • Macintosh users are now able to incorporate scanned and digitized photographic images into their documents at a level of quality roughly equivalent to newspaper reproduction. • Apple Computer introduces the

Photo Opportunities. October or November 1985. *Dirck Halstead.* President Ronald Reagan and Mikhail S. Gorbachev, the Soviet leader, met for the first time in late November 1985 at the Villa Fleur d'Eau at Versoix, Switzerland. A few weeks before the meeting, photographer Dirck Halstead of *Time* magazine visited the site with a White House advance team in order to stage likely photo opportunities, with White House aides standing in for the summit protagonists. Halstead was serving as a representative of an informal association of photographers formed to cooperate with the Reagan Administration in covering the president's appearances abroad. His advance pictures and notes were distributed to colleagues to help them prepare for the actual events. Halstead made the following notes for the advance photographs shown here.

Left: "Outside the Maison du Saissure (the 'Eisenhower').... This is a possible photo op of the President with Mrs. R. taking a stroll through the garden. This was shot with a 50mm." Center: "Outside the Fleur d'Eau.... This will be the first meeting and greeting of the two principals. The President will greet Gorbachev as he walks out of his limo. This is the angle from the tight pool off to the side; it could be *the* picture, then again, it might become cluttered with Soviet straphangers and be a total wash. I would guess this would be a 85mm shot or thereabouts." Right: "Inside the Fleur d'Eau.... This is the plenary session photo op; a seven on seven picture. They will be seated at elongated table. Hope to get the two principals reaching across table shaking hands. Again, extremely tight quarters. Probably a wide angle (this was shot with a 28mm)."

The advance pictures were not intended to be published. However, on December 24, 1985, *The New York Times* published the three reproduced here, together with corresponding pictures made at the actual event by photographers for UPI and the AP. On the opposite page is the photograph of the actual event that corresponds to the picture at the right.

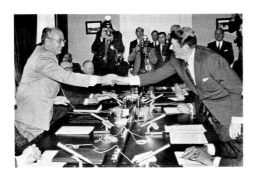

"Geneva Summit." November 20, 1985. "Soviet General Secretary Mikhail Gorbachev (L) and U.S. President Ronald Reagan reach across the conference table to shake hands at the start of the third summit session. The meeting was held at the Soviet mission." *Larry Rubenstein/United Press International.*

PostScript-capable LaserWriter, a high-quality, low-cost printer. • Taken together, these products launch the desktop publishing revolution.

1985 *The* Times *news department begins to make use of computer graphics when Gary Cosimini, a senior editorial art director, creates weather maps with a Macintosh, Mac-Draft software, and an Apple LaserWriter.*

1987 QuarkXPress typesetting and page-layout software is introduced. With extensive typographic controls and precise placement of type and graphic elements, QuarkXPress soon challenges PageMaker as the leading page-layout software for newspaper and magazine publishing. • Leaf Systems announces the Leaf-fax 35, a portable 35mm film scanner and acoustic analog modem capable of transmitting via telephone lines images captured on 35mm film. No longer obliged to make prints in order to transmit their pictures, news organizations are freed from the need to transport bulky enlarging equipment to remote locations.

1988 Digital cameras begin to appear on the market. Unlike still-video cameras, they capture the image directly in digital format.

1989 Adobe Systems introduces Photoshop software for the Macintosh. Scanned and digitized photographic images, as well as images created with digital cameras, may now be controlled and manipulated with a range of capabilities that far exceeds the range of traditional darkroom techniques.

1989 October — The *San Francisco Examiner* replaces its darkroom with Macintosh computers, Photoshop software, and color negative scanners, ceasing to produce photographic prints for reproduction in the newspaper. Color negative film replaces black-and-white film for all photographs; pictures to be printed in black-and-white are digitally converted from scanned color negatives. Many other newspapers soon replace their darkrooms with digital systems built around Macintosh and Photoshop capabilities.

1990 May — Microsoft introduces Windows 3.0 for the IBM PC and compatible personal computers. The improved version of the Windows operating system, originally introduced in November 1985, together with enhancements to Micrografx Picture Publisher, QuarkXPress, and other software that soon follows, provides sophisticated imaging and graphics capabilities for IBM PC and compatible personal computers.

1990s The application of digital technologies to newspaper production reaches a state of maturity that renders obsolete prior methods of handling text and image. The two are now brought together in a single digital system that permits an unprecedented ease and speed in assembling and editing entire sections of the newspaper. • The World Wide Web, a subsystem of the Internet that offers graphical display and audio capabilities, achieves extensive use.

1991 The AP Laserphoto and Laserphoto II networks are replaced by the AP Photo-Stream picture transmission system, in preparation since 1987. Transmitted via satellite, photographic images are received through a satellite dish by the AP Leafdesk Digital Darkroom, a computer-graphics workstation capable of storing and manipulating the pictures. Except for Laserphoto II, PhotoStream is the first fundamental innovation in picture transmission since the introduction of the AP Wirephoto network and the *Times*'s Wide World Wired Photos in 1935. PhotoStream reduces the transmission time of a black-and-white photograph from eight minutes to one, and of color from thirty minutes to three. • By this date, the Internet has grown to include some 5,000 networks in over three dozen countries, serving over 700,000 host computers.

1991 *January — Covering the war in the Persian Gulf,* Times *correspondents for the first time transmit stories through their own satellite telephones, bypassing agency networks.* • *The U.S. Department of Defense makes extensive use of electronic still cameras during the war.*

1992 *January 17 — Arthur Ochs Sulzberger, Jr., becomes publisher of the* Times.

1993 By this date, the AP, making use of digital compression techniques, reduces the transmission time of a color photograph over the PhotoStream system to less than ten seconds. Henceforth the AP transmits virtually all photographs in color. • Nikon introduces the inexpensive CoolScan digital scanner for 35mm negatives and transparencies. Although bulkier film scanners have been available since 1987, the Cool-Scan is the first easily portable model capable of scanning negatives and loading the digital images into a Macintosh laptop

computer for transmission over telephone lines.

1993 *June 6 — Color illustrations appear for the first time in the Sunday* Times *Book Review. In rapid succession, the Real Estate, Travel, and Arts and Leisure sections of the Sunday edition also incorporate color illustrations, including photographs.*

1994 AP photographers begin to make extensive use of the AP/NC 2000, a digital camera developed jointly by the AP and Eastman Kodak. Built around a Nikon 35mm camera body and using Nikon lenses, it captures the image with a digital sensor manufactured by Kodak.

1994 *In a step toward comprehensive digital page makeup, the various style pages of the* Times, *including those devoted to fashion and society news and the entire Living and Home sections, are now composed and paginated electronically.*

1994 *June 9 — The* Times *introduces "@times," an arts and entertainment news service offered through America Online. The service soon includes "The* Times *Looks Back," which presents articles and photographs from the archive.*

1994 *August 31 — Appearing in the* Times, *a picture by staff photographer Michelle V. Agins, of spectators at the U.S. Open tennis tournament in Forest Hills, New York, establishes a technological first at the newspaper. Captured with a digital camera, then loaded by David Frank, assistant picture editor, into a laptop computer linked by a modem to telephone lines, the image was transmitted electronically from the site to the* Times *in Manhattan.*

1994 *September — Covering the landing of U.S. forces in Haiti,* Times *photographers for the first time transmit pictures through their own satellite telephones, bypassing agency networks.*

1995 *In a further step toward comprehensive digital page makeup, the cultural, editorial, Op-Ed, and many of the news pages, as well as the Science Times and Real Estate sections are now composed and paginated electronically.*

1995 *May 3 — The* Times *replaces its black-and-white film processor with a color negative processor, and staff photographers henceforth use color negative film almost ex-*

clusively, although most photographs in the newspaper are still printed in black-and-white. The shift is made in anticipation of the completion of a new printing plant at College Point, Queens. Scheduled to commence operation in late 1997, the plant will enable the Times *to print in color throughout the newspaper.*

1995 August — The *Calgary Herald* in Alberta, Canada, becomes the first major newspaper in the world to convert entirely to digital cameras, abandoning traditional cameras and film.

1995 November — The AP announces that it will begin distributing text and photographs via the World Wide Web.

1996 *January 19 — The New York Times on the Web is introduced on the Internet (http://www.nytimes.com). For the first time, most of the newspaper's contents are available online worldwide on the day of publication. The Web site also offers interactive forums, news updates, material from the archives, color photographs, and a section titled Cybertimes, which offers articles on digital technology and its uses.*

1996 January 28 — Superbowl XXX is the first major news event at which AP photographers use digital cameras exclusively.

1996 *March — The* Times *all but ceases to make conventional photographic prints. Pictures made on film by staff photographers*

Mark Bussell and Nancy Weinstock of *The New York Times* in the temporary quarters of the Picture Library. April 1996. *Ozier Muhammad/The New York Times.*

Nancy Lee, Picture Editor of *The New York Times*, at work. April 1996. *Librado Romero/ The New York Times.*

are scanned from negatives and loaded into the digital editing and page-making systems.

1996 *March 31 — Average daily circulation of the* Times *for the preceding six months is 1,157,787; Sunday, 1,746,838.*

1996 *May —* The New York Times on the Web *presents an interactive photographic essay on Bosnia by Magnum photographer Gilles Peress.*

1996 *Summer — Having converted the Sports and Metropolitan News pages and the Week in Review Sunday section earlier in the year, the* Times *prepares to convert the remaining sections of the newspaper to electronic composition and pagination.*

Selected Bibliography

Baynes, Ken, ed. *Scoop, Scandal and Strife: A Study of Photography in Newspapers.* New York: Hastings House, 1971.

Berger, Meyer. *The Story of The New York Times: 1851–1951.* New York: Simon and Schuster, 1951.

Carlebach, Michael L. *The Origins of Photojournalism in America.* Washington, D.C.: Smithsonian Institution, 1992.

Compaine, Benjamin M. *The Newspaper Industry in the 1980s: An Assessment of Economics and Technology.* White Plains, N.Y.: Knowledge Industry Publications, 1980.

Emery, Edwin, and Michael Emery. *The Press and America: An Interpretive History of the Mass Media.* 5th ed. Englewood Cliffs, N.J.: Prentice-Hall, 1984.

Fulton, Marianne. *Eyes of Time: Photojournalism in America*, with contributions by Estelle Jussim, Colin Osman and Sandra S. Phillips, and William Stapp. Boston: Little, Brown, 1988.

Goldberg, Vicki. *The Power of Photography: How Photographs Changed Our Lives.* New York: Abbeville, 1991.

Jussim, Estelle. *Visual Communication and the Graphic Arts: Photographic Technologies in the Nineteenth Century.* New York: Bowker, 1974.

Kismaric, Susan. *American Politicians: Photographs from 1843 to 1993.* New York: The Museum of Modern Art, 1994.

Lee, Alfred McClung. *The Daily Newspaper in America: The Evolution of a Social Instrument.* New York: Macmillan, 1937; reprinted 1947.

Mitchell, William J. *The Reconfigured Eye: Visual Truth in the Post-Photographic Era.* Cambridge, Mass.: The MIT Press, 1992.

Schuneman, Raymond Smith. "The Photograph in Print: An Examination of New York Daily Newspapers 1890–1937." Ph.D. dissertation, University of Minnesota, 1966.

Szarkowski, John, ed. *From the Picture Press.* New York: The Museum of Modern Art, 1973.

Szarkowski, John. *Photography Until Now.* New York: The Museum of Modern Art, 1989.

Wilhelm, Henry, with Carol Brower. *The Permanence and Care of Color Photographs: Traditional and Digital Color Prints, Color Negatives, Slides, and Motion Pictures.* Grinnell, Iowa: Preservation Publishing Company, 1993.

A Note on the Prints and Captions

All of the plates are reproduced from black-and-white gelatin-silver prints. The prints range in size from about three by four inches to about sixteen by twenty inches; most of them are about eight by ten inches. All but a few of the pictures dated 1970 or earlier are reproduced here from prints made not long after the negative. Most of the later pictures are reproduced from new prints kindly made by the photographers themselves (pages 140, 151, and 159), by picture agencies (pages 146, 157, 158, and 165), or by Preston Rescigno, from negatives generously lent by photographers and picture agencies (pages 142–143, 154, 156, 160–164, 166–175).

In most cases the plate reproduces the entire image of the original print, from which cropping marks have been removed. Several pictures, however, are reproduced in the cropped form that appeared in *The New York Times* (pages 56, 118, 158, 160, 163, 164, 168, and 169). Although many older prints, buffeted by use, have been cleaned and restored, original retouching by airbrush or other means generally has been preserved. (For example, compare the picture on page 79 to variant retouchings on page 182.)

Many news photographs exist in multiple versions, to be cropped or otherwise adapted to each particular use. By the same token, it is often pointless to search for a single, authoritative form of a picture's caption. Whether crafted on the spot by the photographer or a reporter, or later, by the editor of a picture agency or newspaper, captions were written to be rewritten according to the demands of a specific context. The captions presented here within quotation marks are rendered in a form as close as has been practical to captions that accompanied the pictures when they were issued or when they appeared in the *Times*. Like the pictures themselves, these captions inevitably reflect the viewpoints and biases of their authors and of the period and circumstances in which they were produced. Indeed, some of them are obvious instances of propaganda. When known and necessary for clarity, the date of the caption is noted. In cases where original captions were unavailable or inadequate, basic caption information has been provided here insofar as it is known. This information, sometimes presented as a supplement to original caption material, appears without quotation marks.

For much of this century it was common to credit the agency that distributed a given news photograph but not the photographer who made it. At the *Times* it is now standard practice to credit staff photographers (e.g., "Chester Higgins, Jr./The New York Times") or freelance photographers working on assignment for the newspaper (e.g., "Susan Harris for The New York Times") but not photographers for picture agencies (e.g., "Agence France-Presse"). Whenever it has been possible to identify the photographer who made a given picture, he or she is credited here, along with the publication or agency for which the picture was made or through which it reached the *Times*.

Index to the Plates
Photographers and Picture Agencies

Unless otherwise noted, the photographers are citizens of the United States.